THOMSON

★

COURSE TECHNOLOGY

Professional ■ Technical ■ Reference

advertising photography

a straightforward guide to a complex industry

by lou lesko

with bobbi lane

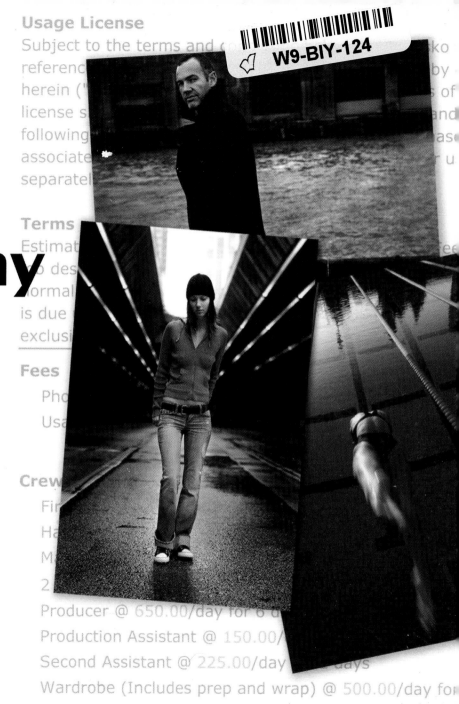

Usage License

Subject to the terms and

reference

herein (

license s

following

associate

separatel

Terms

Estimat

des

rmal

is due

exclusi

Fees

Pho

Usa

Crew

Fir

Ha

M

2

Producer @ 650.00/day for 6

Production Assistant @ 150.00/

Second Assistant @ 225.00/day

Wardrobe (Includes prep and wrap) @ 500.00/day for

ISBN-10: 1-59863-406-2

ISBN-13: 978-1-59863-406-8

Library of Congress Catalog Card Number: 2007923931

Printed in the United States of America

08 09 10 11 12 BU 10 9 8 7 6 5 4 3 2 1

Publisher and General Manager, Thomson Course Technology PTR:
Stacy L. Hiquet

Associate Director of Marketing:
Sarah O'Donnell

Manager of Editorial Services:
Heather Talbot

Marketing Manager:
Jordan Casey

Acquisitions Editor:
Megan Belanger

Project/Copy Editor:
Kezia Endsley

PTR Editorial Services Coordinator:
Erin Johnson

Interior Layout Tech:
Bill Hartman

Cover Designer:
Mike Tanamachi

Indexer:
Sharon Shock

Proofreader:
Melba Hopper

THOMSON

COURSE TECHNOLOGY ™
Professional ■ Technical ■ Reference

Thomson Course Technology PTR, a division of Thomson Learning Inc.
25 Thomson Place ■ Boston, MA 02210 ■ http://www.courseptr.com

For my dad, Big Lou; my mom, "G;"
and Michael DiMartini, the one who
gave me my break and showed me what
the word "flawless" means.

Acknowledgments

Bobbi Lane, who shares a credit with me on the cover of this book, is an extraordinary woman of seemingly endless knowledge about this industry. I have never seen anyone more effective at education about this business in my entire life. She was absolutely instrumental in getting this book written and was kind enough to contribute the writing on half of the photographers featured in the spotlight sections. I owe Bobbi an immeasurable debt of gratitude and feel honored to have had the opportunity to collaborate with her on this book. A very large thank you to all the photographers who gave Bobbi and me their stories and photography to be featured in the spotlight sections—Michele Clement, Brie Childers, John Lund, Bill Sumner, Gil Smith, Cig Harvey, Mark Leet, Caren Alpert, Mark Liebowitz, Paul Elledge, Anthony Nex, Ross Pelton, and Stan Musilek. I am also eternally grateful to these friends, lovers, drinking partners, and cellmates—presented in no particular order—for aiding me in delivering this book. Ali Davoudian, Danielle Mercury, Mark Leet, Anthony Nex, Kezia Endsley, Megan Belanger, Stacy Hiquet, Jordan Casey, Stephanie Arculli, Annie Ross, Jigisha Bouverat, Kimberley Lovato, James Skotchdepole, Craig Titley, and Chris Robinson, who is responsible for starting me on a second career as a writer. During the chaotic final stages of writing this book, a little five-year-old dude kept me sane by constantly beckoning me away from my work with an irresistible smile and offers to wrestle, build a fort, or kick back and watch a movie about fish. Thanks to Flynn who showed me how important it is to keep moving no matter how rocky your gait.

About the Author

At 18 years old, Lou Lesko taped two 8x10 prints into a PeeChee school folder and walked into the top modeling agency in San Francisco. Looking to start his fashion career, he handed the "portfolio" over for review. Three minutes later he was back in the elevator, going down. Too ignorant to realize the uproarious laughter from the booking room really wasn't a positive thing, he naively kept going back with new images until he caught a break.

Under the guidance of one of the toughest agents in the industry, Lou started his career shooting model tests until he was accepted at the University of Southern California. In 1989 he completed a double major in English and a minor in Art History. After graduation, he decided to try his skills as a photo-journalist. Blind luck, good timing, and a bad hangover contributed to Lou landing an assignment that took him to Russia as part of *Montage*, a bold project to publish a magazine in both countries, in both languages. The first periodical of its kind ever attempted, it was based out of Novosti Press in Moscow. Addicted to assignment work that took him to far off places, Lou continued on with photo-journalism for two more years, until he realized he was well traveled, but broke.

Lou eventually landed back in San Francisco where he rekindled his fashion career. Fresh with the experience of his travels, he wanted to bring a more editorial, story-telling, style to his fashion work (an extravagant way of saying he didn't have the cash for a studio and this style could be shot on location in natural light). Always looking upward, Lou moved back to Los Angeles in 1992 in pursuit of more fashion and commercial work. He felt that the Los Angeles market, while extremely daunting, would provide a good test of his abilities. Ultimately, it provided a few really lean years. Just when he thought he couldn't eat another cheap burrito, Lou caught a break with a regional Countrywide Mortgage ad that went national. As his work evolved, Lou found himself shooting for more commercial clients like Honda, Quest Communications, AT&T, and Microsoft. Looking to diversify, he took advantage of his proximity to Hollywood and managed to get his work on sets of movies and television shows. Lou broke new ground with his directorial debut of a breast cancer awareness public service announcement in 2000. Lurking around in the TV circles, his slightly frenzied personality got him an incredibly brief appearance on MTV as a photographer. This successful debut earned him a spot on other TV shows, including a featured story on his behind-the-scenes style that appeared on NBC.

As his exposure became more widespread, he attracted the interest of *Digital Photo Pro* magazine. His honest and irreverent writing style earned him a position as a regular contributor. He continues on his quest for the perfect white buttondown shirt, in the meanwhile continuing to shoot, write, and cause as much mayhem as possible.

Contents

Chapter 3
The Structure of a Bid 45

Chapter 4
Bid Psychology 69

Chapter 5
The Bid Revision 89

Chapter 10
Cash Flow and Good Business Practices 171

Chapter 11
Sex, Money, and Drama 189

Chapter 12
It's All in Your Head 201

Chapter 13
Brand Identity 219

Chapter 14
That's a Wrap! 231

Index 237

Introduction

In 22 years of this business, I have seen one constant. Everyone has a strong opinion about how to become a successful photographer. There are therefore many conflicting ideas about how best to set up a photography business.

The notion that there is one correct way to make a living as a photographer is ludicrous. Success relies on your talent, your ability to understand and maximize the assets that you possess, and a little bit of luck. Things like personality, motivation, and the ability to be resourceful also don't hurt.

Not surprisingly, the road to success is different for everyone. If you don't believe me, look at the two most notable pioneers in the digital age, Steve Jobs and Bill Gates. One became an icon by starting in the garage of his father's suburban house in Silicon Valley before it was called Silicon Valley, and the other became successful by camping out in a hotel room in New Mexico. Both have vastly different personalities. If you asked either one of them whether they were going to be successful, the answer would have been yes. But they truly didn't have any idea of the magnitude of success that they were both racing toward.

The one common attribute of every success story is passion. Loving what you're doing will always propel you to the next level. But it's not easy. There's a lot of crap to deal with and a lot of politics to endure. There is also a bizarre need to sabotage yourself. The idea that work will magically fall from the sky because you showed your book to a few art directors is commonplace, but it can be your career's death knell.

When I was 19 years old, the first real model with whom I ever worked was a girl named Jenny Mourning. We became fast friends and had a curious propensity to "one up" each other financially. The rules of the game were simple. Whoever could run up a more expensive American Express charge and still make the requisite payment on the due date won. Running up our totals manifested itself as fabulous lunches and trips to Macy's department store in San Francisco. As the bill due date approached, it was mad dash to find work. If you forfeited your payment and let your card go past due, rendering it useless for future purchases, you were disqualified.

On the upside, this game taught me how to be resourceful in finding work quickly. On the downside, it established an incredibly dangerous precedent in how to handle the provisional windfalls of cash inherent with this industry.

I have been close to getting a real job three times in my career. Once was when I was young and broke from traveling. The other two times were because I mismanaged my money. Now, before you look at me and say, "that will never happen to me," then you've never received a check big enough to make you temporarily insane.

Cash windfalls carry with them a bizarre allure. You want to spend the bucks quickly because, in some respects, you deserve to. This is an intense business that requires a lot of hard work. But when you finally get a fat payday, it is justifiable to say that you earned every penny of it and you have a right to do what you want with the money.

Cash windfalls also result in an enormous rush of confidence. In a highly insecure business, these huge checks can feel a bit like drugs. Making a nice dose of cash feels pretty good. The problem is that it leads you to believe that you can do it again and again without much effort. With confidence like that, how could you not be a superstar?

In your mother's eyes, you will always be a superstar. Unfortunately, that doesn't pay. The rest of the world will laude you for your epic moments and then quickly forget about you when you're in a creative slump. The bizarre truth is that you need a healthy ego to believe in yourself against the odds so you can move ahead, but you can't have too large of an ego because it will become an anchor around your neck.

The phrase "You're only as good as your last photograph" is only half true. You're only as good as your last photograph *and* your last public action. This is a world of talent *and* politics. Some people you'll encounter will gossip about you because of something you did, or someone you're dating, or just because they don't like your personality. Others will butter you up to take advantage of you. Personally, I adore you and your choice of reading material, provided that you've actually purchased this book and aren't reading this in the aisles of the bookstore.

There is a lot more to becoming successful in this business than taking a few meetings and telling 20 people, including your favorite bartender, that you're a photographer. There are a lot of mistakes you need to avoid that are bad for business. The most important thing to remember as you read this book is that I'm not talking to you from the mountaintop. Personally I have done more things to screw myself than anyone else I know. I've had phases of blatant stupidity, unconscionable arrogance, and just flat out laziness. As you read the following pages, keep in mind that the advice is born from surviving the mistakes.

The firsthand knowledge from the other side of the fence, the agency's side, comes from personal experience, and perhaps more importantly, from the people who work there. It's amazing what you can find out when you buy someone enough drinks. Even for me, at this stage of the game, I learned things I didn't know from some unbelievably candid friends who work at some of the biggest agencies in the world. I am incredibly grateful to them all for sharing their honest advice and insight.

Peeking behind the curtain to gain an understanding of what happens to your portfolio when you send it to an agency has the benefit of making the process seem less intimidating. It also serves to help allay any fears that pop up when you haven't heard from anyone for a long time.

One of my career-defining moments was when I saw the proof sheet from a shoot of a famous photographer whom I admired. I discovered that he took as many bad shots as I did in order to capture a good one. It diminished some of the self-doubt I was having, and imbued me with a splash of confidence that took me to the next level of my career. In a business as isolated as ours, it's nice to know you're not the only one going through what

you're going through. In that same spirit, I invited 13 photographers to share their path to their fabulously successful careers. There are no two stories alike, reinforcing the point that there is no one correct path or method to success. Along with their stories, they were kind enough to donate the usage rights of their images to be printed in the book. Thank you, thank you, thank you.

The photography work that you'll see in the "Spotlight Shooters" sections at the end of each chapter represents some brilliant work, but it also represents a level of success that is attainable. I hate to employ a cliché here, but somehow, after reading the stories of the other photographers, it seems appropriate to say that all great journeys begin with the first step. In other words, we all have to start somewhere.

The intent of this book is to help photographers gain a better understanding of the joys and sorrows of advertising photography and to help such photographers prepare to be good at it. In these pages is essential information to aide you in your success.

My goal is to help you with the business aspects so you can focus on your creativity, because that is what makes you, you.

This is not gospel. It is a compendium of experiences and smart practices. How you apply them to your own life and career is up to you. I have no doubt that some of you reading this book will probably be some of the people I will be competing against for my next job.

It's no secret that I'm not an enormous fan of photographers who act as if the enormity of their success is a result of being touched by the hand of God. If you're reading this now, it's reasonable to assume that someone besides your parents has taken notice of your ability to shoot. That means you have a better than average shot at making it as an advertising photographer. All that remains is figuring out how to navigate the complexity of an industry that seemingly makes no sense. After reading this book, you'll come to realize that this industry really does not make any sense, but that's okay, because it's a cool way to make a living!

1

Getting Started

Getting started as an advertising photographer is sort of like dating for the first time. Everyone has advice—no one's advice is similar to anyone else's advice, leaving you more confused than you were before you asked anyone's advice.

The reason for the disparity is that everyone's path to any sort of success in advertising photography is different. So where does this leave you? Pretty much in the same spot as every other successful photographer on the planet.

Like dating and sex, photography should be on your mind all the time. This business is insanely competitive, so if you aren't ready to live, eat, and breathe photography, you should look into another profession. But please don't take this book back to the bookstore; I need the money.

There are three absolutes to always remember as you break into this industry:

+ Where you are now is no different than the place that every other successful photographer was when he or she started out.
+ There is more advice about becoming successful than there is water in the ocean. It's okay to disregard most of it, especially if it conflicts with your instincts.
+ No one will hire you unless they know you exist.

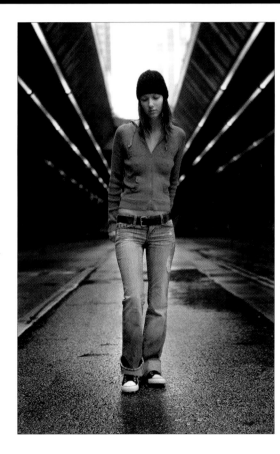

Figure 1.1
Getting started!

Getting an Education and Finding Your Genre

Thankfully, the basic laws of photography remain steadfastly in place amid the torrent of technology that has defined the new era of image making. I can still pick up a digital camera, set the ISO at 200, set the f-stop at 16, the shutter at 200 and go out in bright daylight and come up with a decently exposed image.

Sadly, understanding the basic exposure law won't take you as far as it used to. The days of getting work simply because you know the technology are over. As the digital age has brought an extraordinary transformation to our business, it has also convinced the average Joe that they can do what we do. They can't. The definition of professional photographer embodies cutting edge knowledge of the technology, a singular creative vision, an understanding of the final use of the image, and a profit-driven mindset.

I was an early adopter of digital. I think it's one of the most brilliant evolutionary leaps that this industry has ever seen. But being an early adopter meant lots of screw-ups. Our first year as a digital shop saw a few re-shoots that we excused away by hiding behind the "hey it's cutting edge technology" curtain. Fortunately, the clients we were working with were as bemused as we were about all the digital stuff.

That brief period of understanding has passed, and the digital photographic marketplace has evolved to a point where clients have very little patience for technological ignorance. Educational photography programs have become exceedingly important to improve your odds of success in this field. Photography schools also offer a brilliant way to aide you in finding what genre of photography you would like to focus on, while simultaneously providing a safety net for you to fall into should your initial attempts not go as planned.

Please keep this in mind when looking for a school. Your choice of institution should merit the same thought and attention that a burgeoning doctor gives to his or her choice of medical school. Laugh it up if you want. But the success of any vocation is extremely dependent on the quality of the foundation of the education.

These are the things you need to look for in a strong photography school:

- ✦ A well-rounded curriculum that teaches you more than just photography.
- ✦ A school that has completely invested in digital and other contemporary technology.
- ✦ A school that has a good reputation that attracts students who are smarter and more talented than you.
- ✦ A school that has a reputation for having fun; this is college after all.

As you'll see as you read further in this book, becoming successful in this business requires a lot more than just knowing how to shoot pictures and run a computer. Investing in a broad liberal arts education is probably one of the best things you can do to stack the odds in your favor of success.

Teaching students how to shoot film and how to print in a dark room has a lot of merit for creating a foundation of photographic theory and how light works. But the other half is learning digital. Yes, there are some photographers who are enormously successful and famous and who shoot film. But that film world is losing ground rapidly and will soon become a purist hobby. This industry is based on a digital standard. You have to know how to capture, process, post-produce, and transfer your images digitally by the time you get out of school. If you find a school that doesn't offer an extensive digital education, look elsewhere.

There are a lot of awesome photography schools in the United States. Two of my favorite programs are at Art Center in Pasadena, California, under the Chairmanship of Dennis Keeley and Everard Williams, and the photography program at Seattle Central Community College under the instruction of Robbie Milne.

Art Center is a private art school, and the program at Seattle is in a public community college. Both programs are brilliant. The work coming out of both schools is strong enough that I am often looking over my shoulder for some of the graduates racing up through the industry.

In a discussion with Dennis Keeley at Art Center, I asked him why someone should go to school to learn photography. He very passionately responded that "technique by itself is useless." At Art Center, they push a conceptual component with their technical classes and a technical component with their conceptual classes. Art Center also has a fantastic Letters, Arts, and Sciences program that is advocated along with the student's chosen artistic discipline. Art Center teaches their curriculum with an eye on a professional conclusion. This is why I love the school. They have a genuine interest in what you do after you graduate. For the time they have you, it's not going to be easy. As Mr. Keeley likes to put it, the school is hard to get in and hard to get out.

Another brilliant photography program lives on the campus of Seattle Central Community College. They were the first school that I ever spoke publicly at. As I was walking through the computer lab areas toward the studio where I was speaking, I distinctly remember looking at the student work on the walls wondering what was I going to tell them. The work was really solid.

My discussion with Robbie Milne revealed an incredibly forward thinking real-world program. Don't be fooled by the location in a public college. There's a waiting list to get into the program of about a year, so those who finally get started have had a while to think about it—the ones who show up are committed. It is a lock-step program, meaning that you can only take the two year program. Those looking for a quick Photoshop class are not admitted.

Robbie's program requires participants to purchase state-of-the-art gear before starting classes. Once students are in, they are immediately exposed to healthy competition.

> "First year students get involved with second year students, acting as assistants. Each year we take the entire program to an island in San Juan for a week-long shoot. It is the last push for students close to graduating. Second year students shoot, first year students assist. By doing this, the first year students always seem determined the following year to do better. We find that this type of activity naturally raises the bar and expectations each year."

Both Art Center and the program at SCCC stress a major business component combined with an atmosphere that allows students to evolve their interest through experimentation. It is a brilliant balance of art and commerce or making it in the real world as an bankable artist.

If you're starting to get the idea that this photography school stuff is tough, you're right. Whatever school you look at should give you the same queasy feeling that you're going to get your fanny kicked.

I know I'm asking for the impossible here, but try not to make your entire educational experience about coffee and cigarettes.

The two programs I mention here along with many more across the country offer amazing insight by instructors who make their living from shooting. Listen to them, at least partially. They're proffering the tools and experiences that will give you an edge in a competitive field.

Whether you choose a private or pubic school, be discerning about where you go. It's your time and your money. Your expectation should be that the photography program will offer you the same technology to work with that industry is using in the real world. And the school should absolutely offer educational diversity that includes a Letters, Arts, and Sciences program. In this industry there are a lot of smart people. You are required to bring more to the table than an ability to shoot. Compelling ideas and the ability to craft a visual story come from other disciplines beyond photography itself.

I'm Just Working Here to Pay My Bills

Here's the reality about starting out as a photographer. Until you start making real money shooting, you are going to have to pay your bills through another means. The thing to remember is this. If anyone asks you what you do for a living, tell him or her you're a photographer. Do not tell them that you are working as a restaurant server, but you're really a photographer.

A good friend of mine, Randy Evans, is a working actor in Los Angeles. He also works as a bartender. I see Randy on television all the time, and I know from talking to him that he gets a good amount of work acting. I asked him why he still tends bar. He told me that he has found a comfortable lifestyle. He has a nice place to live and he drives a fabulous car. Some days his acting gigs provide enough for that lifestyle, some days they don't. And until his acting gigs are consistent enough to take care of all of his financial needs, which includes saving money, he's happy to bartend a flexible night schedule and focus on expanding his acting career during the day.

If you ask him what he does for a living, even when he's behind the bar mixing drinks, his only response is "I'm an actor." He doesn't make any excuses about being behind the bar and certainly doesn't care what people think. He knows exactly who he is and what he wants. Most importantly, if you ask to see his reel (a video portfolio of his acting work), he'll have it to you in 24 hours, without any disclaimers like, "It needs some work." It is what it is.

Another friend. A model. Makes a wonderful money doing print work and commercials. She also works as a bartender. Her life is organized such that she takes all the money she makes as a model and puts it in the bank toward the down payment on a house. She uses her bar-tending money to live on. I never even knew she tended bar until I walked into her restaurant by accident. When she was on my set as a model, she never spoke about bar tending. And yet when I saw her behind the bar, she didn't act embarrassed, nor did she make any excuses.

So from this moment forward, I really don't care how many espressos you pulled this morning—you're a photographer.

Where to Work Until You're Really Working

So where do you work until you get your career going? That's a question of personal choice. You need to really think about how you want to live your life while you're building your photography career. But please do give the choice some thought. You always want to be on a path of self sufficiency as a working photographer. That should always loom large in your mind's eye. I'll give you a few scenarios for how you can get started.

Working as a Photographer

There is a lot of work out there for people who know how to shoot a camera and move a mouse around Adobe Photoshop. The work won't pay very well, but it will pay. Model testing, event photography, couples looking for affordable wedding photography, and the one that helped me survive my lean times—head shots. It's a large list that will require you to do a bit of marketing and hustling. It will also require you to deal with the frustration of not getting paid very well and to tolerate annoying clients who have no idea the value that you're delivering them.

Working in a Rental House

The folks who work in rental houses are the unsung heroes of this business. They work their butts off and they know the scoop about the latest gear that is hitting the market. If you're a person who wants to learn a lot about all the gear that's available, working at a rental house could be for you. Rental house employment also has the fantastic advantage of free or extremely cheap access to photo equipment that you might be able to use to shoot the new photos for your portfolio. Also, after paying some dues working behind the counter, you're still going to be connected for any future rentals that you need.

Just do me favor. If you work with a group of people renting camera stuff, and you find your big break before the others do, don't go back and gloat. When you're starting your career, you're just a few lost gigs or an economy shift from ending up right back behind the counter. Always, always respect where you come from.

Working in a Lab

Consider free prints, access to high-end computers, and lots of experience in a digital post production workflow. Learning the post-production process as intimately as you would in a lab gives a marketable skill beyond just being able to shoot. If you translate that the right way, you can add a lot of value to your photography career. I mean, I can do a few things with Photoshop, but I hire out my major post work almost all the time, typically to a person who used to work at a lab and is now on their own getting a few shooting gigs, but also augmenting their income with post-production work.

Assisting

This is going sound stupid. But not having been exposed to a formal photographic education, I had no idea that assisting another photographer was even an option. Right after I graduated from college, I embarked on a stint as a photo journalist. After two years, I was well travelled and desperately broke. I wanted to get back into my commercial fashion career applying my photo journalistic experiences. Truth was, I couldn't afford a cup of coffee let alone the money needed to build a portfolio.

I answered an ad for a sales person at place called The Image Bank, the stock photography house before they were bought up by Corbis. Their Los Angeles offices were in an old mansion on Wilshire boulevard. As I was walking into the offices, I had to side step a car shoot that was taking advantage of the gorgeous exterior of the structure.

My interview went fabulously well, but The Image Bank people were looking for a one-year commitment, whereas I only wanted to give them six months. We agreed that I would consider their offer over the weekend and talk the following week. On my way out, a shortish guy with long blonde surfer hair and a cigar started screaming at me.

David LeBon, a well known and highly successful car photographer, motioned me over and asked what I was doing. I told him I was a photographer and that I was applying for a job. He took a look at my portfolio and looked at me nonchalantly and asked "Why don't you just assist?"

A week later, I declined the sales position and became low man on the totem pole at the LeBon studios. Because the work was on a per-project basis, I had the freedom and time to build my own portfolio while still making enough money to live. I also learned a lot about running a photography business because car shoots are big complicated productions with big money. Some days I worked for free in the offices cleaning out desk drawers and other low-brow tasks on the condition that I could ask any question I wanted about how the business was run. I left after about nine months to get back into the fashion world, only to come back one year later looking for work because I got my butt handed to me by the recession of 1990. My second tenure was for only about six months, just enough time to pay my bills and save enough money to re-ignite my career.

Assisting is a good gig if you find the right photographer. LeBon let his assistants do a lot of the hands-on work, which turned into a great training experience. I always advocate trying to get work with photographers who are shooting a lot or are shooting big production stuff. The more complicated the shoot you're assisting with, the more you're going to learn about running your own business.

Just be careful. Assisting can pay really well when you're at an age when you need the bucks. If you're not careful, you run the risk of assisting all the time and never building your own career. This is called the assistant trap. Avoid it by keeping an exit strategy in mind.

Getting into the Zone

In this business, confidence is king. The only way to carry yourself confidently is to shoot, shoot, and shoot some more. If you take two photographers, each with equal knowledge and natural skill, the one who has shot the most will always win. They've done it. They've clicked the shutter a thousand more times and solved a thousand more problems in their head. Building up your own confidence is the only way to convince a client that you can do a job that actually is way over your head.

And that's essentially how you start your career, by getting a job that's over your head. I'm not talking about technically over your head: I'm assuming that if you're reading this you're probably pretty fabulous at shooting pictures. I'm talking about taking your gear and your skills out into the real world. I know you can shoot, you know you can shoot, but what about those people who write the checks?

Successfully delivering a job that is way over your head gets you to the next rung on the ladder. Successfully dodging a screw up and delivering a job that's way over your head gets you up three rungs on the ladder. And so the process goes. The more jobs you nail and deliver (doesn't matter how big the job is), the more you'll build your confidence.

It's Okay If They Don't Like You, As Long As They Don't Hate You

We live in an industry that is 80 percent rejection. I can't tell you how many portfolios I've submitted that were tossed like six-day-old Chinese food. The insidious thing is that you never know whether it was the work or the fact that the viewer is having a bad day. With exception of a few gems, most of the criticism you'll hear will be hurtful and useless. Sadly, you have to expose yourself to the useless crap to find the gems that can transform your career. All these assaults will turn your ego into an anchor. All that confidence you had two minutes ago, gone. I can't tell you how fun it is to be a photographer and get your butt kicked by the industry that you love. It's downright depressing. Combine that with a lull in work, and you'll find yourself in the middle of a period of creative depression. Clouds of self-doubt will start to follow you around like really annoying friends who are visiting from out of town. You'll shoot less stuff for yourself. You'll panic, cry, and want to buy more equipment that you can't afford in the hopes of shaking your malaise. Your significant other, family, and friends will be driven crazy by the amount of free time you have to "chat."

During these dark periods, there are a few things you should absolutely avoid. Don't spend money. I don't care how much room you have on your credit cards. When you're down, your practical business skills are at their lowest and your powers of justifying stupid ideas are brilliant. Don't call clients trying to find work. Send them an email or a new promo. Anything that doesn't involve your voice or human contact. Have you ever picked up the phone and known instantly something was wrong with the person on the other end of the line? This is what I'm saying. On the other hand, if one of your emails or promos solic-its a phone call to you, the excitement of the attention and the potential for work will naturally transform your voice and attitude into something positive.

Above all, never let them see you bleed. When you're in a lull and bummed out, keep yourself pulled together in public. This industry only has sympathy for the physically dying. If you're just having a spot of bad luck, you'll be avoided like a leper. Get your butt out of bed and into the daylight. Take a shower and dress like you would on a great day. Everyone knows when the industry is slow, but if you're seen as having it together, at least in appearance, people will be attracted to that. And, for gosh sakes, don't go wearing you're heart on your sleeve. If you want to talk about how depressed you are, drive your significant other, family, and friends crazy. Because believe me you'll have a lot of free time to "chat."

Inevitably, as soon as you put your first name on an application for a job at a cafe, your cell phone will ring with a gig on the other end. These are the good times. Working. That little pang of anxiety that you get when you're about to start shooting. I live for that. It's a feeling you never outgrow. Then there's the indescribable feeling you get when a job goes smoothly and it's in the can (for those born after 1983, "in the can" is the same as on the hard drive; it's an historical term). It also really pumps up your confidence. After the job is over, take a day off and blow a couple of bucks on dinner. But don't wait for that feeling to drift away. Now is the time to go look for more work, shoot some stuff for your book, and interact with the advertising community. Successfully completing a job and having a couple of bucks in the bank looks better on you than a Patek Philippe watch. Your creative juices are flying, and you're ready to take on anything.

Just make sure you don't get too carried away. All this confidence can and will make you cocky. This can be good and bad. The key is in understanding yourself and being aware of the effect you're having on people.

Getting Noticed

The compulsive urge to panic while waiting for your next job should be recognized as a medical condition. Many times over the last 20 years I've found myself on the verge of a complete breakdown, spending huge money on promos, emails, and sourcebooks, trying to figure out the magic bullet for getting noticed by the ad agency art buyers and art directors—the people with the work. There were times when resources ran low, and the whole effort seemed overwhelming. And then, out of the blue, often on the very day I'd be using the same coffee filter for the third time, I'd get a phone call.

"Hey, Lou, I'm looking at your promo, and I think you'd be perfect for this ad campaign."

Bravado firmly restored, I'd confidently walk over to the blue sedan parked outside my house and tell the nice gentlemen from American Express to return to their office. I'm working again!

There are a dazzling number of theories about what goes on behind closed doors in selecting a photographer for the next big ad campaign. Some say voodoo, others say sex. My ex-agent says sourcebooks, phone calls, and cocktails.

This section is about the naked truth: What happens on the other side. Why an art buyer will suddenly pick up the phone and say the magic words, "We'd love to see your book."

To get to the nitty gritty, I spoke with eight art buyers and art directors from the East Coast, West Coast, and heartland of the U.S., all of whom were exceptionally candid and helpful. Not once did I encounter any attitude or hear a cross word about photographers. In fact, just the opposite. I learned that if you're a good person who works hard and has some talent, you're going to get booked; if you're a jerk and exceptionally talented, you'll probably still get booked, but people will talk about you; and if you're nice and exceptionally talented, you'll get invited to the agency Christmas parties. Most importantly, if no one knows you exist, I'll take that cappuccino with whole milk if you please.

Combined, the industry people I interviewed represent billions of dollars in global advertising campaigns. They see the work of hundreds upon hundreds of photographers a year. And yet the possibility of getting in the door is better than you think. I asked for absolute honesty, and they asked not to be directly quoted. Some of their revelations are truly surprising.

I'm No Picasso, But Do You Like It?

Annie Ross, the Art Services manager for RPA (think Honda), is holding a ruler. I'm reverting to my Catholic school instincts and hiding my hands under my thighs. She stands the ruler on its end on the desk and points to the 5-inch mark. This is the height of the pile of promos she receives every day. Across town, Jigisha Bouverat from Chiat/Day (think Different) is looking at a similarly sized pile that has just arrived on her desk. They are two of the busiest art buyers in the industry, and during the course of the day, they will take the time to look at each and every promo in their respective piles. Many of the images won't survive the brief audition. But the ones that do will end up in a file, waiting for a job that matches the photographer's style. The truly exceptional images will end up on hallowed ground, the wall of the art buyer's office.

Once I walked into an art buyer's office and saw one of my promos on her wall. I was thrilled. In some ways it was more exciting than seeing one of my photos in a national magazine. Oddly, the design was about as simple as it gets: an image, my logo, and my Web address. After years of getting my graphic designer friends drunk and begging them to produce a promo, the one that makes it on the wall is the one that took me an hour to bang out in Photoshop, which you can see in the following figure.

Figure 1.2 The simple promo that worked.

So what makes a really great promo? The universal response is: great work. Ultimately, the decision to hold onto your piece is completely subjective. There is no magic layout that will give your promo sticking power. That being said, framing your photography with a nice bit of graphic design can be an effective way to create some familiarity. One art director said that one of her favorite shooters has been using the same promo layout for years.

She likes it because it's recognizable, and she always looks forward to seeing his latest work.

Promos with multiple images are also well received, especially if they're a campaign of photos. It shows that you're consistent in your work. And if you assign yourself a series and then use it as a promo, you'll be delivering the message that you can handle shooting an entire ad campaign. Just don't make your layout feel jam-packed; it's a fine line between versatile and crowded.

I Am a Very Fabulous Photographer

Avoid the urge to convert your magazine covers and ads into promos. No one in this industry is going to be impressed that you've shot an ad before. Moreover, if an art director hates the design surrounding your image, you may be considered guilty by association. If your photography is strong, they will know you can shoot. Keep it all about you.

Just for the record, I come from an editorial background. When I started segueing into commercial agency work, I used my magazine covers as promos all the time. I called it the "aren't I fabulous" phase. Never got one call. Fortunately, no one looked at those promos long enough to remember my name. And, as much as I'd like to say that switching to straight images was a conscious decision, it wasn't. I just ran out of covers to show.

I'll Get Better, I Swear

One of the fears I had when I was starting out had to do with artistic growth. My skill and style were always getting better. What I loved yesterday, I hated today. That's the nature of being a photographer. So I was always concerned about the work I sent out in my promos. There were days when I wanted to call everyone on my mailing list to explain that I was so much better than that tired rag I had sent them last week. The truth is, no one

cares. If the work sucks, it will be thrown out so quickly, no one will even notice your name. Unless, of course, the image is truly awful, at which point your promo will be handed around the office as a joke. If you're at all concerned that you could be that bad, I suggest a career re-evaluation.

That Sure Is a Nice Sized...

A basic rule to keep in mind when designing your promo is, will it fit into a file folder? Because if you're lucky, that's where yours will end up. One art buyer I interviewed held up a beautifully designed promo poster. The photography was gorgeous, but there was no room to keep it anywhere. She said she would probably hold onto it a while longer, but ultimately it was going to disappear because she couldn't store it, show it, or hang it easily.

All the art buyers and art directors I interviewed said they liked email promos just fine. Hmmm, "just fine." I pressed the issue further. If you're going to shoot for an agency, you're more than likely going to be shooting some sort of print work. Art buyers and art directors like to see how your work translates to print. Also, when an art buyer is searching for a photographer, it is easier and far more efficient to go through the printed promos than it is to open up email after email, looking at images on the screen. Tangibility and print quality are important to these people, so help them hire you.

Don't give up on email promos, just don't use them exclusively. According to my interviewees, an email promo is fantastic when someone is intrigued by your work and they have the time to check your Web site. But they also pointed out that when their inbox gets full, the email promos are the first to go. Lastly, think about this: when an art buyer who is a fan of your work leaves an agency, they usually leave their computer behind. They will, however, take their promo files with them.

Remember Me?

For all you photographer's assistants out there, if you're on a set and the art director hands you a business card, don't hesitate to send them something. Send them a printed anything with a note to remind them where you met. Art directors love to meet up-and-coming talent. If a low-budget, low-maintenance assignment comes across their desk, there's a strong possibility you'll get the job.

However, mind your manners on the set. When you're working as an assistant, you're not getting paid to schmooze with your boss's clients. It's not a bad thing to remember the art director's name and then pursue a connection on your own time. You can always send a promo with a note saying, "remember me, I was the assistant on that last big shoot you did."

Leave a Message after the Tone

How often do art buyers and art directors return a photographer's follow-up call? "Almost never." How do they feel about ambitious and tenacious photographers leaving lots of messages, trying to get their attention? "Annoyed." My sources were basically in consensus on this. There's a message here.

Calling to check in is not going to land you a job. If a job comes into the agency that you are right for and the creative team has your promo on file, they'll call you. If you happen to get an art director on the phone who has very little going on, they might agree to a meeting where you'll get some feedback about your book, which is always a good thing. But if you're leaving messages and no one is calling you back, don't even remotely take it personally. These people are insanely busy all the time. Sometimes it's hard to keep this in mind when you're looking for work, because you have lots of free time to dwell on the fact that the phone is not ringing.

Your Book, It's So Big

For those of you not familiar with publications like the Workbook or the Black Book, they are basically giant directories of photographers. A photographer pays about $6,000 to $8,000 per page to be featured in these books, which are distributed to an enormous list of art buyers, art directors, and graphic designers nationwide. The biggest in both size and distribution is the Workbook. It used to comprise two volumes and has since been consolidated into one.

In my experience, the trend has shifted away from the large source books as a viable way of garnering new clients. The most common complaint about the sourcebooks was the sheer volume of photography with no selection criteria. Basically, if you've got the bucks, you're in. This results in page after page of photography (good and bad), which makes it more difficult to be seen and stand out. Art buyers and art directors are increasingly searching for photographers online because it's a much more efficient means of locating the talent that they want.

Some of the small sourcebooks that art buyers and art directors do look at, like AtEdge, have a selection criteria for who goes into the book. They distribute several times a year, and the book resembles those mini Penguin classics, small enough to throw in a purse or computer bag.

However, some photographers stand by their decision to go into the big sourcebooks every year.

For my money, and we are talking about a lot of money, when you are starting out, focus your efforts on constantly expanding your portfolio and your targeted mailing list. Produce a promo at least once every two months, if not every month, and get it out to your mailing list. Invest in your online presence. This is the ultimate way to be accessible to potential clients worldwide.

Start Me Up

Having an online presence is as important as having a portfolio. Don't consider going into business as a photographer without a Web site. If I've put you into a mild panic about getting your Web site up and running, don't worry; there are many painless alternatives that will keep you out of programming school.

The number one consideration in setting up your photography Web site is simple, simple, simple. There is an enormous difference in the way you surf the Web versus an art buyer who's looking through 100 photography sites.

Flash intros, graphics-laden pages that take a long time to download, and mystical navigation methods are a death knell to an effective photography Web site. Remember, you're creating an online portfolio, not the next version of Second Life.

If you are designing your own site, either from scratch or using one of the wonderfully easy Web-building software applications like Apple's iWeb or Realmac Software's RapidWeaver, don't make your site overly fancy just because you can. If you could see the chaos that is constantly unfolding at a typical ad agency, you would completely understand that you really have very little opportunity to keep people interested in clicking through your site to see your images. Your perspective will always be skewed because you have a lot more free time on your hands. So if you find that you're talking yourself into groovy features on your Web site that you think other people will appreciate, you're wrong.

During the design stage, find a friend or relative who is on the edge of computer illiteracy. Have this person visit your site. If they can't sort out how to look at your pictures, you have a problem. Don't forget the primary purpose of your Web presence is to get your work in front of the eyes of those who can pay you

money. The site should be a major showplace for your work and only a minor extension of your personality.

Without exception, my most ardent recommendation to photographers is to get a LiveBooks account. They make having an online portfolio the easiest process I have seen. Not only can you design a relatively custom look for your site, but updating and changing your Web portfolio images is drag-and-drop easy. Not only that, but you can also store several types of portfolios on your site. So if you have a potential fashion client, you can log in to your LiveBooks Web site and load your fashion portfolio. If you get a call from a client who needs corporate portraiture, you can swap your fashion portfolio with your portrait portfolio in a matter of seconds.

Figure 1.3 The LiveBooks edit suite. Easy and fast.

My photography site is done in LiveBooks. You can have a look at it by navigating to www.louislesko.com. And then have a look at www.livebooks.com and see what they have to offer.

Imported Yak Hide from Tibet

By far the biggest religious war in the photography industry is the one surrounding portfolios. How big, how small, how sexy, how simple. Personally, I've had 14 different types of portfolios in 22 years. Go ahead, say it. I have issues.

To be sure, no matter what I say here, you will undoubtedly pursue your own path and design your portfolio as you want it. So rather than dictate any rules, I'll just give you a few practical observations along with the one constant comment I've heard from almost every art director I have encountered.

You are going to need at least three portfolios. Those three portfolios are going to have to be FedExed around the world all the time. Your portfolios are going to get left at agencies and magazines. Here is a list of considerations you should keep in mind when building your portfolio:

- ✦ What really matters is the work on the inside.

- ✦ You are going to obsess about the content of your portfolio all the time. Make sure it's easy to swap images in and out of it.

- ✦ Your portfolios are going to get mucked up and so are the images...see above.

- ✦ One or all of your portfolios is going to get lost or stolen, so make sure the cost of replacing it isn't going to cause you to have to get a small loan. Also make sure it isn't going to take months to have a new portfolio made.

- FedEx makes three sizes of boxes and has a very nice padded envelope. Make sure your portfolio is going to fit in one of those boxes. There are also boxes specifically made for shipping portfolios.

- Don't make your portfolio massive. The offices at ad agencies aren't that big, and they call in a lot of portfolios at a time.

- Don't make your portfolio too small. Things can get lost easily when there's a major call for books at the agency.

- Avoid using dense, heavy materials in the construction of your portfolio. Overnight shipping is expensive and is based on weight.

- Overnight shipping is the only way a portfolio is shipped anywhere.

- Yes, you can use a nice inkjet printer with nice paper when printing your images.

- What really matters is the work on the inside.

If I Can't See You, You're Not There

You'll never get hired if no one knows who you are. Your work is your stamp, and it's thrilling to learn that the powers that be are open to finding new and different talent. In researching this book, I dispelled one of my own myths that I've been carrying around for years. I always assumed that art buyers and art directors hated managing all the promos that come their way. If I were them, I would. In fact, the opposite is true. They are passionate about good photography and about matching the right shooter to the job at hand. Just as you and I can look at a hundred of our own images and quickly edit the good from the bad, so can the creative execs. At all the agencies I visited, the promos were filed in an incredibly organized fashion. And as they come out for consideration, so do they go back, ready to be easily located next time.

Art directors and art buyers universally will tell you that what they care about is how the photography looks, not the wrapper it comes in. I found that to be true for the most part. Clean, simple, and elegant is what my book looked like when I got the most work. It only took me 14 tries and thousands of dollars to figure that out.

How I Got Started

On my Web site, there is a wonderful story about how a camera fell out of a window of a San Francisco bus and landed at my grandmother's feet. My grandmother gave the damaged camera to my father and the rest is history. Well, not quite.

The story is true. It was a Mamiya with a nasty dent in the prism housing. The light meter was obliterated, and so I had to depend on my father's light readings I took using his fancy Nikon F2. I was 12 years old.

By the time I got to high school, I had given up on photography until about halfway through my sophomore year, when I was asked into the principal's office. He kindly told me that he hoped that I had "not gotten too attached to St. Ignatius College Preparatory." I was unceremoniously asked to leave.

At my second high school, a new friend name Mike Simms showed me how to print in the school's darkroom. I finished my high school years as a yearbook photographer. After graduation I stayed friends with a girl name Lisa Kerth. She was a model in

San Francisco and called me one day to give her a ride to a photographer's studio downtown. She had to pick up some test shots. Not knowing what test shots were, I was intrigued by the fact that she paid this guy a hundred bucks to shoot three rolls of film of her on the beach at 7 a.m.

I thought this was an easy way to make money. So I grabbed my father's Nikon F2—the same one he was using to give me light readings with six years earlier—and shot a picture of my friend Pam in beautiful speckled noon-day light in her back yard. Then

I shot a head shot of the stunning Kendra using the white hood of my car as a reflector.

The two resulting 8 × 10 prints were double stuck to the inside of a Pee Chee school folder—you remember the folder with the drawings of various sports on the cover and all kinds of conversion tables on the inside. I took that to the sixth floor of 207 Powell street. The Grimme Agency. The second largest talent agency on the west coast. I told the secretary I was a photographer who wanted to shoot their models.

Figure 1.4 Now that's talent.

She was kind and took the *portfolio* into the booking room where all the talent agents worked. About five minutes later she emerged in the wake of uproarious laughter. Continuing to be kind, she graciously told me that I wasn't quite right for their agency, but encouraged me to try other places.

I got into the elevator and ignorantly assumed that the laughter meant that they liked me. Hey, I was 18, what did I know from rejection? I shot more pictures of friends and tried to get in to see someone on the sixth floor to show them my new stuff. After repeated failed attempts, I annoyed the secretary enough that she dismissed me to the fifth floor. The agency modelling school. When I walked into that office, I told them I was sent down from *upstairs* to shoot pictures. They took the comment at face value, and I started shooting modeling school girls.

A few months later a broken down elevator forced me to walk up five floors to turn in some photos I shot. In the stairwell coming down was Michael DiMartini, an agent from the sixth floor who was renowned for having the best eye in the business. Not only could Michael edit film better than anyone, ever, but he could also look at a sea of young women at a suburban mall and pluck out the next miss thing. To this day, he is legendary.

He stopped me and asked me who I was. I told him I was a photographer. He looked at my pictures, rolled his eyes and said, "The photography is not horrible, but these girls," he winced, "puhlease stop it, where did you find these girls." I told him they were the modelling school students. He rolled his eyes again.

"Stop it. Come with me." He took me upstairs to the sixth floor into the booking room. Glancing only briefly at the model board, he took some zed cards down and told me to test with the girls on the zed cards.

Figure 1.5 A friend named Dauray who needed a head shot. Her zed card was the first time I saw my name in print. It took me a while to realize that there was other light besides sunset light.

Figure 1.6 Wow, great work. Do it again!

A week later I brought back my first model test. He looked at the strips of slide film through a loop and told me it looked good. I smiled to myself. Then, rather suddenly, he rolled up the film tossed it back to me and told me that if he wanted good he would talk to 90 percent of the photographers out there. If I was going to shoot for him, I was going to shoot brilliantly or not at all.

And so began my photographic education.

So How Do You Get Started?

Somewhere out there are clients you want to shoot for. You undoubtedly have tear sheets of campaigns that have inspired you. How do you get in touch with the agencies and art directors who have the work?

Start Locally, Think Globally

Two habits you should get into as you're starting out—shooting and communication.

Shooting a clothing catalog is not a bad gig. It pays well and everyone has a good time. It also requires an insane amount of shots in a very short period of time. When you're shooting a catalog on location, you'll be required to look around your landscape and come up with 20 to 30 setups in a day. This means you have to be able to judge lighting, time of day, and scenes creatively and quickly. No matter how gifted you are as a shooter, moving that quickly while still being effective requires experience behind the camera.

At the beginning of your career, try to shoot all the time. For yourself, for small newspapers, magazines, property management companies, salons, malls—anyone who will pay you a buck for lifting the camera to your eye. Not only will the time behind the lens aide you in assessing story and lighting quickly, you'll get the immense joy of working a bunch of very un-glamorous jobs for very little money. Sounds dreadful, doesn't it? This is called paying your dues.

Some of you are reading this and thinking that this probably a good time to throw this book in the trash along with the empty toilette paper tube you just unravelled. Please don't. I'm not trying to patronize you in the slightest. The concept and value of paying your dues is meaningless until you've paid your dues.

As you're slogging through these minor little jobs, please have the faith that one day you'll appreciate how valuable the experiences are. When you get to that point, you'll have license to hoist a glass, toast yourself, and turn around and annoy some rookie with the same annoying advice.

The second habit you should get into is communication. Start sending promos out to the agencies. Start attending functions where you can meet art directors and art buyers. Start handing out your card. Call people who are tied to advertising. If you get shooed away from one spot, don't dwell on the fact; focus your energy somewhere else. You want it and you want it bad. Keep pushing until you find a break.

Traps to Avoid

This is a business that has no structure, with no one telling you what to do until you get hired. It requires an enormous amount of self-discipline. And as romantic as that previous sentence sounds, I know as well as you do that photographers are about as disciplined as a spoiled celebrity who has had too much drink after winning an Oscar.

It is almost impossible to be honest enough with yourself that you're being lazy. The traps below are marvellous ways to self-induce a career paralysis. Avoid them if you can. Trust me, although it's a lot of work, constantly moving up the ladder to bigger jobs is a pretty fabulous feeling.

By the way. I raised the "divine expectation" trap to new heights. I'd talk incessantly in grand hyperbolic terms about each meeting I had as if they were international summits. It made for great bar chatter, but truth was they were just simple, infrequent, show and tell meetings.

Divine Expectation

If you get a meeting or few with some art directors, outstanding. Well done, you've done some really good work. Do not sit at home and wait for the work to come in. It won't. Marketing yourself, even after you've had some success, requires a lot of constant effort.

One of my worst years was the one that followed a six-month stint of a lot of work. I was so busy that I thought that I didn't have to run around doing that marketing thing anymore. Boy was I wrong.

The Assistant Trap

This happens all the time. You get a killer reputation as an assistant and you're in demand. With the overtime, per diems, etc., you're making a lot of good money, and you start getting lazy about your own work and your own career.

Too Busy to Shoot for Yourself

You cannot be a good shooter unless you are shooting all the time. Experience breeds confidence, which breeds good work, which gets you noticed for paying gigs.

The Almost Ready Portfolio

Accept this now; you will never think your portfolio is ready to show anyone. I've been shooting for 22 years, and I still don't think my portfolio is done. Fight this feeling with everything you are. When no one is looking at your book, no one knows you exist. Get it out there. No one worth anything is going to expect that you have it all together when you're starting out.

Spotlight Shooter: Michele Clement

In my mind, Michele Clement is a heroic figure in photography. Mostly because there's no bull with her. She puts her work out there as she imagines it in her mind's eye, and then she lets the rest of the world, advertising or art, sort it out for themselves.

She was working as graphic designer and photographic enthusiast in Carmel, California, when her photography caught the eye of a gallery owner visiting from Chicago. She was invited to exhibit in the smaller of two rooms in his gallery at the same time that another photographer was showing in the main exhibit space. Sadly, the person with the main exhibit space stymied Michele's exhibition by categorizing her as a Graphic Designer *not* a Photographer. It was this absurd categorization that he used as the premise for his successful lobbying to have the gallery owner rescind his show offer to Michele. She responded by becoming one of the most successful women photographers in the industry.

I have a great fondness for those who rise up against adversity and stand tall by their talent. It sets a fantastic precedent that everyone benefits from. Sitting with Michele and talking with her about her work, you can't help but to sense an unstoppable passion for shooting. It is this passion that she relied on most to navigate her way to success.

Michele settled in San Francisco because she loved the music scene. "It was smaller than New York or LA and had a great European feel to it." Looking at her work and her style, that makes a lot of sense to me. She is a commercial success based on a foundation of artistic brilliance. It's her art that feeds the commercial work.

She doesn't make excuses for making money. But in looking at her most recent photographic endeavors, I didn't see one ad. Instead, I was fortunate to be given a viewing of her latest black and white landscape work. It is breathtaking.

Michele started making money by shooting for Macy's in San Francisco. Back when I was starting out, that was *the* client to shoot for. Macy's was shooting all the time. They had a magazine/advertising section each week in the Sunday paper as well as catalogs and various other advertising needs. To support their busy shooting schedule, Macy's had a studio called Studio 71 that produced most of the work. But for covers and special features, the main art department would hire freelancers. Michele showed her portfolio to their fashion art director, having met her when assisting for a local fashion shooter. She gave Michele a chance to shoot for the Sunday supplement and that was that.

There is an image that Michele shot years ago for a Baby Guess campaign of a baby in a bassinet. The point of view was from directly above looking down at a clothesline with freshly washed sheets just slightly blowing across the frame and this baby in a white wicker cradle. It was a simple shot that conveyed an incredibly compelling story. It wasn't contrived; it was just flawless. I recall admiring how someone could bring such a remarkable artistic aesthetic to the commercial world. In fact, it was that image that compelled me to look at Michele's other work and seek her out for this book.

Michele also showed me some of her daguerreotype images that she's shot, framed in antique cases thus presenting a complete package. She has an absolute lust and fascination with the old ways of producing images. You would think this duplicitous in a digital world, but that's not it in the slightest.

She never once dismissed the new technology with any sort of cynicism. Like her work, she never stops short and she never cuts corners. At the same time, her San Francisco studio is on the cutting edge of the digital world. She has all the facilities to produce and deliver a full digital complement.

It was fascinating to interview someone who is exceedingly comfortable with all the contemporary technology that this industry utilizes, but would also be capable of being transported back in time and working with a glass plate and pinhole camera. I know of no one else with that breadth of photographic skill and knowledge that isn't a guest of an asylum somewhere.

Michele just takes it all in stride. She has no qualms with being a success in two worlds. Her studio is fabulously busy. She doesn't sit back and wait for the work to fall in her lap. Even at her level she's constantly marketing. But she doesn't just market herself with her commercial images. Her promos have a little commercial work and a lot of art. I can only think that art buyers and art directors look forward to the arrival of Michele's promo pieces. I would.

She also has a list of awards she's won that's as long as your arm, including the Black & White Spider Awards Photographer of the Year 2007. I get the sense that her vacation from shooting pictures is shooting pictures in a different way.

Michele never thought to choose sides between the commercial and fine art worlds and that, I feel, is the reason for her success. In her world, there are no categories in spite of the fact that her career was launched as a result of someone trying to force her into one. It would be easy for someone of her caliber to dismiss the commercial side of her career as "something she just does for the money." But she doesn't. Rather, she just maintains fierce dedication to the image making. Whatever image that may be.

You can find Michele's work on studioclement.com.

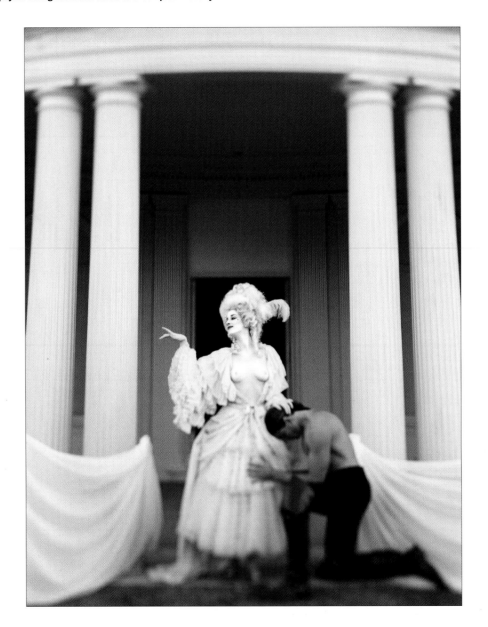

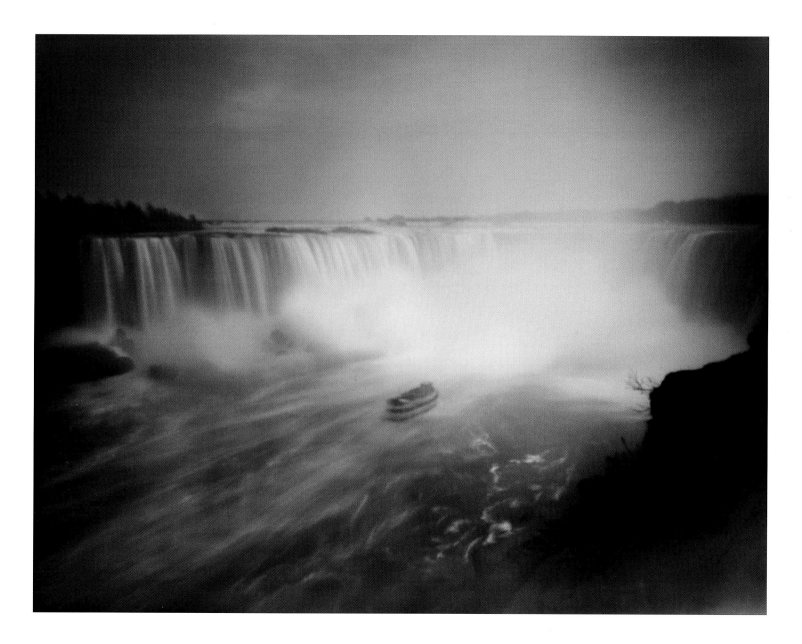

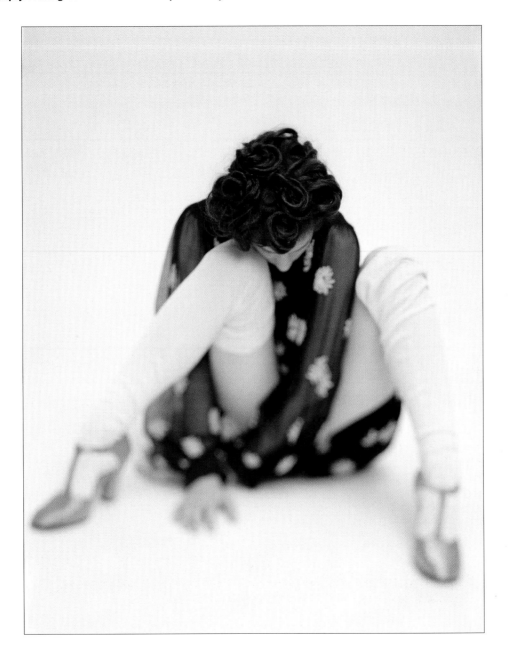

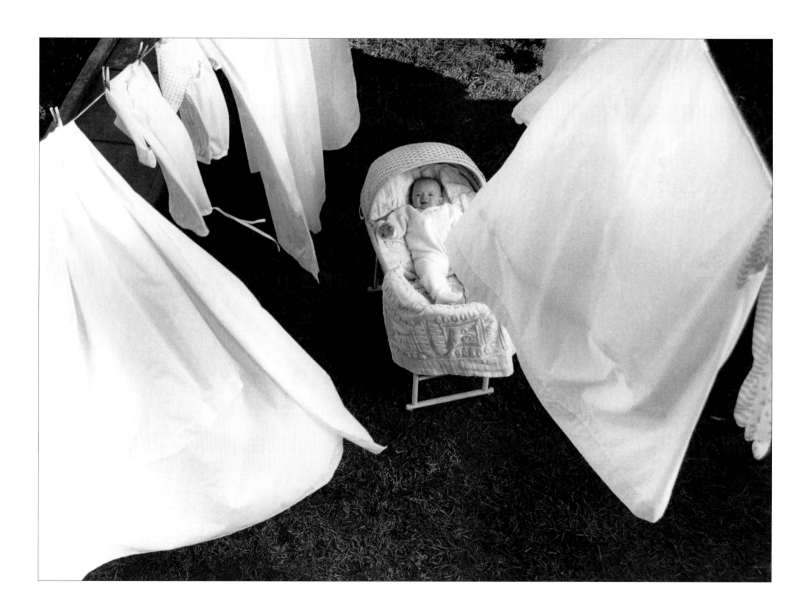

2

The Players

The dot-com boom had an interesting effect on the ad industry. There was so much disposable money floating around that everyone was working and working well. This resulted in everyone having a rock star attitude.

In the middle of a run of five back-to-back jobs, my agent got me a showing at a very happening ad agency in San Francisco. I was to meet one of the art buyers. My agent had sent the art buyer my portfolio, so all I had to do was show up, be charming, talk about my portfolio, and leave.

I arrived at 12:45 for a 1:00 appointment. I was called to her office at 2:00. I took a deep breath and painted on my best Hollywood smile to cover up the fact that I was totally annoyed that I was forced to read four articles in Adweek while she ate her lunch, the remnants of which were sitting on her desk and on the corner of her mouth. In my best diplomatic voice I introduced myself and thanked her for taking the time to see me. She looked at me, and in her practiced patronizing voice asked, "Who are you and why am I seeing you."?

For a split second, I actually thought about sucking it up and tolerating her attitude, but I had been working too steadily and my bank account was doing just fine, thank you very much. So I walked over to her desk, grabbed my portfolio and told her that she should get a watch, a better attitude, better clothes, and napkin for the chunk of hummus that was camped out on the corner of her mouth.

I never got one job from the agency. Ever.

Curiously, there was favorable fallout from getting blacklisted. Word of my little moment got around town, and I got a bunch of calls from art directors at other agencies. Everyone wanted to meet the Prima Donna who set new record for shooting himself in the foot.

Wackadoo

I was at lunch with my friend Annie Ross the other day. Annie has been an art buyer for 27 years and has earned an amazing reputation as being highly effective while also being one of the nicest people you'll ever encounter. We were trying to conjure a word that we could use to describe our industry to the brave photographers venturing into advertising. *Wackadoo* is all we could come up with.

Contrary to what some people might make you believe, you do not need to be endowed with a miraculous photographic gift to make it in the advertising industry. What you do need is real talent, a high tolerance for rejection, a knack for politics, and a suspension of disbelief. I mention the last item because your wildest nightmares will never even be close to giving you a glimpse of some of the absurdity you'll have to accommodate in order to make the agency and clients happy.

Advertising photography is like no other genre of photography. It combines all the craziest elements of a creative industry— money, ego, legal paranoia, great expense account dinners, fabulous set adventures, assistants, producers, travel, insane deadlines, all of which are centered on a photograph. Wackadoo!

In order to understand wackadoo, you need to understand a little bit about the roles of the people at the agency. You will primarily be dealing with the art buyer, the account executive, and the art director. But understanding that there are more levels of approval and politics beyond these folks will give you an appreciation for what goes into getting an ad shot. It will also, hopefully, help you understand that all the drama you'll have to deal with is not because of anything you did—well at least some of it won't be. Also keep in mind you'll be interacting with a lot of different personalities, most of whom are totally cool, some of whom will drive you crazy.

The Client

To launch the Windows Vista operating system, Microsoft will spend half a billion dollars on advertising. Putting that kind of money into the creative circle can employ a lot of freelancers. Unfortunately, that money has to trickle down a long way before we photographers can start dreaming about buying our first Porsche.

This is it. The beginning of the journey. Microsoft has a product, and they need to tell the world about it. So, as the product is developed, meetings are held, and somewhere in Redmond, Washington, a decision is made about how much money should be spent on advertising the new software.

But, before anyone starts writing any checks, Vista needs an ad campaign. So they start looking for an agency to handle the creation, production, and dissemination of the campaign. It's now up to a select group of ad agencies to win the business of handling the advertising needs of Microsoft.

At its core, the process an ad agency goes through to get this new business is not too dissimilar from the way we get our jobs as photographers. They have to present their work and hope that the client likes what they see. The difference is, whereas we may spend thousands of dollars on our portfolios and Web sites, ad agencies will spend upwards of a million dollars on their pitch to win the business.

The process of winning the business is essentially creating ad campaigns that the agency thinks will work for the client. As a photographer, you may get called upon to shoot a pitch campaign. The money is nothing to sneeze at, and the shoots are a lot of fun. When the campaign is finished, the presentations are stunning and lavish. The financial risk is enormous, but when you consider some of the numbers that I cite above, you can understand why so much cash and effort goes into trying to win the business. The agencies that win can be set for years financially; the losers usually start laying people off. It's an incredibly high-stakes game that gives a whole new meaning to waiting to hear if you got the gig.

The Agency

Last year the advertising industry spent $175 billion in major media, such as TV, radio, print, outdoor, and movie theaters. If you include direct mail and other direct-response ads, the number is $269 billion or 1 percent of the global GDP. So, if you're sitting in the waiting room of ad agency and wondering whether you could buy a house in the Midwest for the money they spent on the decorating the entry area, you could.

Ad agencies create a brand identity for a client's product through targeted campaigns. The campaigns have to be customized for the different markets and then ultimately exposed to those markets through strategic placement. The campaigns get created, approved, produced, and then placed in the appropriate media. Campaigns will include ads for television, print, outdoor, collateral brochures, direct mail, and point of purchase—you get the idea. The creation, management, and placement of all these ads are monumental tasks. When it's done right, it is incredibly profitable for the agency and, hopefully, for the client with a rise in sales. When things don't go so well, the catastrophe ends up in the trade publications as a gaffe. This will trigger a review by the client, at which point the agency will have to scramble to keep the business.

Agencies are divided into two camps: creative and accounting. As photographers, we're initially concerned with the creative side. Ultimately, we'll have to pretend to like the accounting people as well. If it sounds like there is a bit of a rivalry between the creative folks and the accounting folks, there is. But don't be too ready to take sides. Although you'll identify with one side more readily, the other is equally as important for you to make a living.

The Creative Director

The only real adult on the creative side of an agency is the creative director. It's not because there is such a significant difference in maturity between the creative director and the rest of the department. It's just that the job has an enormous amount of responsibility.

The creative director's job starts with looking at their dominion of talent so they can choose which writing/art directing team will be right for which project. Once the assignments are handed out, the writing/art directing teams will come back to the creative director and present a slew of concepts. It's up to the creative director to pare the myriad of concepts down to a few that will get presented to the client, who will ultimately choose one.

When the art director and writer are presenting their ideas to the client, the creative director will also be in the meeting to support his or her people. A good creative director will make sure to reign in the client when they start asking for too much. But they will also listen to the client's needs and make sure that those needs are addressed as the concepts progress to ads.

As a photographer, you might not have a lot of direct involvement with a creative director, but if you happen to meet one in a dark hallway, be nice and offer to buy them a drink. You'll be schmoozing with one of the most powerful people in agency.

The Art Directors

There are two distinctly different types of art directors. Those who are confident and know exactly what they want and those who are insecure and are searching for the way that they are going to illustrate the concept they sold to the client. You must be friends with both. In the long chain of agency people involved with producing an ad campaign, the art director is your most direct client.

I had a meeting with an art director named Hambis. No last name, just Hambis. He was a stocky fellow from England who wore flannel shirts, jeans, and boots, and drove a motorcycle. In front of me were the *boards* (an art director's sketches of an ad campaign) for a jeans campaign that I was booked to shoot for Hambis and his agency. No matter how hard I squinted I couldn't get past the fact that the boards looked like Rorschach tests with stick figures. Trouble was that Hambis had a reputation as an incredible art director. So I was sure I was looking at something brilliant. But what was it? I focused and re-focused my eyes, looking for something intelligent to ask when I heard

his booming voice come up behind me. "What d'ya think mate? Great right? Where d'ya think we should shoot this thing?"

I responded as anyone should when faced with upsetting the person who is responsible for your rent that month. Vaguely. This bought me another 30 seconds of deciphering time as well as a little more information from the man himself. He pointed at a black blob that was hanging off one of the stick figures. "A good butt mate. Makes any pair of jeans look great. So where d'ya think we should shoot this?"

After squinting at the drawings long enough, I began to see some familiar shapes and offered a long straight road in the high desert. The girls could be hammering a poster for the Rodeo up on a telephone pole. He looked at me and smiled. "Oy, I like that better than this side of the barn location." I smiled nervously, and he slapped me on the back. As we walked away, I took one last look at the sketch. I desperately wanted to see a barn.

A few months later, the Rodeo campaign, which took two days to shoot, was out. It was fantastic! All the images told their own story, but, also fit together to complete a larger story. Hambis was brilliant. He may not have been the best sketch artist, but his dexterity with computer tools and his ability to conceive visual stories was pretty amazing. Best of all, he wasn't a control freak. Aside from some comments about detail, he let me and my crew do what we do.

Working with an art director is a collaboration. The reason you're being sought out is because of the way you shoot pictures. When you are close enough to getting a job that you're asked to look at the boards to work up a bid, you'll be taking a meeting, or more likely a phone call with the art director, to brainstorm over your ideas on how to execute the ad. The most important thing

to remember is the word *execute*. You are not being hired to re-create a brand new ad. You are getting hired to execute the existing ad. This means that you take the idea that they have and tell them how you envision it being shot.

My propensity to get overly excited about shooting, combined with my big fat mouth, has put off more than one art director. As matter of fact, had it not been for the honesty of an art director who became a friend of mine, I'd probably be annoying people right out of using me today.

In some of the darker moments of my career, I've taken meetings with art directors who weren't so sure about their ideas. The brainstorming session would typically be centered around a vague board that consisted of a color scan of a photograph from a magazine and some text placement. If, during the conversation, it sounds like the art director is on a fishing expedition in your brain, they are. Don't storm out of the office or anything like that. Just don't go throwing your best stuff out on the table unless you have a deal to shoot the ad.

My worst experience was when the art director called me in to chat about a board that had one of the images from my Web site in it. By the time I was done, I had given him the location and all kinds of other ideas. I was sure that the gig was in the bag. Sadly, the only thing that was in the bag was all the information I had given him. This is an extreme example to be sure, and certainly doesn't speak to the industry norm, but it is out there and you need to be aware of it.

Which brings up a topic worth mentioning. There is much controversy over the use of a photographer's work in an ad mock up that an art director might use to communicate his or her concept to the client. Technically, this is an illegal use of your photo. The Advertising Photographers of America has mounted several campaigns against this practice. Many of my photographer friends are divided on the issue. Personally (this where I get a bunch of nasty emails), I don't mind if someone uses my work in that very limited capacity. There is a distinct line between inspiration and theft. I feel that art directors know that line. If you were to take issue with an agency for using your work in a mock up, you would get little more than having your image removed from the board and a lot of ill will. I look at the box of tear sheets that I used to collect when I was starting as a photographer and figure I did kind of the same thing when I was trying to find my own style. It's just one of those things.

When you're shooting, an art director's job is to scrutinize the crap out of the test images. What we think is just fine, will never be close to what the art director thinks is perfect. Too much room, not enough room, what's that spec, why are the eyes like that, etcetera, etcetera. Don't take this personally. You don't suck as a photographer. You just don't have 15 bosses you have to show the shot to when the gig is done. Rather than make the mistake of getting defensive and screwing up your ability to be creative, just go with the flow. You'll be surprised about many of the comments are actually valid. Okay, okay, just keep that paycheck on your mind; it will make the time go faster.

The Art Buyers

I love all art buyers. They are the most immaculate, wonderful people in the business.

Many of you may read this and think that I'm blatantly kissing the butts of a select group of people because they're directly responsible for hiring me.

Maybe.

My favorite offices in any ad agency are the ones belonging to the art buyers. On the walls of their offices are their favorite photography promos. As you look at all the breathtaking works, one phrase will repeat over and over in your head: "Whatever…I could do that."

Art buyers are the most important people in the ad agency for us shooters. They are the ones who find the photographers who are appropriate for a specific job. The first contact you get for a job will be from an art buyer. They will be the person to whom you FedEx your portfolio. They are also the ones to whom you submit your estimate when you've been selected to bid on a job. Consider all the jobs that are being produced at any one time at an ad agency, and you'll come to realize that art buyers are professional chaos managers.

Because of the amount of work that needs the artistic talents of photographers and illustrators, art buying is its own department run by the Senior Art Buyer or Art Services Manager. Under them they have a team of art buyers, one of whom you'll be dealing with.

The series of events that leads up to you getting a job goes something like this. Having received approval for an ad campaign, an art director will provide the art buyer with a short list of photographers whom they like for the job. The art buyer will draw upon their resources and add to that list and then call all the photographers and have them send in their portfolios. This is known as *calling in the books.*

When you get your book called in, you need to do two things. The first is have a quick look at your book and make sure that there are a few photos apropos to the client in there. For example, if you're sending your book in to be considered for a fashion campaign, don't send the agency a portfolio of animal nature images.

Second, you need to put your book and a few promos into the FedEx fast. Do not test this theory. The longer you wait, the more books will pile up in the art buyers office, making yours one of many. If your book misses the initial selection meeting, absolutely no one will care.

Once all the portfolios arrive, the art buyer and art director will go through all the portfolios and choose a select group to be considered for the job. These portfolios are then presented to the client with the recommendations of the art director and art buyer. Once everyone agrees on a set of photographers to be considered, the art buyer will then contact the selected photographers, send them a copy of the boards, and have them estimate the job. A photographer will be selected, and the job will be awarded to the photographer. Once the job is awarded, the photographer will deal with the art buyer for the advance and the final invoice.

You have to keep in mind that this scenario is a basic example of what might happen. Their are dozens of variations. Sometimes an art director will fight hard to have a photographer they know get the job. And sometimes an art buyer will do the same. A client might give a strong recommendation that the agency go with a photographer whom they've worked with in the past. Ultimately, it doesn't matter what the process is, as long as you're the one they call at the end of it.

The Writers

The writers are the other half of the creative team. They're the ones who come up with all those words that get in the way of your photography. I've never met a writer I didn't like. A lot of this probably has to do with the fact that they're not too involved with the shoot. They've already written the copy and are waiting for you get your shot done, or they haven't written the copy because they are waiting for you to get your shot done. Either way, writers the ones that are most chill on the set.

The Account Executive

There are few major clues that will help you identify an account executive on a photography set. They are usually dressed a bit more formally than the rest of us. They talk on their cell phones more than anyone else. *And they're never far from the client.*

There has always been an unwritten rivalry between the account people and the creative people. A lot of it stems from the account executive's position. They manage the budget for the ad campaign. They are advocates for the client, but work for the agency. They look good if they save the client money and treat the client well (fabulous lunches and dinners). And they are usually the ones who veto the idea of shooting a job in Barbados because of budgetary concerns.

I'll be honest, some account people are extraordinary. They do an incredible job at being a diplomatic liaison between the agency and the client. I even had one go above and beyond the call and take one for the team.

And then some are total nightmares. Politically selfish with their own agenda about how the budget for the gig should be used. In 22 years, two of my top five worst experiences in the business had to do with an account executive.

At the core, account executives are politicians with budgets. They are the go-between for the agency and the client. They have the unenviable job of keeping the client happy and the creative team on budget and on time. You will deal with account executives for a variety of different reasons, all of which seems to change with each new job. I've shot jobs where I met the account person once, said "hi" to him or her across the dinner table, and then gave him or her a hug when the job was done. And then I've worked with others who were on the phone with me or my producer five times a day making sure that everything was on point.

When dealing with account people, I ask you to understand their position, but also stand up for yourself if you need to. Ultimately, your boss is the client and the art director.

The Ad Campaign

Much in the same way that we photographers present our creative work to ad agencies in the hopes of getting a gig, ad agencies present their creative work to the companies they represent in the hopes of selling a campaign. The amount of work and process that goes on before you get involved is staggering.

Knowing that process will go a long way to helping you understand all the politics and other nonsense that you get exposed to when shooting an ad.

Looking for the Messenger

There are businesses that match up companies to ad agencies. About 10 agencies will be suggested, at which point the companies will have chemistry meetings with the agencies.

I'm sure desperately important things are considered. How do the art directors dress; do they smell funny? What kind of coffee do they serve in the kitchen? All-important hallmarks that have to pass muster before risking billions of dollars with the agency.

Next, the agencies under consideration will get a brief from the company. The brief includes all kinds of information about the product they want to sell. They will also give the agencies under consideration some seed money to put together a pitch. The seed money is not a lot; it's more like a stipend, and the agency will typically spend a bunch of its own money on the pitch in the hopes of winning the business.

In advertising, the creative is only a small part of the overall campaign. There are things like media planning (where the ads are going to get placed) and strategy planning (who do we want to reach, how do we reach them, and what time do we go to lunch). Budget planning. And the creative.

As much as I'm sure you would like to know the nitty gritty of all those different planning departments, I'm going to focus on the creative department.

I Dunno, What Do You Think?

The agency has its seed money. They've figured out all the different strategies that are appropriate for the client. The creative director starts doling out assignments to his writer and art director teams. And they're off.

As a photographer, you should pay special attention. During this phase of winning a new client, art directors are going to be looking for photographers to shoot spec ads. This is good because you can make a couple of bucks in an environment that is fun and much more lenient for creative interpretation. It's also an opportunity to prove yourself to an art director. And if you do a phenomenal job, you'll probably get asked to bid on the actual gig if the agency gets the client and if the particular campaign you worked on gets picked up.

It's for those reasons that, if you get called in to shoot a spec ad, bring your absolute best game. The art director is looking for creative input, not just an operator. If you have some groovy ideas about how the ad should be shot, throw them down on the table. This is your time to be impressive in an environment that has room to change the look and feel of the ad as you go through the process. Normal ads do not have nearly the same latitude.

Also keep in mind that the spec ad you're shooting is not going to become an actual print campaign. The public will probably never see it, but it will sure look good in your portfolio.

Don't Count Your Chickens...

Okay here's the truth. I shot a decent number of spec ads in my time. I had a good time, made friends with the art directors, and went to bed after completing the job dreaming about shooting the actual campaign. This turned into a constant daydream when I learned the agency I did the spec work for won the client.

On a few occasions when I was asked to bid the job, I started talking big at the bar. "Yeah, I already got the job in the bag. Shot the spec you know. This bid stuff is so the agency can look like it's doing its job and looking around, but I expect to have that gig awarded any day. The drinks are on me!"

It never worked out that way in my early years of advertising. Man oh man would I get depressed. I would launch into a massive bout of self-loathing combined with an obsessive recounting of every syllable I said in an attempt to figure out where I went wrong. The mental spiral got even more dramatic when I had to go find some head shots to shoot to pay the credit card bill I ran up when I was showing off buying everyone drinks.

What happened? A couple of weeks prior, I was the dude of dudes, a shoe-in, I was well respected for my creative input—today some superstar shooter is photographing my campaign.

I came to understand that it wasn't my fault. It won't be your fault either. I could tell you not to take these situations personally, but I won't. I'd be a hypocrite. Honestly, even after all the years I've been shooting, if a suburban housewife were to tell me at the last minute that I couldn't shoot her six-year-old kid's birthday party because my work was too intense, it would still monkey with my head. As a creative sort, rejection on any level sucks.

By the time the agency wins the new account and one of the spec ads is approved to be part of the campaign (this is rare, but it does happen), a whole lot more meetings occur. Inevitably, someone on the client side will yell out the name of a famous photographer, or the art director may want to turn the ad over to a friend or someone more experienced, or likewise. You get the idea. It just wasn't meant to be.

But don't assume that this will happen to you. If you're approached to shoot a spec, hop to it. Get creative and bring your ideas openly to the art director. The experience is never a bad thing. It's a lot of fun, and if you do get called back to do the ad, it's the real deal. For all the times I got looked over, I had one time that I didn't. And that turned into a lucrative campaign that I got to shoot twice in a row.

Okay, Now What Do You Really Think?

Now that the agency has won the client, the creative process becomes more formalized. The creative teams will sit in on the big product meetings that not only include the ad agency, but also all the people on the client side who produce the product.

The product gets talked about in minutia. Details like a car's shift lever getting moved half an inch are discussed. As boring as you think all these details may be, the creative teams pay close attention. You never know from where you're going to derive your next idea and selling point.

Armed with shift lever measurements, the creative teams get to work on ideas for ad campaigns. A team may come up with, no exaggeration, hundreds of ideas. These ideas will in turn be discussed with the creative director. The writer, art director, and creative director will also be in close contact with the account

executive. The account executive is the liaison between the agency and the client. They also have their eye on the budget and the timing of when the ad needs to get finalized.

From the hundreds of ideas, the list will get culled down to around 30 for presentation to the client. These ideas are presented with full boards and scripts. At the presentation meeting, the creative team is hoping the client will buy or approve one of their campaigns.

Celebrate Immediately

A good friend who is a major art director in LA told me that when a client approves an ad campaign, the best thing to do is shut up, pack up, leave, and celebrate immediately. You absolutely do not want to give the client any room to change their mind.

Are Your Ears Burning?

With the ad approved and the celebration hangover successfully treated, art directors begin looking for photographers. The art buyers are brought in, and the art directors will give them a wish list of whom they would like to work with.

Art directors never know how much money is in the budget and who is affordable in terms of photographers. That's the job of the art buyers, who are keenly aware of the money. When communicating with the art director and the world of photography, the art buyers determine whether the shooters on the art director's short list are available and affordable.

Then the art buyers will start to research other photographers they know, know of, and find through various methods. Then the books are called in and the connection with our world is made.

Now that you know how integral and powerful the art buyers are, you'll understand why I like to say, "Art buyers are lovely amazing people."

Too much? Probably huh.

The initial onslaught of portfolios is scrutinized by the art buyer, art director, creative director, client, and even the account executive. After much discussion and selling of favorites to the client, the contenders emerge. This is when you get the phone call that we all live for and dread at the same time.

We live for it because it's work. We dread it because no one, except for the seriously deranged, likes to put a bid together.

The Bottom Line

As you put together your bid, think about it in terms of the bottom line. That's what the agency is most concerned with. If you know a way to cluster your locations so you save money in permits, this gives you a couple more bucks for your fee. That's a ridiculously puny example, but the point is think of the whole picture.

Art buyers will scrutinize the line items of your bid, but they're looking for really stupid mistakes, gross exaggerations, or blatant decadence like an on-set massage therapist. Yes, I did try to slide that by once. I was dating a girl who needed some work.

If your numbers are in the ballpark of expectation, the art buyer will come back to you and tell you where your numbers need work. They're also really cool about questioning things that you missed, especially if you're a rookie.

Celebrate Immediately, Part II

There are a significant number of people involved in producing an ad. If you think about the personalities and the politics, you can understand why things can move smoothly or chaotically. The shoots that are nightmares, and you will have several, will by definition keep you up nights. You will always survive them. The absolute best thing to do in these disasters is maintain your integrity and admit to your mistakes.

The best shoots are the ones that have a little chaos with a group of calm experienced people working on it. You get to learn the most, and have a lot of fun in an environment where everyone is trying to achieve the same goal. It is on those shoots that you will make your friends.

When the job awards you, celebrate immediately.

Spotlight Shooter: Brie Childers

Brie Childers started her career as a celebrity photographer watching E! Entertainment television. She was 21 years old taking classes at Cabrillo College, in Santa Cruz, California. The photo instructors at the school held their noses up at the editorial world, espousing much more of an artistic agenda. Brie absorbed the fine art aesthetic that the school had to offer. She learned the importance of the relationship between art and quality work. Although the school she attended may not have been the biggest fan of the commercial world, they were adamant about good work.

When Brie left Cabrillo, she left with photographic knowledge, and a stack of images of her beautiful friends. Unsure how to dive into the fashion world, she did what any bright, talented 21-year-old would do; she chose to go to the source to make her start.

Struggling with the choice of spending her savings on prints to put in a portfolio, or on a new leather jacket, Brie compromised and made less expensive color copies of her prints and spent the rest of the money on the jacket. She had chosen Paris as ground zero for her career. Her greatest fear had nothing to do with how her work would be received; rather, she was worried about how her outfit would be received.

Looking fabulous and armed with a portfolio full of color copies, Brie impressed the agents at the Karen agency in Paris. Their only criticism was that her work was too "natural" looking. Brie replied that of course it was, she didn't have money or connections for makeup artists and clothes stylists. Realizing that she was able to create stunning from nothing, the agents at Karen quickly asked Brie how long she was going to be in town. Three days, came the answer.

The agents laughed, but yet were inspired enough by her work that they took the time to offer their opinion. Brie fell in love with the fashion industry. Energized by her trip to Paris, Brie began to plot where she wanted to settle down and set up shop.

Brie landed in Los Angeles and began to work as a bartender and headshot photographer. Constantly shooting, she began to make more and more connections through her headshot clients until one day her makeup artist arranged a shoot with Shannon Elizabeth. It was a little fate, a little luck, and a lot of tenacity. The shoot went extremely well and as Brie puts it, "Shannon is one of the nicest people to work with. I could not have been luckier for my introduction to celebrity portraiture."

Brie attributes a lot of her success to her tenacity. Although she doesn't cite one event as her big break, she is quick to recognize that if she didn't stay focused on shooting, none of the breaks she did get would have ever been able to find her.

I asked Brie what fueled her persistence. She remarks that she just didn't know any better. All she knew was what she ultimately wanted. But as far as gauging where she was on any given day in her career, she had no one to compare herself to—so she figured she was doing just fine as long as she was shooting. This state of blissful naiveté shielded her from ever wondering whether she was failing.

After the Shannon Elizabeth shoot, Brie's reputation began to build quickly. This demonstrates that it's not just how you perform on one shoot, it's how you perform consistently on all your shoots so when the *one* shoot gets booked, the right people notice and start saying the right things about you and your work.

Brie rose quickly through the editorial ranks, moving from inside pages to magazine covers rapidly. This steady rise owes a lot to the fact that Brie makes no distinctions about the way she shoots. Celebrity or not, she assigns the same alacrity and intensity to everything she points her camera at. If only all of Hollywood could be so unaffected.

So what does a famous celebrity shooter in Hollywood do with her off hours? You know, saves the world. Or at least part of it.

Brie realized early on that her passion and talent for beautiful image creation had more latitude to it than the money and the glam slam. Her current project *Exposed: Celebrity Insights and Inspirations on How to Feel Fabulous* is a book that will feature stunning celebrity portraiture benefiting cancer patients, and all women who need some assistance raising their self esteem. Knowing the dogged tenacity that she has demonstrated in building her career, I can only imagine the impact that Brie will have with this project.

Considering the hyperbolic domain that she works in, Brie, rather effortlessly and enviably, is very much herself. Coming up through the ranks, she chose to ignore the people who told her that "maybe she should try something else." Instead she chose to stay true to her vision, which she says started with wanting to shoot a Guess jeans campaign. This dedication to her own vision has remained a mainstay of her work. Even though her work constantly evolves, there is always something about the images that makes them stylistically unique and very much her own.

There are very few people in contemporary society who would have the innocent conviction to calmly walk into one of the top model agencies in Paris with a book of copies and a fabulous leather jacket to kick off their career. But, then again, there are very few people like Brie Childers.

You can find Brie's work on briechilders.com.

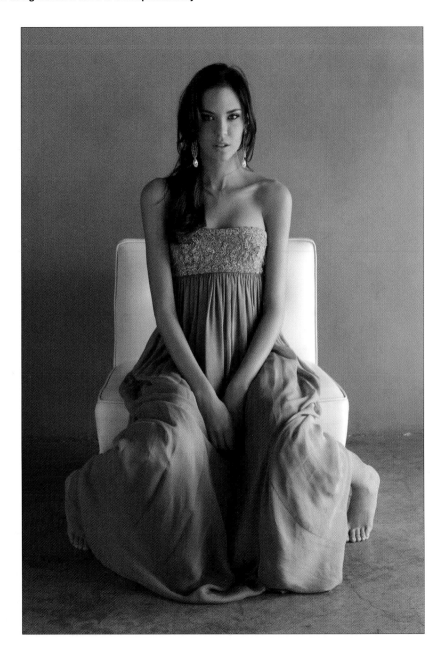

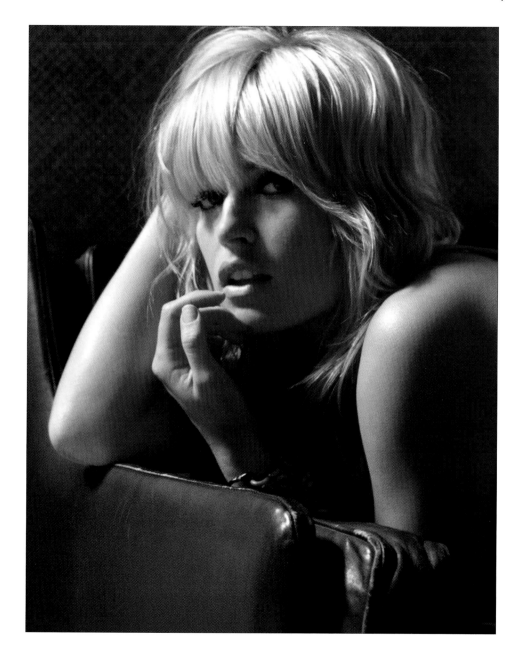

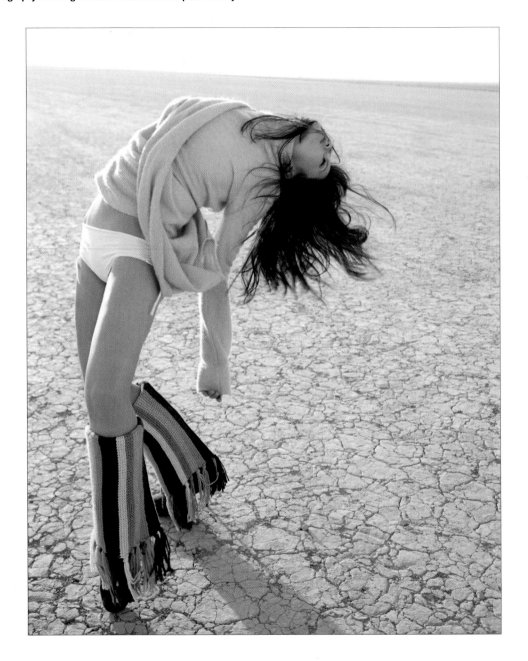

3

The Structure of a Bid

When I started shooting, life was simple. I would shoot a model test or a magazine spread and get paid a fixed amount of money for it. The fees were rarely negotiable and usually dictated by the market. Simple! Then I landed my first advertising assignment. I was shooting a small regional ad for a big client at a worldwide agency. I was being treated like a big shot, with valet parking and cappuccinos at all the meetings. It was thrilling. I figured those business-minded photographers with their percentages, markups, usage rights, and agents didn't know what they were doing. Why should I complicate things? I was getting good money for an easy shot, and I didn't have to pay an agent. I concluded that those other photographers were old school and I was new school, all about the art. Well, I completely screwed myself.

Somewhere between the valet guy parking my car and my second cappuccino, I signed away all my rights to the image. The image was shot so well that the client decided to upgrade the ad from regional to national. It ran for three years. A hindsight assessment revealed that my cocky little pen stroke had cost me $30,000 in additional usage fees.

Because of the exposure from my first ad that I made no money on, I started getting calls from art buyers who wanted me to bid on jobs. They would fax me a layout with the cryptic question, *how much?* Estimating the value of your time as a photographer is one of the most difficult things to do in this industry. Bid too high, and people think you're out of your mind and won't take you seriously. Bid too low, and people think you're desperately inexperienced and won't take you seriously.

If you are of the mindset that a bid is merely a number that you hope is close to what the client wants to spend, you're wrong. Bidding is an art form that governs profit potential. The more practiced you become at bidding jobs, the more money ends up in your pocket. Also, you'll find, as you become more deft working the numbers, you'll become better at delegating the work, which means you'll have more time to get more work and make more money.

Like most art forms, your skill at bidding will get better only through experience. You can read this book a dozen times to build a good foundation, but truly great bids are a result of lots of interaction with agencies and design firms.

One last thought. Don't ever delude yourself into thinking that you've figured out how to pull a fast one over an art buyer. Art buyers crunch numbers all day long. They know the market value for everything. In this industry, always keep your eye on the long term. Part of that is building and maintaining a solid reputation for being a straight shooter. Art buyers like working with people when they don't have to constantly question their integrity or their prices. It makes their lives easier, and makes you a more likely candidate to get more work in the future.

Bid versus Estimate

There is a lot of confusion in this industry about the terms *bid* and *estimate*. Both are thrown around interchangeably. To some people, the terms are synonymous. Others differentiate the terms according to their technical meanings.

A *bid* is a list of fees and expenses with a final price at the bottom indicating what the cost to the client will be for the shoot. When you and your client agree on a final number, that number is set in stone. It is now your job to produce the agreed-upon work for that price.

Personally, I love working with bids because they offer the most potential for profit beyond my fees. They also require the least amount of paper work because you don't have to *support* the numbers with actual receipts. For example, if I agree to shoot a jeans ad for $15,000, and the fees I'm going to make on the job are $6,000, that leaves me $9,000 to produce the shoot. Typically, the numbers indicated for the expenses (or below the line, line items) are going to be pretty close to accurate. But when you actually start producing the shoot, that's when you get creative.

When you hire sub-contractors like hair, make up, and set designers, all their prices are negotiable. Ask the person what their price would be to work on your job before blabbing what you have in the budget to offer. If they come in under what you anticipated in the bid, you've just made a few bucks. You will also have other opportunities to bring your bid in under budget, but I'll talk about that in the next chapter.

The risk in advocating a bid format is that you'll do as I did when I was relatively inexperienced and completely blow your numbers. I went through a little cocky phase when my career had a growth spurt. For a few jobs, I inaccurately guessed what the various expenses would cost, or I forgot some of the things I would need to make the shoot happen. Because the bid format is an agreed-upon hard number, I was responsible for producing the shoot for the agreed-upon price. Because I blew it and went over budget, I was the one who had to cover the overages. Trust me, you only need to do that once or twice before you start slowing down and methodically think about your bid.

An *estimate* is a list of fees and expenses with a final price at the bottom indicating what you think the job will cost the client to execute. It is different from a bid in that the final invoice of the job can vary from the estimated total. Whereas, with a bid you quote a number, and the client pays you that amount, a job that you estimate for $15,000 may only cost $12,000 to produce. You will then only bill your client for the $12,000. Or if you find that the shoot goes over budget, you'll need to get signatures for overages.

Also, when you produce a job in the estimate format, you typically have to provide the actual receipts or *backup* along with your invoice to prove that you spent the money you say you

spent. Do yourself a favor. Unless the agency or design firm specifically asks you for the actual receipts, don't volunteer them. It is a pain in the butt. But just in case you do need to provide the backup for your invoice, keep every single receipt that you get during the job safe and organized.

As I said before, the terms bid and estimate are used interchangeably and incorrectly. So you'll have to get a feel for what your client wants. Most of the ad agencies will want an estimate and expect to be billed for the actual invoice amount. Some design firms just want to know what the bottom line of the shoot is going to cost and are willing to pay that price without getting too huffy about the particulars. Keep in mind that, just as a crewmember is a line item on your invoice, you and your shoot are a line item on the ad agency invoice.

Now that you know the difference, you'll know what to be on the lookout for. It's not a bad thing to ask what the clients expect, nor is it a bad idea to lead them in the direction you want them to go. The most important thing is to be clear about the expectations *before* you close the deal. Also, don't try to educate your clients if it's obvious that they are not using the proper terms. No one likes a show off. Just be cool and use phrases like, "I just want to clarify that your expectation is to pay the amount I bid…"

Bid/Estimate Terms

The primary mission of this book above everything else is to get you into the habit of "covering your ass," *CYA*. You can only do this one way, and that is to use exceptionally clear language defining each document you send out as well as getting into the habit of using an estimate and/or invoice document with every shoot that you do, even if it's a favor for your friend. Here's an example of the terms you should include with your estimate:

Estimate is valid for 15 days from the date of issue. Fees and expenses quoted are for the original job description and layouts only, and for the usage specified. Actual amounts are subject to a normal trade variance of 10%. A purchase order or signed estimate and 50% of the estimate total is due upon booking. Job cancellation within 48 hours = 50% of fees, plus all incurred expenses; 24 hours = 100% of fees, plus all incurred expenses. All rights not specifically granted in writing, including copyright, remain the exclusive property of Louis Lesko.

Let go over the paragraph point by point.

There are a lot of well-intentioned people in the world who will get excited about the prospect of hiring you for a shoot. The problem is that occasionally the timing of their intentions is out of sync with the timing of their cash flow, so shoots are delayed, sometimes for many months. During that time you will have garnered more experience from other jobs, which raises your value as a photographer. Also, the market prices of production elements required to produce the shoot may have shifted. The "estimate is valid for 15 days from the date of issue" phrase protects you from such issues. You can re-bid the job at a higher rate if you feel it's appropriate. Personally, I've exercised this option only a few times. It is a balancing act of keeping the client happy and getting the job versus whether or not you feel like you're getting manipulated.

"Fees and expenses quoted are for the original job description and layouts only, and for the usage specified." This is the most important phrase in the paragraph. When bidding a job, you are doing so for a very specific set of images to be used for a very specific usage. If your client decides that the scope of the shoot has changed, you need to re-bid the job with the changes incorporated into the price.

"Actual amounts are subject to a normal trade variance of 10%." A trade variance applies to an estimate format of a job. What it means is that you and the client agree that you can go over the estimated price of the job by 10% without written approval.

"A purchase order or signed estimate and 50% of the estimate total is due upon booking." A purchase order (*PO*) is a document from an agency that indicates that they have agreed to pay your estimated or bid price for the job—and that the job has indeed been awarded to you. If your client does not use purchase orders, you need to get a signature on the bottom of your bid to solidify your agreement.

Advances before starting the job are standard in this industry. Unfortunately, the amount of the advance is not. I always try to get 50 percent of the job up front. But, as you'll see, each client will have a different policy. Some agencies are only willing to extend 50 percent of your hard costs (below the line expenses) up front. Some will give you all your hard costs up front. Get what you can before starting the job. And never, ever start a job without a signed agreement or purchase order and an advance check. The only exception to not getting an advance check is when you have a solid relationship with a reoccurring client who pays your entire invoice on the day of the shoot. These clients are rare, but they do exist.

I have had more than one occasion when an advance check was promised me on the day of the shoot, but the check never materializes because of some random excuse. Situations like these require delicate judgment calls. Regular clients I'm familiar with get the benefit of the doubt. Typically, they'll have a check hand-delivered to the location by lunchtime. But twice in my career I've had to threaten to "walk off the set" because the check or PO wasn't in place. Like I said, these are judgment calls. Large agencies aren't known for any problems, but smaller design firms with small working budgets may be suspect. Go with your gut. Inevitably, you'll be screwed a couple times in your career. Typically, it all works out in the end and becomes water under the bridge pretty quickly after the check clears.

"Job cancellation within 48 hours = 50% of fees, plus all incurred expenses; 24 hours = 100% of fees, plus all incurred expenses." This is pretty straightforward. If your client cancels a shoot, you need to get paid. In my experience, postponements happen more often than cancellations. Cancellations typically occur after you've been told that you've been awarded the job and then the job "goes away." It's disheartening, but usually happens before anything really gets started on the job anyway. The clause becomes necessary when you're working with a client that's not used to working with professional photographers and they cancel a shoot for whatever reason. Get your moolah.

"All rights not specifically granted in writing, including copyright, remain the exclusive property of Louis Lesko." Do not give up the rights to the out-takes of your shoot. Your usage license will only cover a specific number of images to be displayed in specific media in specific geographic locations. You are the copyright holder of every other image from the shoot. Although it may seem wrong to assume this, and some art buyers/directors will try to make you believe otherwise, don't give in. The additional images from the shoot could be worth more money.

Usage Licenses

It is absolutely critical to associate each image that you release to anyone for whatever reason with a *usage license*. This is a paragraph that defines, exactly, the allowed use of the image or images. Controlling the rights of your work is at the heart of maintaining the longevity of your business.

Figure 3.1 Building a usage license.

Think of the first season of the hit TV show "24" with Kiefer Sutherland. Now think about how that first season was released on DVD and then syndicated for re-runs. Then think about how the syndication was released to different countries around the world. Every time a deal was made to show that first season somewhere, money was made for the writers, producers, and the actors, which they receive in the form of a residual payment.

Photography is no different from the TV industry. Maintaining control of the rights can yield you significant future revenue. The tool for controlling these rights is the *usage license*.

Here's an example of a usage license:

> *Subject to the terms and conditions below, Louis Lesko the creator of the work ("Work") referenced in this document (number LES1009), hereby grants to The Groovy Agency defined herein ("Client") an Exclusive license to use 4 images of the Work in The United States only. This license shall be valid for 2 Years from 23 May, 2007, and shall cover publication of the Work in the following media only: Print Advertising. The only credit line to be associated with the Work is "Louis Lesko." Any other use of the Work by the Client shall require a separately negotiated license.*

Lets go over the paragraph point by point.

The document number is the number on the invoice. This ties the usage license to the document that describes the shoot as well as lists all the elements involved in producing the shoot.

I define that the client gets four images from the body of work I produce. Whatever four images they choose can only be displayed in the United States.

Next, I indicate that selected images can be used for two years from 23 May, 2007, and that they can be used only for print advertising. Most ads do not have a credit line associated with them, but if for some reason the image does, I want to be sure that everyone knows what name should go with it.

The last phrase is critical. When your client signs off the usage license, they do so with the understanding that, this is it. If the clients want more or less, they have to request an addendum to this agreement.

As I write this, I'm on a plane to France to shoot images for a book. The usage license that the publisher and my agent agreed upon specifically indicated how many images the publisher can choose from the body of work I bring back with me. They have an exclusive to those images only. The images that they do not select are mine to do with what I want. The reason the usage license was structured this way is because I'm getting sent to some fabulously remote regions in the south of France. The images I'll get will be incredibly marketable, so I wanted to clearly spell out my ownership of the non-selected images. I was fair in that the agreement has a clause in which I won't shop around the out-takes for three months after the publisher makes their final selects. This gives them a chance to change their mind without the worry that one of their new choices may have already ended up in a magazine.

This was a unique situation that required a unique usage license. I mean seriously, the south of France in the summer time? I had to go. So I ended up adding bits to the basic usage license to make it work for the client and for me. If you start with a good basic usage license as a foundation, you can add your own conditions to make the job go. You're not a lawyer, so don't try to write like one. Say what you mean simply and clearly. And tag it onto the end of a license like I gave you above. Not all the gigs you'll encounter will fit a boilerplate usage license, no matter how good it is. You need to be able to improvise sometimes. Giving up too many rights is bad for business, but not being able to adapt to your clients' needs is equally as bad for business.

Usage Licenses Adapted for the Web

The Internet has presented some intriguing challenges for usage licenses, one of which is the lack of borders. Previous to writing this book, I used to throw in a line saying that the client could use the images on the Internet along with whatever other media they were looking to license. With the unfathomable explosion of the Internet, it became necessary to start dictating where the images can be used on Web sites.

How Internet usage will pan out is a work in progress. But here are some of the questions being bantered about:

+ *Will the image be used in an email blast?* This is basically an electronic version of a direct mail campaign.

+ *Will the image be used on the client Web site only?* Ever read a person's blog and see a YouTube video on the page? Placing that video on the page is as easy as copying and pasting a string of text. Is your ad going to be subject to that kind of distribution?

+ *Will the image be used as part of a banner ad campaign?* You know all those inline ads you see on Web sites like CNN as well as on *pro* blogs? Those ads get a lot of exposure and that means more usage money for you.

+ *Will the image be used in any sort of company blog?* In the current economy, companies (clients) are using blogs as a means of offering a measure of transparency to their customers. If you shoot a picture of a car and Honda uses that image on their home page, that's one thing. But if they use that image in a blog, in my mind that constitutes additional usage because a blog can easily be considered *collateral* material in much the same way an informational brochure is considered collateral material.

As far as I can see, there are four new categories for image distribution on the Internet:

- ✦ Email blasts (any size)
- ✦ Home Web site display
- ✦ Web banner ad display
- ✦ Blog usage

I wrestled with defining numbers for the email blasts. But as our industry moves forward, the paradigm for how many "eyes" see your image is dwindling. Circulation numbers used to be the way usage was defined for magazines. But in the last decade, magazines have defined fixed budgets for each image in each section of the magazine.

My feeling is, if you present a client with a usage license defining how many emails they can use your image for, you're going to scare the client off to another photographer. The future is in managing the *time* your image can be used and *where* your image can be used. I feel that we need to start considering months as a viable time segment for Internet usage. This is a very tangible and easy way to define usage for a client. Using definitions like how many "impressions" an image may get is way too nebulous, especially considering that everyone's perception of the size of the Internet is different.

Get the Balance Right

Usage licenses need to protect your copyright in a way that makes you money. A usage license in large part is how you monetize your talent and maintain control of your images that may have a second or third life beyond their initially intended purpose. Conversely, your usage license cannot be so bogged down with rhetoric and conditions that it sends your client searching elsewhere. You must balance copyright with accessibility.

A usage license must appear on *every document* sent to the client. This includes the bid/estimate and all the revisions as well as the final invoice. Whoever your potential clients are going to be, they must know from the very start that you are savvy enough to manage the right of your work. Do not compromise this point, ever.

If you're shooting a job as a favor for a friend, give them an invoice that has a total of zero or the words *no charge*, just so you can have a signed document with a usage license printed on it. Even if you plan to sign over all the rights for an unlimited time for your friend, make up a usage license indicating that. It is a smart business practice, it gets you in the habit of assigning value to your work, and when your friend catapults to the top with the help of your images, you won't be so resentful because you've got that paper with your signature on it.

Invoice Terms

Here are some examples of the invoice terms that should accompany your invoice:

Invoice is payable upon receipt. License usage rights are transferred upon full payment of this invoice. Failure to make payments voids any license granted and constitutes copyright infringement. All rights not specifically granted in writing, including copyright, remain the exclusive property of Louis Lesko.

or

Invoice is payable upon receipt. A late charge of 1.5% per month will apply after 7 days. License usage rights are transferred upon full payment of this invoice. Failure to make payments voids any license granted and constitutes copyright infringement. All rights not specifically granted in writing, including copyright, remain the exclusive property of Louis Lesko.

Let's go through these examples point by point.

I love the look of the phrase "payable upon receipt" when I see it on my outgoing invoices. If gives me a wonderfully false sense of hope that I'll get paid quickly. Unfortunately, this is a business where getting paid is almost as difficult as getting the job in the first place. By far, the worst offenders for slow payments are the editorial companies (magazine clients). Their budgets are usually miniscule. They don't pay advances. And you typically don't see your money until 30 days after publication. Which, depending where you come in on the editorial schedule, could mean two to five months.

Corporate and direct clients usually pay pretty quickly, and ad agencies can be somewhere in between to downright fast depending on how well your invoice submission conforms to their standards. By that I mean, do you have all receipts organized, and so on.

In 22 years I have never, ever collected a late charge. Honestly, if your payment is so late that you're calculating your late charge bonus, you should probably be talking to a collection agent instead. When you come right down to it, you have to think about whether or not you want to make those kind of waves and upset your client enough that they completely take you out of contention for any future work. (There's more on this in the "Late Fees and Collecting Your Money" section of Chapter 9.) But the line sure does look tough and sexy doesn't it?

"Failure to make payments voids any license granted and constitutes copyright infringement." This is the most powerful line in your invoice terms. If your client does not pay you in a reasonable amount of time and they are actively using your image, they are in violation of copyright law. This is a nice leveraging point if things get nasty.

Finally, the last line of the paragraph above mirrors the one in the bid terms. But it bears repeating because it is one of the most important concepts of your career. Do not give up the rights to the out-takes of your shoot. Your usage license will only cover a specific number of images to be displayed in specific media in specific geographic locations. You are the copyright holder to any other image from the shoot. Although it may seem wrong to assume that, and some art buyers/directors will try to make you believe otherwise—don't give in. The additional images from the shoot could be worth more money.

Terms and Conditions

Equally as important as the usage license is the Terms and Conditions document, often referred to as the T&C. This is a long-winded document that spells out all the terms and conditions that go along with hiring you as an independent photographer. Although this document may be long and arduous, it can be a lifesaver if you ever have to go to court for any reason whatsoever. This document is usually presented when you've been awarded the job and you're finalizing all the paper work and agreements so you can begin the job.

Here's a brief glimpse at some of the topics that are covered in the T&C:

+ *Definitions*—What is an image defined as, what is meant by "transmit" the work, and so on.

 Fees, Charges, and Advances—This reinforces your trade variance, for when you use an estimate and the client is responsible for the actual expenses.

+ *Postponements & Cancellations*—Tells your clients that they have to get written consent to kill a job without paying the fees discussed in the bid/estimate terms.

- *Force Majeure*—Covers weather delays, acts of God, and so on.

- *Client Approval*—The client needs to have someone on the set to authorize each phase of the shot. For example, if you are set up to shoot, the client needs to sign off on the test image before you continue.

- *Overtime*—What is overtime and when does it come into play for your crew? Sorry, you don't get overtime.

- *Redoing Services*—What defines the conditions for a re-shoot and who pays for it?

- *Limitation of Liability*—If someone decides to sue your client because of the image you shot, this clause holds you not liable because you were executing the client's request.

- *Rights Licensed*—Reinforces your usage license.

- *Return of Images*—Technically, the images belong to you once the usage license expires. This defines the protocol for getting them back to you.

- *Loss or Damage to the Images*—Where does the responsibility lie at the various phases of production?

- *Payment and Collection Terms*—Reinforces your invoice terms.

- *Releases*—Who is responsible for the model and property release—both garnering and storing?

It's a lot of stuff and seemingly useless. But if at anytime in your career should the poop hit the fan, you will absolutely need this signed document. This is typically used with advertising and corporate clients. Editorial clients have their own contracts that they will give you to sign. These documents spell out what the magazine's rights of usage are for your images. Because magazines don't pay a lot, they usually buy "one time publishing rights" with a clause that lets them use your image in the context of the magazine layout to advertise the magazine itself. Think about the subscription cards that fall out on your legs when you're sitting on the toilet with your latest copy of whatever. Notice how the subscription cards have a picture of a past issue of the magazine on it? If you shot the cover photo for that past issue, you typically have to give up the right to let the publication use your work in that context forever.

Structure of a Bid

Here's a universal truth. Art buyers and clients do not care how pretty your bids are. They care about the numbers. They want to know what they're getting, and for how much money. They want to see this represented in a clear, easy-to-read document. There are absolutely no points given for having a more artistic representation of your bid than the other guy.

Absolutely every bid you submit should have a description of the "usage license" as well as a very clear description of the work to be performed. Here's an example:

> *Shoot is to execute boards for RPA agency for Honda of America for the "That's why we give it to them" campaign. A woman running on a wooded trail at sunset. Photographer will provide all digital images on a hard drive from the shoot to be edited by the Art Director. Only one image may used from the shoot as directed by the Usage License. There are no post-production expectations for the photographer.*

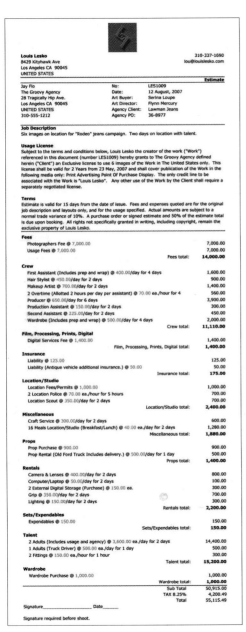

Figure 3.2 Here's an example of a simple two-day shoot that you'll read about in Chapter 7.

Because your are primarily working from boards for an agency, there is inherently a pretty clear description of the job. However, if you're working without boards, your description should be more detailed, as follows:

The "San Diego living" shoot for Paines Properties shall illustrate the following scenarios only.

A man and woman couple walking in the Gas Lamp District. The image will capture a happy couple while also featuring a Gas Lamp District landmark or recognizable feature that establishes the location to the viewer. 1 scene.

A man and woman couple at a cafe with coffee and dessert, exterior, day. 1 scene.

A man and woman couple at any naval ship open to the public. Three unique scenes featuring the ship as the back-drop.

A male adult in business attire getting onto or off of the tram. 1 scene.

A woman running along the water and near the shipyard. 2 scenes.

A man and woman couple smiling and looking at floor plans for Paines Properties new development. 1 scene, various expressions.

A "scene" is synonymous with a shot set up.

The photographer will do an initial edit of all images and then present the results of his first round of selects to the client. The photographer will collaborate with the client for additional image edits for only two additional occasions both by phone while looking at Internet accessible proofs.

The photographer will be responsible for post-processing of 10 final images. Post-processing is defined as balanced exposure and balanced color, as seen by the photographer on his computer monitor. Any subsequent exposure or color-balancing to match printer specifications and calibration are the responsibility of the client. There is no retouching expectation for the photographer.

I don't care if you're shooting a wedding for your mother's third cousin. Having a document that very clearly spells out what your going to shoot on every job avoids the dreadful post shoot "he said, she said" arguments. It also protects you from getting intimidated or manipulated into giving away more rights than you are getting paid for.

When you put expectations in writing for a favor, it saves a lot of misunderstanding. You'll be amazed how greedy people can be when they get your services for free.

In an estimate or bid there are two types of charges, "above the line" and "below the line," more commonly known as "fees" and "expenses." Fees include things like how much you're getting paid to shoot the image and the usage fees the client has to pay for the privilege of using the shot. Remember that according to the law, if you create it, you own it. Other cool fees include getting paid for your time on an airplane or getting paid if there is bad weather. The fees portion of the invoice is most important to your rep or agent, because this is where they make their money. They get a percentage of the fees, or above-the-line costs.

Below the line, in the expenses portion of the bid, is where you put the production expenses for the shoot. Anything or person (besides you) essential to executing the images goes below the line. Below the line is where you also find the magic of the markup. If a roll of film costs you $20 to purchase and process, you can mark up that cost anywhere from 50 to 100 percent.

Crew		
First Assistant (Includes prep and wrap) @ 400.00/day for 4 days		1,600.00
Hair Stylist @ 450.00/day for 2 days		900.00
Makeup Artist @ 700.00/day for 2 days		1,400.00
2 Overtime (Allotted 2 hours per day per assistant) @ 70.00 ea./hour for 4		560.00
Producer @ 650.00/day for 6 days		3,900.00
Production Assistant @ 150.00/day for 2 days		300.00
Second Assistant @ 225.00/day for 2 days		450.00
Wardrobe (Includes prep and wrap) @ 500.00/day for 4 days		2,000.00
	Crew total:	**11,110.00**
Film, Processing, Prints, Digital		
Digital Services Fee @ 1,400.00		1,400.00
	Film, Processing, Prints, Digital total:	**1,400.00**
Insurance		
Liability @ 125.00		125.00
Liability (Antique vehicle additional insurance.) @ 50.00		50.00
	Insurance total:	**175.00**
Location/Studio		
Location Fees/Permits @ 1,000.00		1,000.00
2 Location Police @ 70.00 ea./hour for 5 hours		700.00
Location Scout @ 350.00/day for 2 days		700.00
	Location/Studio total:	**2,400.00**
Miscellaneous		
Craft Service @ 300.00/day for 2 days		600.00
16 Meals Location/Studio (Breakfast/Lunch) @ 40.00 ea./day for 2 days		1,280.00
	Miscellaneous total:	**1,880.00**
Props		
Prop Purchase @ 900.00		900.00
Prop Rental (Old Ford Truck Includes delivery.) @ 500.00/day for 1 day		500.00
	Props total:	**1,400.00**
Rentals		
Camera & Lenses @ 400.00/day for 2 days		800.00
Computer/Laptop @ 50.00/day for 2 days		100.00
2 External Digital Storage (Purchase) @ 150.00 ea.		300.00
Grip @ 350.00/day for 2 days		700.00
Lighting @ 150.00/day for 2 days		300.00
	Rentals total:	**2,200.00**
Sets/Expendables		
Expendables @ 150.00		150.00
	Sets/Expendables total:	**150.00**
Talent		
2 Adults (Includes usage and agency) @ 3,600.00 ea./day for 2 days		14,400.00
1 Adults (Truck Driver) @ 500.00 ea./day for 1 day		500.00
2 Fittings @ 150.00 ea./hour for 1 hour		300.00
	Talent total:	**15,200.00**
Wardrobe		
Wardrobe Purchase @ 1,000.00		1,000.00
	Wardrobe total:	**1,000.00**

Figure 3.3 Below the line items.

Shoot a hundred rolls of film, and you've made a nice chunk of change.

In the digital age, there is no longer the opportunity to mark up film. This caused a frightening ripple through the photography industry. That is until Los Angeles-based photographer, Anthony Nex, coined the phrase *digital services fee* or DFS, which is used instead of the film markup. I'll tell you how to implement the DFS later in this chapter when I talk about that section of the estimate (see "Anthony's Digital Solution [DSF]").

The primary purpose of your markups or digital services fee is to help you cover your overhead, which includes studio space (if you have one), camera gear, computers, advertising, and so on. The idea is that you want to take home as much of the above-the-line section of the bid as possible. It doesn't matter if you're a photographic artist, journalist, or commercial shooter—if you're not conjuring up an idea to shoot or you're not behind the camera, you should have a Wall Street state of mind.

Fees

The Fees section of your bid, also known as the above-the-line section, is where you charge your client for you. Your time, your thoughts, anything that you do that contributes to the successful execution of the project. It is also the section where you charge for the usage of the work. Technically, you own the rights to any image you shoot, even when the clients hired you to execute the shoot—they are only leasing the image from you for their purposes. This is why the usage license is so important. It defines exactly what rights the client has in terms of using your work.

The most important line item in the Fees section of the bid is the one where you list how much you're going to charge the client for your services and for the rights or *lease* of your images. There are two schools of thought on how best to do this.

School of Thought A: Combine the Creative Fees and Usage Fees

The first method, which is the way that I have always done business, prescribes that you have one line item called the *photographer's fee*. This fee includes your charges for your time in shooting the job *as well as* the charges for the usage of the produced imagery. So, if I charge $4,000 to do the shoot and $6,000 for the usage for two years, my bid has one line item called the photographer's fee for $10,000.

The advantage to presenting your fees this way is that, if your client comes back to you to extend the terms of the usage license, you can calculate those fees as a percentage of the original usage fees charged. Because you are combining the two fees into one, you have a larger base amount to start your negotiation for additional usage fees.

In talking to a few art buyers about the matter, they all agreed that they like the combined format as well. It makes it easier for them to explain the usage to their clients. And since they're the ones paying everyone's salary, I always find it wise to make things as simple for the money grip as possible.

School of Thought B: Separate Your Creative Fee from Your Usage Fees

The second school of thought is to list your *creative fees* separate from your *usage fees*. The advantage to presenting your fees this way is that it adds value to you as a photographer and educates

the client about the process involved in producing a shoot. It also has the added benefit of reinforcing the concept of the *usage license*. One thing to keep in mind—although you and I both know that having the experience and talent to execute a shoot is worth its weight in gold—some people get weird about paying someone a creative fee and a usage fee.

Other Fees to Consider

Although getting paid to shoot and license your images is the primary revenue of any job, there are other fees that your should consider when putting together your bid. As you read about the following fees, it is important to make a distinction here. These are included in the above-the-line section of your bid. Everything discussed here has nothing whatsoever to do with the *production expense* or below-the-line section of the bid. I mention this because some of the terms I mention here will be similar to some of the terms used below the line. Keep this distinction in mind as you read on.

Weather Delay Fees

Weather delays are negotiated up front as a contingency should the shoot get cancelled or postponed due to weather. It is also a fee that tends to come into and out of vogue depending on how the economy is doing.

Weather delay fees are calculated as a percentage of your primary fees. That is your photographer's fee or your creative fee, depending on which way you bid the job. The rationale goes that you can't help the weather, so you should still get some bucks for showing up ready to shoot. The understanding of this fee needs to be crystal clear to your client before you start shooting. Because if you actually get screwed due to the weather, you have

to be sure that your client understands that they owe you some money.

The weather delay fee does not have anything to do with paying your crew or your other per-day expenses. Your client, no matter what, assumes this expense. Depending on how much additional money is needed to cover the expenses for the lost weather days, you might need to petition for overages. For example, remember how we talked about the 10 percent variance before? If the expenses for the weather delay fall within that 10 percent variance, you don't need to get an overage document signed. If your expenses extend beyond that variance, you better start getting signatures from the art director and account executive. I usually like to obtain those signatures about two drinks into cocktail hour.

Travel Fees

Travel fees are fees that cover your time should you have to travel to location. Your time is valuable and if you are stuck on a plane all day, you can't be back at the studio running your business. The travel fee compensates you for that. Use this fee only when getting to location takes more than three to four hours. Living in Los Angeles, I shoot a lot in San Francisco. It takes only an hour to fly, so I don't include the travel fees on short hops like that. This is also a highly negotiable fee, so if you're about to lose the gig because your client is squeaking about your travel fees, dump them. The popularity of this fee also seems to be dictated by the general health of the economy.

As with the weather delay fee, keep in mind that this is a *fee* and has nothing to do with covering the expense of flying you to location (such as the price of the plane ticket). That is a hard cost, which you find below the line in the travel section of the bid.

Post-Production Fees

Other fees you should charge for are things like *post-production fees*. You know all that screwing around you did with Photoshop when you first got your hands on it? That translates into experience, which translates into money. When I do a job that requires me to hire someone to do the Photoshop work, this person's fee goes *below the line* in the post-production section. But if I'm at the post-production studio guiding the Photoshop specialist, that is reflected up here as an above-the-line fee.

If you're starting to see the pattern that your experience as an image creator translates into your time and opinion having value, you'll be successful as a photographer. It is one of the oddest concepts to get your head around because ultimately what we do is really fun and gets increasingly easier the more that we do it.

Expenses

Below the line, in the production expenses portion of the bid, is where you categorize and list all the expenses associated with executing the shoot. This is also the section where you find the magic of the markup.

If a roll of film costs you $20 to purchase and process, you can mark up that cost anywhere from 50 to 100 percent. Shoot a hundred rolls of film, and you've made a nice chunk of change. Other items like expendables (tape, gels, and so on) can also be marked up. If you manage your items well, you can produce a decent profit *below the line*. But before you stash all that money away under the mattress, don't forget your overhead expenses. The rule of thumb in marking things up is that that money should cover the overhead of running your business. You want the fees that you charge to be your profit.

Bidding Below the Belt

Following the fiasco I told you about at the beginning of this chapter, I was able to land a rep and things were starting to flow. My bids were coming together and landing me work, my rep was doing well by me, and I was starting to think about an advertising budget for myself. I had finally found a groove. As long as my creative skills kept growing, I thought, I could take it easy. Then I hit a rut. I misfired on three or four jobs in a row. I discovered later from my art-buyer friend that I was getting nailed on my expenses. But wait, I thought that you knew that I knew that you knew that I was marking up stuff?

As I learned, some photographers were manipulating their markups and film budgets to bring the job in way under my bid. The trick was to estimate 20 rolls of film for a job that needed 50. Then, after getting the job, start shooting, and in the panic of the moment have the client sign off on overage charges. Combine this strategy with manipulating the markup rate, and a photographer could effectively underbid 70 percent of the competition. Fortunately, the advent of digital photography has done much to level the playing field.

With digital film, the most profitable below-the-line expense was gone. I had to look at bids in a whole new way. It was pros and cons time. On the one hand, photographers were saving on messengers and FedEx transporting film to and from the lab. Certainly, the film and processing costs had evaporated. On the other hand, computers are pricey, and in the digital workflow, they have an 18-month life span. Laptops, software, cameras, and storage devices are just a few of the costly items required to convert to digital. We needed our markup back.

The answer came from my friend Anthony Nex, a fabulous shooter in Los Angeles. If I was a pioneer in going digital, Anthony was an explorer. He was one of the first to have a viable business strategy for the digital workflow. Without him, I would probably be stuck in some café somewhere, broke and over-caffeinated, reminiscing about the glory days of film.

Anthony's Digital Solution (DSF)

Anthony called it the digital services fee, *DSF*. It was a line item on the bid that would replace the markup lost from the displacement of film. Most clients had no problem with this line item, and the rest were easily convinced when photographers explained how this fee made their lives better.

If you believe that, I've got a bridge to sell you in San Francisco.

The first time I was asked to explain the DSF, I was caught off-guard. How do I tell this person he's basically paying me a markup on film that doesn't exist? After looking down at my coffee for a second, I babbled something about bits, bytes, and Web sites. He looked at me, paused, and then a smile swept across his face. "I'll never quite get all this technology stuff."

With a sigh of relief, I spent the rest of the day talking about the virtues of the new technology and its ultra-fast turnaround times. That night, my producer and I made a list of where the DSF money was going and how we could explain the concept to our clients. We determined that the DSF covers those overhead expenses that can be broken down into three main categories: processing, delivery, and archiving.

Although chemicals have become a thing of the past, you still need to process the images from a shoot. This usually includes creating a digital proof, basic exposure, and color correction of the selects. Plan on doing as much work on the selects as you would if you were shooting film. If you're doing any Photoshop work at all on the images, that's a talent-related fee that goes above the line in the fees section. It's easy to take for granted your own abilities to operate the computer because it's fun and you're good at it. Don't. Those skills are worth money.

Delivery covers things like CDs, DVDs, and server storage space for online access to the proofs and final images. The DSF should cover enough media to store the entire job. If your client starts asking for duplicates to give to different people, charge them for the additional media. Also make sure to mark up the additional media. It's not just the discs you're charging for, but the wear and tear on your burner, which you'll need to replace about once a year.

An archiving strategy is one of the most important issues of the new age. You need to decide if you're going to archive each shoot, and if so, for how long. Believe me, it's fabulous to be able to shoot gobs of images without having to change film, but those images take up your hard-drive space real fast. Make sure you understand your client's expectations of how long you should archive their images after you've delivered the finals. Archive management is a daunting task. Start figuring out your strategy now, before you get overwhelmed.

Depending on how long you've been shooting, there are two ways to calculate the DSF. If you were working in the days of film, estimate how much film you would have used to shoot the job. Multiply that number by your actual per-roll cost, and divide by two. This will equal a 50 percent markup had you shot the job on film.

If you're coming to the game as a straight digital shooter, figure on about $5.00 per 50 images. I know it's difficult to figure out how many images you're going to shoot before you actually shoot, but after a few jobs you'll get the hang of it.

Just keep in mind that the DSF is for the time you spend managing the images and for the wear and tear on your gear. The DSF is also a great line item to manipulate to help you get the job.

Talent Fees

The talent fees line item below the line in a bid is one that requires special consideration. Understandably, most clients like to see a complete bid in that they want to know how much the shoot is going to cost— including the talent fees.

From your end, there might be an incredible urge to want to show off to the talent agency (for which you've only been shooting model tests) by sending them one of your studio checks for thousands of dollars for the talent that you just booked for a job. What the heck, it's not your money, and it makes you look like you've arrived. Resist this urge!

You absolutely do not want the financial responsibility of thousands or tens of thousands of dollars of talent fees running through your studio. Like you, talent agencies are stone-cold businesses. As soon as the job wraps, they start invoicing and calling for their money. And considering that it's going to take you 30 to 60 days to get the balance of your money from your client, you absolutely do not want to jeopardize your relationship with the agency, nor do you want to jeopardize your cash flow should they get pissy about their money and put you in a position to pay them before you get paid by the client.

Also, deducting large amounts of money like talent fees on your taxes will always raise an eyebrow. Not that talent fees aren't perfectly legal and legitimate tax deduction, but no one wants to get the attention of the IRS.

To get avoid this potentially unpleasant situation, always include the full subtotal of the job, a line that reads "Sub Total, Less Talent Fees Payed Direct," which, as you may have guessed is what your end of the job is going to cost.

Some of the jobs you'll shoot in your career will have small budgets for talent. You will either book someone "direct" (a model that's a friend may work for you without going through their agency) or you'll "go to the street" (book real people). In situations like this, providing you can carry the financial burden of paying your talent, it's fine to run the talent fees through your business. Talent working on the cheap will always appreciate getting paid on their last day on the set. Budgeting so you can afford this will help get a good reputation and also serves as a fantastic negotiating point when trying to convince someone to work below their rate. My producers like to paperclip an envelope with the talent's check in it next to their model release. It makes that whole signing process fast and less fussy.

The Paper Trail

Once you start bidding for a job, it is imperative that you keep track of all your bid revisions as well as all your communications with the client. This industry is rife with misunderstandings. And when misunderstandings happen, the photographer is always the fall guy or gal. Usually things can get sorted with diplomacy, but if the doo doo hits the fan, your paper trail gives you hard evidence. So get into the habit of creating a folder, either physically, electronically, or both, that you can throw every single shred of evidence ... um ... paper into. This can be a business of high drama and politics. Protect yourself.

Spotlight Shooter: John Lund

John Lund is one twisted photographer. Or should I say he twists his images. If any of you are familiar with the hysterically funny "Animal Antics" greeting cards, you know what I mean. Cats are getting massages, waterskiing, jumping rope, catching Frisbees, dancing in a conga line with dogs: and then there are the dogs, cows, chickens and bunnies all in anthropomorphized situations—there's nothing straight about it. Except his success. The Animal Antics series, published and distributed by Portal Publications, sells about 200,000 cards a month. That's not including the calendars, gift books, figurines, coffee mugs, posters, matted prints, purses, wallets, stickers, jigsaw puzzles, and Christmas ornaments. This phenomenal success is due to John's creative and somewhat weird vision, his talents in the digital world, and his ability to make a lasting impression upon us simple humans.

His entry into photography was a little out of the ordinary, too. One lovely sunny day in the mid-70s, during the time John was studying to be a writer, he engaged in a bit of alternative recreational activity and spent the day photographing. It was a totally enjoyable experience. Later he cut up the photos and pasted them on wood. John sold $150 of these prints at an arts and crafts fair, the most cash he had ever made in one day. Ah, the lure of easy money. Soon after he was hired by *Yachting Magazine* to write an article and shoot the accompanying photos. It took John a week to write the article and one day to shoot. The photo fee was five times that of the writing. Obviously, photography was the right direction.

In the 80s and early 90s, John shot for a variety of editorial, corporate, and advertising clients. This was during the high-tech boom in Silicon Valley, so John was rightly poised to take advantage of it. But he found that his creativity was expressed in how to give the client what they wanted. No room for personal vision. So, when he first got into stock, he found it liberating and gratifying, filling his need to be creative. "I use stock photography to do what I want to make money. I make a yearly set of business goals based upon what I want my life to look like the next year." John worked on conceptual images before Photoshop existed. He would photograph the elements and dupe them together. In the early 90s when Photoshop did arrive, it opened up a whole new and exciting world to John. He had been struggling with his business, but this incredible tool gave him the opportunity to truly expand his personal ideas. Even though some actions would take 45 minutes for Photoshop to render, it was well worth the wait to make the kind of art he wanted. John embraced the technology and mastered it. He has since served as the digital Photography Editor at *Digital Imaging* magazine, served on Advertising Photographers of America's National Digital Committee, has written numerous articles on digital imaging and stock photography, spoken to many groups on the aforementioned topics and has written a book on Photoshop called *Adobe Master Class: Photoshop Compositing*.

Here at last was John's true calling: using Photoshop to create conceptual images for stock. The images were clichés, but they work so well because clichés are universally appealing. It's John's styling and imagination that elevates them to a new height. Some of his most popular ones were "When Pigs Fly" and "Raining Cats and Dogs." All were created by establishing a concept, and then shooting the parts and compositing them digitally.

At one point, John had only about 40–50 images with Tony Stone, but the demand was tremendous, earning him considerable royalties every month. The kind that we all wish for. Some of those early images still are relevant. For example, an image of three $100 bills flying through the air on egret wings was created 17 years ago, yet was licensed for a 2007 cover of *Time* magazine.

John's goal is to make images that touch people and are timeless. Oh, yeah, and make money, too, through Corbis and Getty. In addition to his animals and concepts, his travel photography is stunningly beautiful and evocative. He wants to create images that will help make the world a better place. He regularly gets email from Russia, Germany, Australia, and elsewhere from people who love his work. John gets his inspiration everywhere; magazines, radio, books, the Internet, and ideas that spring from his head. When he travels, he photographs everything—rice fields, dried mud, elephants, Indian cobras—anything that can be metaphorical. He uses life's experience and figures out what he can do with it. Sometimes it takes him years to actually produce an idea, due to, well, laziness, or what appear to be insurmountable problems. But that's just problem-solving, the photographer's main craft. He had this idea of stampeding long-horned cattle, which is not an easy thing to find in San Francisco. He finally mentioned it to someone and was told he could get the cattle in Sacramento for a reasonable fee. Problem solved. He loves the tinkering, working on the image, and bringing it to completion. John says, "The coolest part, what I like the best, is putting on the finishing touch, and sitting back and admiring what I've done for a day. It's a gratifying experience."

In 1998 John came up with the ideas for Animal Antics and approached Portal Publications. To his amazement, they jumped on it. He was determined to be the "Anne Geddes of Animals." After the initial set of images, Portal has supplied ideas based upon the market, although some of them stem from John's previous work. "I love working with Portal's art director, Collette Carter. She is awesome," John says. Between cats and dogs, he wisely prefers cats. He is absolutely sure that cats hallucinate, and I agree.

John's advice to photographers: Although he was too shy to assist, he believes that working for other photographers is the best way to get into commercial photography. He stresses the importance of the estimate, finding out what their budget is, but being truly realistic. Figure how to do the job perfectly and pay yourself enough to feel good about yourself.

You can find John's work on johnlund.com.

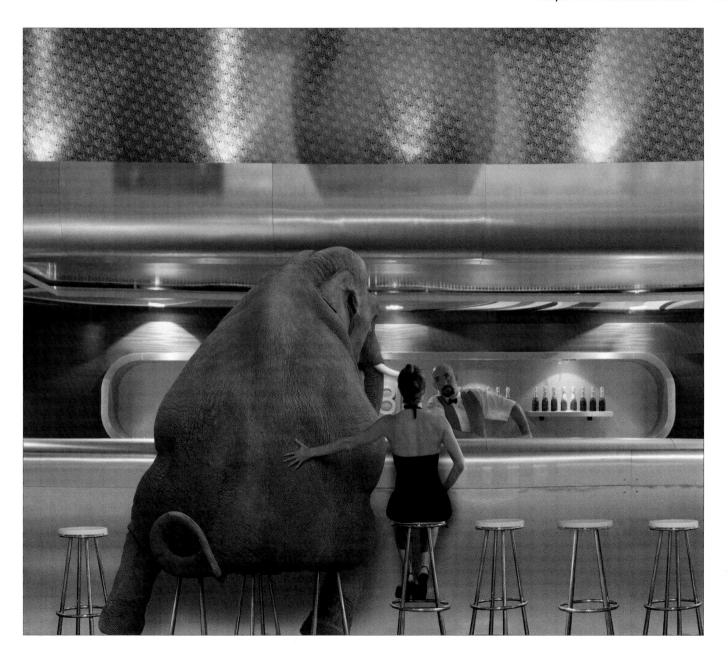

4

Bid Psychology

Now that you know what a bid looks like, you are ready to consider how best to fill one out. This is the bizarre part of being a photographer. Getting your bearings when you've been called to submit a bid is a little like being in a restaurant for the first time with your dream date who keeps getting distracted by everyone walking in the door while you're trying to have a conversation. What can you do or say to get the focus on you without looking like you'd be willing to do or say *anything* to get the focus on you?

The Comparative versus Competitive Bid

There are these magic times when you get called to shoot a job because you are you. Your style, your set demeanor, your execution. The only question that remains is whether the client has a budget that you can work with. This is a *comparative* bid. You and the client or the agency are trying to arrive at a common ground about how much it will cost to execute their ad with your creative suggestions.

There will probably be another photographer or two that they will be looking at, but the bid is based on money *and* talent.

Which means that you have to, in the words of one of my favorite art directors, "bring it." When you're bidding a job like this, have a look at the boards and get creative with how you would shoot the ad. If it's a shot of a runner on a trail, maybe you should suggest that it's a trail in the rain forest in Costa Rica. The agency is looking for you as a creative person to add some visual depth to their concept while being mindful that there is a money component involved.

With these kinds of bids, you need to get into the zone that you're worth something. You've been asked to deliver your creative talent as the last piece in the vision of the ad. With these jobs, it's okay to go a little higher with the fees than you think. Because the agency is looking at you specifically, they'll come back and tell you if your bid is too high, at which point you can re-work the numbers.

The other type of bid is a *competitive* bid. The client or the agency is casting a net for a reliable execution at a price that fits their budget. You may be competing against a large field of photographers here. The best thing you can do is deliver a bid that you think the client will buy while still making yourself some bucks.

If the client tells you the number they're looking for, your job is to get as close to that number as you can while still making the gig worthwhile. In this situation, start by compiling the production expenses (below the line) for the job. Pad things a bit, and give yourself some room to screw up. When you have all your line items together, consider how much money is left over for you. Is this a number you can live with to expend the effort to shoot the job? If it's not, how much more money would you need to make you happy? If the additional fees are within 10 to 15 percent of the budget they gave you, put it in and see if it will fly.

Sometimes, when you're given a budget number, it's a pretty accurate number that includes a fair fee for you. But sometimes the budget number may be a bit on the arbitrary side, and the art buyer may be trying to get a feel for how much the shoot is really going to cost in comparison to a number that they got from an account executive or client.

I know it's a bit like voodoo and just a little maddening. You'll never really get used to it. You'll just start to think you're clairvoyant when you start nailing a few jobs. Then inextricably you'll miss, and you'll think you've lost your magic powers. Pass the fairy dust, please.

Determining a Fair Bid

Both types of bids will benefit from as much information as possible. This starts with asking yourself a key question.

Why do you think they called you?

Be honest with yourself. The answer to this question determines in large part your strategy. If you made an impression on an art director or art buyer at a social gathering and they're throwing you a break, you need to keep your fees modest so you can land the gig and prove yourself and start a professional relationship. When you get asked to bid a job that any capable photographer could shoot and doesn't necessarily have to do a whole lot with your particular style, you're getting some love.

If you've done a lot of low-budget jobs for the client in the past, you are maybe getting called to do more of the same. Could be time to take one for the team and bid a bit higher so you can start giving a little notice that you're worth more.

These are two extremes and, believe me, there are a lot of variations in between. The secret here is not to overanalyze. If you do, you'll send yourself into a whirling spiral of insecurity and self-doubt. Just get a vague idea of where you stand before you try to decipher the answers to the following questions.

Next you have to start fishing for information from the art buyer. Here are a few examples of some questions you can use to ascertain some details that will help you plan your bid:

+ **What's most important for you on this bid?** This is a question you can use to get a feel for whether the art buyer is on the lookout for price or for speed.

+ **How many people are bidding this job?** If you're one of 20, the agency is looking for the low bidder.

+ **Who's going to be at the shoot? Is the client going to be on the shoot?** I always like asking these question under the guise of making sure there is enough food and craft service on the set. Inevitably, the answer to this question reveals how important the shoot is. If the client is going to be hanging on the set, the shoot may have more significance than when it's just you, your people, and the art director.

Once you have a vague idea for the type of bid you need to create, you can give it your best shot. One piece of advice. Get your bids in quickly. I don't mean slop it together and hope it flies. Just don't dwell on it. Agencies expect a very reasonable turnaround after they've requested a bid.

How Much Am I Worth?

Understanding your worth as a photographer is an insanity-provoking mind game that has no conclusion. I'll wait while you reach for a cocktail.

Your worth as a photographer is based on what your clients think you are worth, which is in part based on what the market will bear. Market value is set by how much a photographer like you gets paid, which is also based on how much the clients in that market think photographers like you are worth.

Money, Money, Everywhere

During the "dot com" era, I was able to charge a lot more for corporate head shots than I am today. It doesn't make any sense because I'm years more experienced and there is a reasonable expectation that prices should rise as time passes. The big difference between now and then is that *then* there were a lot of very silly people in charge of enormous amounts of money.

My wonderfully savvy agent at the time took a huge gamble with my fees when she bid a job for a dot com startup. She put my fees at close to three times what we would have normally considered a high fee. And then she waited for the phone to ring.

When the client called to freak out about the bid, my agent cited the fact that I just came back from a huge fashion run and that I was highly in demand and that I was being sought after by a lot of cutting edge startups. Somehow it worked, and I got the gig. But then I had to think about delivering an experience that made the client feel fabulous about spending all that dough.

Most corporate headshots consist of some kind of backdrop, natural or artificial light, cheese and crackers, an assistant, maybe a hair person—the basics. The people in front of the camera consider most corporate headshots a necessary evil.

The day before the corporate gig, I asked if I could swing by the offices for a location scout. I gave my assistant a clipboard, and I got a triple cappuccino. My assistant and I ran around those offices like two Broadway producers. We settled on a gorgeous courtyard for our natural light location to shoot something like 20 or 30 people.

I showed up the next day with makeup, hair, wardrobe stylist, three assistants, and a dedicated craft service person serving gourmet coffee and mimosas. We built a daylight studio out of two 20x20 duvateens and had a clothes rack, a make-up table, c-stands and power grid all exposed and taped down with gaffers tape. Lot's of extra grip equipment lined up in formation waiting in the wings. By the time we were done, I had converted the courtyard into a movie set.

It was unbelievably excessive for corporate headshots. But everyone was totally blown away by the set. They had a good time, which translated really well in the camera. The images I captured were almost fashion, which did a lot for the hip image that the company was trying to convey. It was a blast.

That company shut it doors 16 months later when they ran out of money and couldn't successfully close on another round of venture capital dollars. I was paid seven days after the shoot.

The reputation I earned around silicon valley had very little to do with my talent but more with the experience I was delivering. Although I never saw a corporate headshot job that excessive again, I did do very well during the dot com madness.

It was a savvy utilization of a fat market, good hype, and an outrageous statement. It was also a large gamble. The wind could have blown the other way, and I could have been branded as a cocky moron who charged too much. But my agent went with her gut on the bid. and I went with my gut on the delivery. Had either of us asked anyone's advice, we would have probably been dissuaded from our choices.

To make that shoot work, I had to dip into my fees to deliver the extravaganza. I would normally advise against that, but my fees were inflated, and I was looking to make a large splash in a wealthy marketplace. I considered it an investment in my future.

One thing I did not do was to take company stock in lieu of cash money, although it was part of the offer for some of the jobs. And it was tempting. Oh boy, was it tempting. But, ultimately, I decided that I was a photographer and not a day trader. I have to credit my father for the advice. He told me no one ever went broke having too much cash in the bank.

A month after the crash, I saw a great TV ad for the *San Jose Mercury News*. It depicted a guy in his late twenties wearing jeans, a T-shirt, and a zip-up sweatshirt riding a bus. The voiceover said "Yesterday you were a 28-year-old millionaire...today you're just 28."

The Most Amazing Thing of All, I Get Paid for Doing This

It took me a really long time to get my head around the fact that I was getting paid to do what I love. And when I say long time, I'm talking about almost a decade. Yes, I got paid to do model tests, hair shows and things like that. But most of what I was doing were low-budget gigs. Getting to the point of asking for what I was worth was a part of paying my dues.

Six Steps of Self-Worth

The following steps relate to advertising photography, not editorial, wedding, portrait, and the like. Those all have fairly obvious ways of ferreting out market values or, as in the case of editorial, the prices are for the most part dictated by the magazine.

1. **Understand you're more than you think you are.**

 What you do for a living is fun, sexy, and has probably gotten you a few dates. Doesn't make sense that you should get paid for it too. You should. Your talent is worth money to a lot of people. The more experience you gain, the more valuable you become. Not only does your talent improve, but so does you ability to deal with clients and crises. All these things combined make you, as a package, worth more with each new experience.

 Do not think of yourself with blinders on. Think about all your assets beyond the ability to shoot pictures. You're pitching all of it, not just the camera and the operator. I got sent to Russia when I was 24 not so much because I was such a brilliant shooter, but because I was reasonably talented and I knew a lot about a global network called the Internet, which, at the time, very few people knew about.

Figure 4.1 Understanding yourself.

2. **Don't undervalue yourself for too long.**

There isn't a single photographer alive who didn't spend a lot of years getting paid too little. If you ever listen to a veteran photographer talk as if they had it all figured out from day one, don't believe it—they didn't. We all get arrogant after we reach a financial milestone. And then we delude ourselves into thinking that we had all this stuff sorted out the whole time. Puh-leeze!

The knee-jerk reaction when you're starting out is to do anything for anyone at any price. A good policy when you're hungry for experience. But at some point you're going to have to find the strength to turn a peasant wage down. Personally, I waited too long to do this. I sort of meandered through the first 10 years of my career getting underpaid. My big breakthrough came when a client offered me a nice fee to shoot a simple job. My advice is to not wait for that magical person.

3. **Take a leap.**

You are going to have to suck it up and ask for too much money every once in a while. When all the interrogation methods I suggest above fail and you have no inside information, you're going to have to shoot blind. Don't be an idiot and ask for some astronomical fee, but try asking for several thousand dollars more than you think you should and see what kind of response you get. Sometimes it's the only way to move forward. It will cause you all kinds of anxiety, but oftentimes it can be a great indicator of what the market thinks of you.

4. **Understand rejection.**

Getting rejected doesn't mean you suck. This is a profession of constant rejection. No matter how hard you try to understand why you didn't get a gig, you never will. Never, never, never! It could be legitimate like you just weren't the right person for the gig. It could be nepotism—another photographer was already chosen, and the agency just needed to look like they were shopping around. Or it could be as random as a vegan art director taking offense to your cowhide portfolio. You'll never know.

What you can do is not get prissy and burn a bridge. (I'm speaking from experience here.) What an agency didn't like about you today, they might love about you tomorrow. Just grab your portfolio. Give the agency a big smooch and a "thank you" and go get a drink. Because tomorrow you're going to find someplace else with an open door.

The worse thing you can do is start mentally spinning. You know the feeling when you postulate a theory about why something didn't go your way and you start to obsess about it. Truth is there are no conspiracies against you. There aren't a bunch of agency people hanging out by the espresso machine talking about you, with the intent of emailing everyone they know about you, only to have your awful portfolio end up on CNN international so you'll never get another job in this solar system ever again.

It just didn't work out this time. That's all.

5. **Stand tall.**

There are times in your career when people are going to try and make you feel like crap. They'll scream at you, patronize you, threaten you with lawsuits—basically try to intimidate you. Keep in mind there is either a psychotic or an agenda behind the threats.

One of the toughest things to do is maintain composure and hold your own during these disasters. But you have to. There is no reason for anyone to treat you like garbage. Most people in this industry maintain a certain level of professionalism. When you come across the ones that don't, you absolutely have to stand up.

The first time I ever got really yelled at was over the image you see in Figure 4.2. It was model test, and the agent had an insane meltdown about the makeup in the shot, which just happened to be applied by my girlfriend. The modeling agent totally berated me in front of the entire agency and my girlfriend. It was awful, and I didn't do a thing to stand up for myself even though I thought and most everyone else agreed the image was pretty good. But, in retrospect, I realized that the agent was yelling for the sake of yelling. Psycho.

Years later, I shot a catalog for a golfing clothing line. It was one of those negotiations where we couldn't come to an agreement on the amount of the bid, so I pulled out of the running. I just had a bad feeling about the guy and his operation, and I felt like it would be easier to be broke than to get involved.

Figure 4.2 Pretty damn good, I thought. How could you yell at me for this?

Ultimately, he came back and met my bid price as well as my conditions for 50 percent up front and the balance due on the last day of the shoot. Like I said, I just didn't trust him. When we wrapped the shoot, I sent the client off with all the images, and it looked like I was going to get away clean.

Two days later he came back to me and asked me to color correct and do re-touching on 200 images. I told him that I would work up a bid and get back to him by the end of the day. Oh, no, no, no, he wanted this as part of the price for the shoot. We went back and forth, and he started making noises about suing me unless I would do the work.

I stood my ground and pointed out that there was nothing in our *signed* estimate that indicated any post-production work or color correction. He countered with the fact that I wrote "color images" in my description and that he would be able to convince a court that that meant "color corrected." I told him he was out of his mind. He asked me to think about it and he would call me the following day.

I called my lawyer. The next day when he called, I told him that all future communication on the matter was to be handled through her. She wrote a letter confirming the fact and that was the last I heard about the lawsuit.

I came to learn that this guy had gone through eight photographers in six years. He used his lawsuit threats to get an unbelievable amount of free work from shooters who fell prey to his intimidation tactics. I also found out that he was running a sweatshop in downtown Los Angeles. A total scum bag. Agenda.

6. **Avoid bidding for bills.**

There are times when funds are low and you'll get asked to bid a job. Salvation you think. If you can get the gig and get your advance check, you'll make all your bills this month. Try to avoid these situations. Bidding while desperate for money will cause you to make bad decisions. It puts you in a climate where you'll devalue your talent for the sake of trying to low-bid the field. This does nothing for you or your reputation. I know it seems like I'm speaking from some otherworldly utopian existence where no one has a bad month. Just keep it in mind as you move forward through your career. Being tight for money has a funky affect on your ego. Try to keep in mind that your talent did not diminish, your funds did. Having a lean month doesn't mean you're not worth what you should ask for; it just means that you had a lean month.

Help with Pricing

In this industry, as you're starting your business, trying to get someone to talk to you about pricing is sort of like trying to get a meeting with the pope. Fortunately, there are others ways to get an idea of pricing that won't leave you shooting in the dark. Your fees are based on a variety of factors, including how the photo is to be used, your expertise, your length of time in the industry, and of course, your popularity. There is no price fixing in photography, so there is no one definitive guide that will tell you exactly what your fees should be.

Fotoquote is standalone software that is basically a database of pricing scenarios. What I like about Fotoquote is it provides a lot of information about how it comes up with the price suggestion that it gives you. It asks you various questions about where the image is going to appear, and then it gives you a high, low, and median price as well as some tutorials on why you would charge high or low, or outside of their suggested range. This feature is fabulously educational. Fotoquote is a good place to start to educate yourself about pricing.

Fotoquote tends to offer prices that can be on the low side of the market, but at least it will give you a general idea of where to start, especially if you are new to pricing. The company does not update their market data often enough to keep up with current prices. Sometimes it takes them a couple of years. So a good strategy is to cross-check what you learn from Fotoquote with the prices that a similar image would sell for on the Getty or Corbis stock photography Web sites (see gettyimages.com and corbis.com).

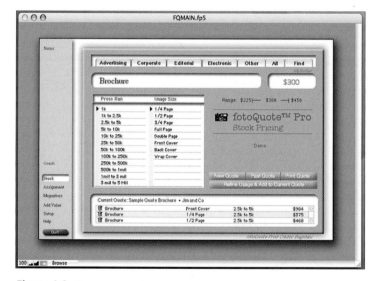

Figure 4.3 Fotoquote main screen.

On both sites, you can get an account for free and then use their pricing calculator to sort out the price of various types of images. As you bid more jobs, you'll start to get a feel for how to price your own fees much more confidently.

Fotoquote sells as a standalone product for $139, or it is included with Fotobiz estimating software, which I'm not allowed to comment on because I own a company that produces a competing product called Blinkbid for estimating jobs. (All the estimates and invoices in this book were produced with Blinkbid.) With that disclosure, I would be remiss not to tell you about Fotoquote. I have a lot of respect for what it does and the amount research and work that went into it. As of this writing, Fotoquote is not a Universal Binary application, meaning it does not yet run natively on Mac computers with Intel processors. But the Mac's built-in Rosetta translator let me run Fotoquote just fine.

Other ways to add to your education are to get on forums at the Advertising Photographers of America. There are a lot of great, veteran photographers who will gladly give you their advice. (You can access these forums through the APA Web site after you become a member—see apanational.com.)

Do not become dependent on one way of pricing. Figuring out the fees you should be charging based on where you are in your career is a non-stop educational process. If you garner any sort of press notoriety at all, your fees could go way up overnight. I would have never even thought about this if I didn't have a savvy agent. There are countless sensationalistic influences that can make you more valuable. But the one constant is experience. The more experience you gain, the more valuable you become. Your fees need to reflect that, always.

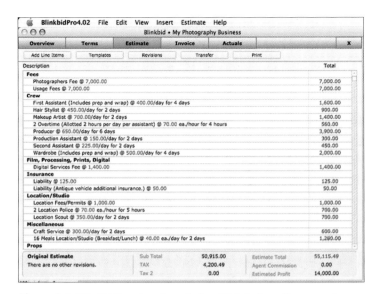

Figure 4.4 Blinkbid's estimating window. This is the software used to create the documents in this book.

Don't Ask Me about the Numbers

Pricing ads has changed. There used to be a time when the print run of an ad was a factor in calculating the price of the image that was appearing in the ad. That's no longer the case. Ad agencies used to do their own media buying. They don't anymore, which they are not thrilled about because it used to be a source of tremendous profit for the agencies. What this means for you as a photographer is, if you ask an art buyer how many times your ad is going to be printed or how many people are expected to see it, you'll probably piss someone off. If the media buying agency buys ad space for your client with media conglomerate Time Warner, there is no telling how many magazines your ad

may end up in. Additionally, because the agency doesn't know what the media buy is, there is no way to tell you the circulation of each of the magazines.

Your focus in pricing ads is duration, location, and media. Consider for how long are the rights assigned to the client, what part of the world will your image be seen, and what media will the add be appearing in. The expectation of the clients when purchasing rights is that they can print that ad as many times as they want within the defined usage criteria. The days of how many eyes are going to see my image are gone. Asking that question of the wrong person could get you a cold shoulder.

Bidding Consultants

Photographer's consultants, or bidding consultants as they are sometimes called, are a brilliant resource if you don't have an agent. Consultants, such as Suzanne Sease and Amanda Sosa Stone, will bid a job for you for a fee plus a small percentage of the fees you're charging the client. Both Suzanne and Amanda are ex-art buyers, so they have an extensive knowledge of what agencies are looking for in a bid. Some consultants are not ex-art buyers, but that doesn't remotely diminish their capacity to bid effectively. They've had years of experience bidding, which puts them in a fantastic position to know what will fly and what won't.

When looking for a consultant, you have to be savvy. You wouldn't just go to any doctor to perform your surgery, and the same diligence applies to people who might represent you and your photography. Ask around. Everyone is going to have an opinion about consultants. Weigh the responses and then take a meeting. See if you like the way these consultants present themselves. Remember, like an agent, the consultant's personality will be a tacit extension of your image.

Negotiate a contingency or reduced fee for your first deal. If all goes well, you've found your person; if not, you need to keep looking. Listen to your instincts at the first meeting. If your gut says yuck, nothing is likely to change that initial impression.

The consultants will typically work with you in one of two ways—behind the scenes or on the front line. If they are working behind the scenes, they will put your bid together and advise you as you negotiate the deal. If they are working on the front line, they will put the bid together as well as negotiate for you.

Working with these consultants has two very strong bonuses:

+ First, you're working with someone who has been behind the scenes and understands what's required to get a job awarded. Good consultants know what the agency and the clients are looking for in terms of actual line items as well as budget.

+ Second, you will learn an incredible amount of information about bidding so you can become less reliant on paying a consultant in the future.

If the job is awarded to you, you'll be responsible for the bidding and negotiation fees *and* a small percentage of the fees that you are charging. (The above-the-line charges.) If the job is not awarded to you, you're responsible only for the bid creation and negotiation help. It's a great arrangement that has an incentive built in for winning the job.

If you don't have an agent, I think photographer's consultants are brilliant way to go, especially if you're unfamiliar with the territory of major advertising bids. Also, it has given some photographers reason to think that maybe they don't need a full-time agent.

There are things to love about agents besides having someone that has to listen to you complain about the industry. Good agents hustle to get you work. They spend many hours getting the scoop on where the gigs are and who to talk to about getting them booked. Agents have established reputations, good and bad, around town, but they're known. And they don't charge you hourly when they are re-arranging your portfolio. But, best of all, good agents look at every version of a bid before it's sent to an art buyer. A good agent will help you set your pricing and suggest a thing or two for your bid that you might have missed.

Having an agent is like being in a relationship without sex. Literally. You'll laugh together, you'll cry together, you'll scream at each other, and then you'll make up over cocktails. It's like the mother or father that you didn't know you needed. A good relationship to foster, especially for the price.

It's Bound to Happen

Nobody, no one, not a soul gets bidding right the first, second, or twentieth time they do it. Bidding is a process that can be honed only by experience. And that's okay, because as your talent grows as an artist, so will your business acumen. Mistakes are inevitable; don't consider your mistakes disasters. They're just annoying little things that make you slap yourself upside the head because they seem so obvious in hindsight. Repeatedly making the same mistake *is* a disaster, however. If you're prone to that type of behavior, seek therapy.

Everyone undervalues themselves their first few years in the fray. It's human nature and a part of being a creative person. After a few successful gigs, no matter how small, don't be afraid to bump up your fees. See what happens. If the raise meets without resistance, bravo, well done; you owe me a cocktail.

And only because you've never heard me mention it before, employ usage licenses at every turn. Your photographs are your business and controlling the creative copyright to your work is paramount to making money. If you don't believe me, take a few minutes and look how much money is made in the film industry at every level. Any money the film makes subsequent to its release in the theaters is all rights management.

Spotlight Shooter: Bill Sumner

Bill Sumner lives on a boat in Miami—Coconut Grove to be exact—and shoots travel, resort, and tourism. Sweet. Bill has photographed for hotels throughout the Caribbean and Mexico, worked for tourist boards for cities, states, and the Caribbean islands, and continues to shoot a wide variety of other ad work, too, including sports heroes for Nike. A general photographer with a wide range of experience, he has shot large format products, annual reports, furniture, fashion, food, underwater, skiing, portraits for many uses, industrial, lifestyle and motion action. "Good advertising photographers should have versatility. They should be able to compose well, know how to light, have good eyes, and communicate with new and fresh ideas." Bill says, "I don't like doing the same thing over and over. Specialists make more money, so I market myself to different people with different specialties." Never one to be typecast, Bill's work is recognizable by his incredible sense of color, his clean and simple design, his honor and respect for his portrait subjects, and his ability to take his creativity to a higher level in delivering the concept. And he's a blast to work with.

Bill's first experience with photography came from his dad, an amateur, who set up lights to photograph his two sons and turned the kitchen into a darkroom. The boys were intrigued by the magic of the print developing in the tray. But that wasn't what eventually led him into the pro business. Coming from New England, Bill is an expert skier, and he worked with legendary filmmaker, Warren Miller, filming on the mountains in Killington, Vermont. He also worked on a farm with horses, jumpers, and hunters in the summer. That's when he got his first camera, a Rolliflex with a Zeiss lens. At Franconia College in New Hampshire, he shot for the yearbook, and he also was involved with Vista shooting documentary work for the program. After graduating with a degree in sociology, Bill opened a multi-service studio with two other photographers and shot portraits and weddings, did the framing, and sold cameras and films. They did pretty well considering the closest competition was over 50 miles away. John Jerome, an editor for *Skiing Magazine* and *Car and Driver,* started giving Bill work and recommended that he make the move to New York City. Around that time, Bill and his mates photographed the wedding of the daughter of the governor of New Hampshire. The lab ruined all the film, so Bill thought it was a good time to leave the state.

Once in New York, Bill would go to the Ritz with a pocket full of dimes, and use the comfy phone booths to make calls to photographers. He had done his research and wanted to work as an assistant to people whose work he admired. He pounded the pavement, made the calls, and started working as Pete Turner's second assistant, with Eric Meola as first. But, by now, Bill had a wife and a son, and he needed to make regular money. He landed a job working for the legendary environmental portrait photographer, Arnold Newman. Arnold worked only with hot lights, but his perception and use of light made an impression on Bill. One commercial job, a telephone on a car seat, required the use of strobes, so Bill went to one of the rental houses, got an hour lesson, and lit the shot for Arnold. What he learned most from Arnold was the mastery of black and white printing, including bleaching, using warm undiluted Dektol to bring out certain areas and perfectionism for archival printing. It wasn't unusual for Bill to be working until 11 at night.

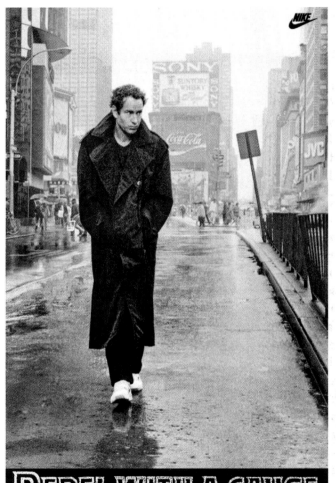

Bill continued to look for other work, both assisting and shooting, and ended up building sets and assisting another legendary advertising shooter, J. Barry O'Rourke. The building at 28th and Broadway housed several other photographers, including George Hauseman and Al Frankovitch. Bill worked for them all and started shooting more jobs on his own. One of his greatest learning experiences came from working with Joyce Rainbolt on a kids' campaign for Avon children's products shot in California. It was a massive set, with 18-foot fiberglass models, 15–20 child models, and a huge scaffolding allowing the photographer to shoot from above. Joyce became ill, and, out of necessity, Bill shot the job. In those days budgets were huge. Barry did a lot of work for Playboy and no expense was spared in locations, helicopters, sets and crew, and then everyone going out to dinner after the shoot. Those extravagant days are gone, but were fun while they lasted.

Bill and his family moved back to New England, settling in Gloucester. Bill opened up a studio in Boston near South Station. It was an old firehouse, and Bill had the top floor and loft, with two walls of windows and 12-foot ceilings. I had the good fortune of meeting Bill while I was at New England School of Photography and eventually became his first assistant. It was from Bill that I learned to see light. The 70s were great years in advertising, and Bill's accounts included Digital, Bernat Yarns, Converse (which is when he started developing his strobe/blur technique that he would use later for Nike), furniture, banking, jewelry, and educational film strips for Houghton Mifflin. In the late 70s, as the ad market was still booming, he had an opportunity to relocate to Dallas, and he stayed for 11 years, working for Neiman Marcus, shooting fashion. Then Nike came along.

Nike hired Bill to shoot creative and interpretive images for posters of sports legends, everyone from Nolan Ryan to the famous Mary Lou Retton shot of her doing a perfect vault. Bill pushed the envelope in creativity, winning many awards along the way.

But the pull of the water was strong. Always an active sportsman, he enjoys hiking, scuba, skiing, and is an avid sailor. Bill had a dream to live on a boat. In 1989, he made that a reality by buying a 44-foot catamaran, the Melly-Magoo (nicknames of his two children) and moved to Miami. Since then he has worked many fabulous travel and resort jobs around the Caribbean, Mexico, and South America. Although travel is his primary work, Bill still continues to shoot a variety of kinds of photos, from fashion accessories to annual reports, to wildlife.

Bills says that as he moves from one genre to another, he keeps his vision the same—clean and powerful graphics, outstanding use of color, and new ideas. Bill gives credit to the collaborative process and appreciates the talents of his art directors: Bill Boch in Boston, creating innovated and humorous banking ads and work for the humane society, Tom McBride in Dallas with terrific work on the E-systems annual reports, and Don Sibley for Jerell Fashions, and annual reports for National Gypsum. And the long-term association with Nike on innovating and eye-catching sports heroes. He brings his love and passion of the art to every job and gives the art directors more than they ask for. Bill derives a great deal of pleasure from shooting. The process of photography is the ultimate high; the act of creation is better than any drug could ever be.

Bill has always embraced new technologies, from multiple imaging, retouching layers, to combining strobe and tungsten, so he loves the whole transition to digital. Digital technology has elevated the level of experimentation for him, because the immediate feedback helps refine the ideas on the spot. The computer has been a great tool, too, for completing jobs, retouching in Photoshop, but also for the access to stimulating ideas. Instead of watching TV, Bill watches ted.com , the BMW-sponsored site that stands for Technology, Entertainment, and Design. "It's the exposure to other ideas, other directions, that gets you thinking in different ways, nothing to do with photography but with stimulating the mind to get ideas of other things." Bill says, "It's like a good stew, the more crap you put into it and let it simmer for a while, the better it gets."

Bill's advice to those photographers wanting to get into advertising:

> Don't do it! Just kidding. It's an extremely competitive environment out there. You have to love it, so do what you like to do and the money will come. Get a solid business education, which is more important than a photo education and work with a good rep or business manager. Don't do it for the money, do it for the love of it.

You can find Bill's work on billsumner.com.

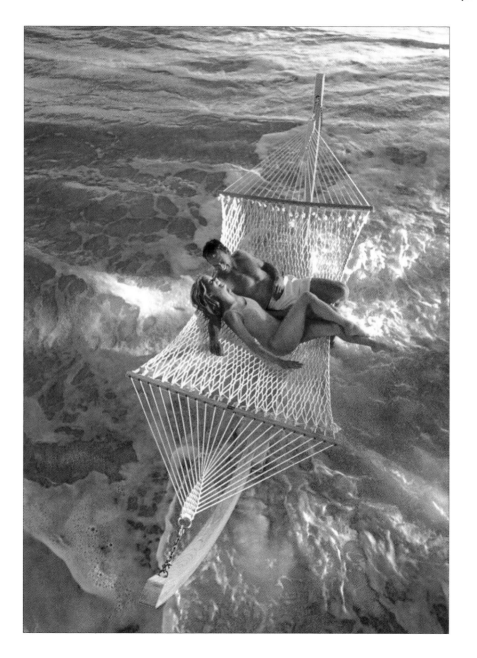

5

The Bid Revision

"You're in play" is one of my most favorite phrases. Not that anyone in the advertising industry uses the phrase all that often, but it's a phrase that I hear in my head when an art buyer tells me that I'm being considered for the job. Being considered for the job means it's time to re-work the numbers of your initial bid.

Bid revisions are a norm in this business. Whether you're working with an ad agency and bidding against two other photographers, or you're working with a regular client who intends to book you, everybody wants to see another version of the bid for less money.

Bidding is a game of psychology as much as it's a game of numbers. If a bid *looks and feels* right, along with delivering the magic bottom line, you are in. I really truly wish I could give you the formula for the psychology behind a successful bid, I do. But to be honest, I have bid jobs that I thought we're exceptionally reasonable and right on target, only to find that I was out in round two. And then I've bid jobs that I thought "no way," and next thing you know I'm on the set clicking away.

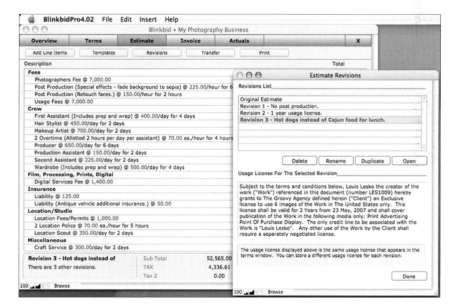

Figure 5.1 In this business, all bids get revised.

Listen to the Client

The first step to revising your bid is to listen. Listen closely (or if communicating via email read intently) to everything the art buyer or client has to say. There will be line items that they don't like, or will question, and you need to target these items first when you're putting together your first revision. You have to get into the habit of listening to the subtle cues of the conversation. If the art buyer or client says something like, "Your craft service budget seems a little low—oh well, I guess this will be a dietary shoot"—and then laughs, they're not really making a joke, it just seems like they are. Bolster the food sections of your bid.

Write all the pertinent points down so you don't forget them. Trust me on this. For years, I was just too fabulous for my own good and never wrote any notes down from my conversations with the art buyers. Then one day I did. I started to notice that my success rate was improving.

Try to Leave Your Money Alone

When revising your bid to shave some bucks off the bottom line, try to leave your primary fees alone. Go through the below-the-line section of the bid to see what you can start living without. Although I'm sure we can all make a spectacular argument for having an onsite sushi chef, you might want to think about losing that line item. Also look at your crew. I always pay my first assistants well. They are indispensable for having a well-running set. But could you live with one overworked second assistant instead of two with easy schedules? By losing one of the second assistants and shifting part of that money to cover the overtime for the remaining second assistant, you can save some money.

Start looking around at your line items—what can you do without and where can you shift the money. If, as you read this, you're thinking this would be a lot easier if some of my below-the-line items were padded a little bit—well, you've just seen in action a primary device in the art of bidding.

About 16 years ago, I was bidding one of my first major ad gigs. I had no idea what I was doing and pretty much listed all the below-the-line items at cost. I got a call back from the art buyer who was laughing. (I wasn't—I was nervous as hell.) I asked if he thought my bid was too astronomical. He said no, not at all. He was just concerned that people were going to wonder how I could get the same production items, which were listed in the other three bids he was looking at, so comparatively cheap. He then proceeded to go through my line items with me and tell me what the market tolerance was for each one. I didn't get the job, but the education was priceless.

I know, I know, neat story, but what's in it for you? Most expendables (seamless, tape, gels, and so on) can be marked up about 100 percent. If you're shooting film, you can mark that up anywhere from 50 to 100 percent. If you mark something up too much, believe me you'll hear about it right away. With these items marked up, not only do you stand to make a little money off them, but you also have room to bring your bid down if you need to later.

Also, if you're using your own gear for the shoot, you should be renting that gear to the job. The advantage to using your own equipment is that you have a little room to discount the rental prices as well. But never give away the rentals for free—you paid money for that stuff, and you need to make it back. Also, it's a bad precedent to set.

The market value of assistants is pretty much set by the assistants themselves. They'll have a rate that they charge and that's that. Other crew members, such as producers, stylist, hair, and makeup, have more negotiating room. The prices charged by these types of specialized crew members tend to fluctuate from market to market (city to city).

I work in Los Angeles, which is one of the highest-priced markets for specialized crew such as makeup, styling, and the like. When I bid a job for a Microsoft campaign that was to shoot in Seattle, Washington, I bid the job according to LA prices. This was an enormous mistake.

Had I done my homework and investigated the market in Seattle, I would have learned that the typical prices for specialized crew were about two-thirds what they were in Los Angeles. This difference translated into thousands of dollars extra on my bid that didn't have to be there. Thankfully, I got a heads up before the bid had gone too far down the chain. I was able to adjust the prices and submit a bid revision that was accepted as a favor to me.

To avoid mistakes, start at the top. Whatever market you plan on shooting in, do a little research and find the agencies that represent the type of specialized crew members that you need. They will be more than happy to give a general idea of rates that they charge for their people. Leave a little padding that you can *wiggle* with on the bid revision.

As difficult as this all sounds, it's not. Ultimately, as you embark on your career, you're going to befriend specialized crew people who are starting out just like you. Everyone is negotiable, and everyone wants to work. There is always a way to get your bid to work out nicely for the client.

Working the Numbers and Eating Well

One of lessons I learned very early on when shooting fashion is that you should always carry tampons and Advil in your camera bag. Always. A makeup artist made the suggestion to me. I almost never needed them, but the four or five times that I did, I quite literally saved the day.

As my sets started to grow in the number of people, it became very obvious that the best way to keep people happy was to keep them comfortable. You would be amazed at the power of food and drinks. Ad people will gladly sit on rocks instead of director's chairs on a location if they have a bagel and cup of coffee in their hands.

Understandably, photographers are most concerned with having all the right gear on the set. But if you look at the shoot from the set visitors' perspectives, they could care less about the equipment. It's not their concern. They care about having a bite to eat, some coffee or water, and all the things that a body needs.

So when you start playing with your numbers to get the bottom line down, don't immediately jump to the food portion of the bid and start slashing and burning. It's important to keep your clients happy. Even if the shoot is having a minor glitch, believe me, the distraction of a well-stocked craft services table will keep people from looking over your shoulder.

And always have tampons, Advil, and a small first aid kit on your set. You may never need to use any of those items, but if anyone ever whispers in your ear, you will forever be remembered as having it totally together.

How Much Is That Gear Really Going to Cost Me?

When I bid jobs, I always estimate on the high side for the rentals. If a small lighting package is going to cost me $125, I put $200 in the bid. If I'm renting my own camera to the production, I determine the rental cost of that camera plus the lenses and add $75. You get the idea. I'm padding things a bit for the first estimate submission. If I'm called to rebid a job to bring my bottom line down, I start looking more closely at what things are actually going to cost me.

The most important thing is to determine exactly what you're going to need for the shoot. *Do not scrimp on backup gear.* On location, I always have a backup camera. If the location is remote enough, I have two. For advertising jobs on location, I bring enough lighting so that I can illuminate the set in case of inclement weather.

Once you've determined your essentials, you can look up actual prices from the catalog from your rental house or ask your rental house to write up an estimate based on the things you will need. With accurate numbers, you can start whittling down the rental section of your bid.

Hard to Soft

Just as you need to be hyperaccurate with your rentals during the rebid, you should take a look at other hard costs. Start with items for which you can determine exact numbers, such as rentals, location permits, and travel expenses. In essence, you need to dig deeper into what these hard items are actually going to cost you by making phone calls and doing more extensive research. The key here is to start the whittling process with items for which you cannot negotiate an alternate price.

The next set of numbers to look at have to do with your crew. I implore you, do not monkey with your assistant's money. They are the hardest working folks on the set. Start by looking at the other members in the crew category. Everyone that you hire as a sub-contractor—makeup, hair, set design, set builders, and so on—all have room to negotiate. To further decrease your bottom line, you can go to these people and ask if they can adjust their fees to accommodate your budget. Everyone has room to

move. Whether they will or not has a lot to do with how busy they are at the time. It also has to do with their resources. I've hired many stylists who have an incredible collection of clothes and accessories. Often times, they'll be happy to bring some of their own inventory to augment the shoot. It's important to keep in mind that the inventory a stylist brings to help you out is usually leftovers from another shoot. If your budget calls for purchasing clothes and accessories that don't have to be returned, be a cool person and offer the stuff to the stylist to keep.

It's important to keep in mind a balance. Don't constantly hit up the people you work with regularly for deals. If you get a job with a fabulous budget and your makeup artist has been giving you deals for a while to help you build your career, be sure to give that stylist her full rate when you have it.

You'll figure the balance out as you go—especially if you keep the basic concept of fairness in mind. It takes a lot of support to build your career. Stay loyal to those who have invested in you as you've come up the ranks. Everyone in this business is aware of budget fluctuations from job to job. It's up to you to keep the big picture in mind.

Shop Around

There's more than one air carrier, rental car company, and RV company. Shop around and see what's available. It's a pain in the butt, but sometimes you have to do it to get your numbers in line. Just don't compromise quality. If you're in the middle of nowhere and your rental car breaks down, you'll end up spending more money than the savings afforded you in the first place.

Keep this absolute in mind at all times. *Crises cost money, lots of money.* When you're in the middle of a crisis, you will expend any amount of money to get yourself out of it to save the job and your reputation.

Don't Get Caught

Even though travel arrangements are cheaper if you book in advance, no one in this business knows what is going to happen in advance. If you do book in advance, you typically get caught paying change fees and other things of that nature. Ad agencies and clients know that this is a capricious business. They also know that they are typically to blame for the last-minute changes. So they expect to see prices that are indicative of open, changeable tickets.

A La Carte

When I book a studio shoot, I like renting studios that offer equipment rentals. That way, I can keep a tight reign on the rental section of my bid. By only pulling the gear that I need, when I need it, I'm saving the expense in planning for the worst-case scenario. If the worst-case scenario happens, I just ask for the additional gear that I need. Working like this offers the perfect balance of being prepared for anything, but allows you to get your numbers lower.

Last Resort Tactics

If you're close to getting a job, and the budget sucks, but you really, really want the job, go to plan "z." Start asking for favors. Will your specialized crew (makeup, styling, and so on) cut you a huge break because you've gotten them a bunch of work in the past? Will the rental house give you 20 percent off because you haven't asked for that this year yet?

I'm not supposed to advocate this in any way, but I wouldn't mention it if it didn't exist. Do you know a model whom you can *book direct* for cash, instead of the much more pricey avenue of going through their agency? I say this with extreme caution. You don't want the drama that comes with getting caught. You get yelled at, your model friend will get yelled at—and depending how much money he or she brings in to the agency—may be dropped. But, if you're shooting an ad that will never be seen by anyone who can call you out… Like I said, I wouldn't mention if it didn't exist. Just make sure to weigh the good and the bad—and do not make a habit of it. This section is called *last resort tactics* for a reason.

Please do me a favor. When calling in favors from other people, never, ever use the following phrase, "If you do this for me now, I'll make sure to get you lots of great work in the future."

That line is so old and steeped in so much bull, that you'll still be able to smell it five years later in your career. You'll hear that phrase a lot as a photographer. It will be bull to you as well. Please don't perpetuate this phrase's existence. And please don't have it anywhere associated with your name. The people whom you are asking favors from know exactly what they're doing. If they don't want to do it, they will tell you.

Killing Line Items

There are many people who will argue that your first step in re-working your numbers is to delete any line items that you know can go. I've never subscribed to that philosophy. Your initial instinct when putting a bid together is pretty accurate. If you run through a bid a few times and look at how you can adjust the numbers of each line item before deleting anything, it will get you to thinking about why you put it in initially. After a few passes through the bid, you'll have a much keener sense of what you truly need and what you can truly do without.

The golden rule here to remember is: *It's a nightmare to ask for more money later because you forgot something.*

Once you're confident that you have a handle on your numbers, start the slash and burn and see where you end up. It's my hope that you'll get to a number that will allow you to execute the shoot successfully without touching your fees.

Make Sure the Client Is Educated

You won't run into this with an ad agency. But you might a few times with a smaller design firm. Did they know that there were usage license options? That is to say, if you get the feeling that the client is asking for two years of usage because they think that is the standard term to ask for, it might be prudent to ask, "You know, if you only need a year usage on these images, that would go a long way to reducing the bid."

Like I said, when you're dealing with an art buyer at an ad agency, this will never be an issue. So consider the context of the deal before you go bounding forward with this strategy. No one likes to feel like they're not savvy and don't be too quick to ask for less money.

Touching Your Fees

Uhhhh. I hate the prospect of reducing my fees. Hate it, hate it, hate it. But there are times when you have nowhere else to go. You've adjusted numbers below the line. You called your ex-lover who happens to be a model and asked for a favor. And you really want or really need this job. Barring any markup you may have arranged below the line, your fee is the money that you make. So how much are you willing to make on this job without looking desperate or damaging your reputation? Don't go racing in and cut your fees by 50 percent. Think about cutting them by a lot less. Tread lightly, slowly, and carefully.

A Word about Padding Your Bid

Padding the numbers in your bid has two primary purposes. The first is to cover your butt in case of some sort of chaotic happening on the set. The second is to give you room to *work* your numbers during a bid revision.

When you've been asked to submit a revision to your bid, keep in mind it might not be the last revision. The record number of revisions for me was 12! That was an extreme case that involved a couple different usage license scenarios. The point being that you don't want to give up your entire budget padding on the first

revision. The other side of that concept is you don't want to get too greedy because the padding is going to make you a few extra bucks. Your fees are your only true source of profit on the job. Everything else is disposable until you land the gig.

Walk Away!

One of the worst moments in my career came when I was directing commercials. The production company that was representing me got a low budget ad awarded to me. I was thrilled; it was my fourth spot, and I was hungry for anything that would give me more experience. The budget really sucked. The company assigned a seasoned producer to me so she could squeeze every last penny out of the budget and make it all work.

The client was a notorious, unreasonable, psychotic. Apologies, but she was just mean. Once the deal was signed and we began pre-production—meaning that we hired all the department heads (art department, camera, wardrobe, and so on) and they were getting ready to hire the people that they wanted on their crews (crewing up)—the client started heaping more stuff onto the shoot without any intention of giving us more money in the budget. This included shooting a live elephant.

When we protested, she just threatened to yank the job from us and give it to someone who "could pull their resources together" and make the client happy. We looked at the situation as a challenge and started calling in favors. This went on for two days until we got another phone call requesting another change. "Just one more thing. Since Lou is a photographer as well, can you set a mini daylight studio on the set so he can shoot some portraits of my kids?"

The budget had been stretched to the limit. I had agreed to forgo my fees in lieu of the experience. The production company was not going to make any profit, but they wanted me to get more exposure and another piece for my reel, and the crew was giving us discounted rates as a favor for getting booked in the future. When the client phoned in that last request, I had to sit everyone down and announce that we were walking away from the gig. It was hard because I basically told them that the two weeks work that they thought they had, they didn't have anymore.

As you evolve in your career, some jobs, no matter how many times you re-work your numbers, will end up costing you money. If you gain some knowledge and experience from those shoots, it is worth it. Only let that happen a few times in your life. In spite of what some people's attitudes toward photographers are, you are not a technician who is willing to work for peasant wages. What you know and what you have experienced gives you a unique set of skills. That is worth money. So, if the numbers are no longer adding up and you can't work with the client to remedy that situation, calmly stand up and walk away.

Spotlight Shooter: Gil Smith

"Lights! Camera! Action!" The bustle of the TV and movie location sets and sound stages in New York and Hollywood made a lasting impression upon child actor, Gil Smith. That cry has been part of his life ever since. Our movie fantasies growing up were Gil's everyday real life, and his DNA was embedded with grips, dollies, 10ks, and more. His true first step into photography was taking a summer photo class in junior high with the renowned photo teacher Warren King in Los Angeles. He never looked back and has been a photographer ever since. King exposed the class to many great photographer's work for inspiration, and Gil thought it was something he could easily do and enjoy. He used to watch Bob Cummings' portrayal of a photographer on TV, the early predecessor to David Hemmings in *Blow Up*, and thought if Bob can do it, so can he. Little did he know what hard work it would be. He transferred to Reseda High so he could study with King and went on to RIT with a merit scholarship from Eastman Kodak and Professional Photographers of America. But, after the rigors and experience of King's classes, RIT was too basic and boring, and he left his formal education after one year. Then he did what any long-haired college dropout would do in the early 70s—he got in his VW and toured the east coast, landing in Greenwich Village.

This was a different and palpably exciting New York from his youth. Gil was inspired by much of the art of the day—Jasper Johns, Rauschenberg, Pop Art, the Rolling Stones, and rock and roll. He developed a fondness for big work, which he still loves to this day.

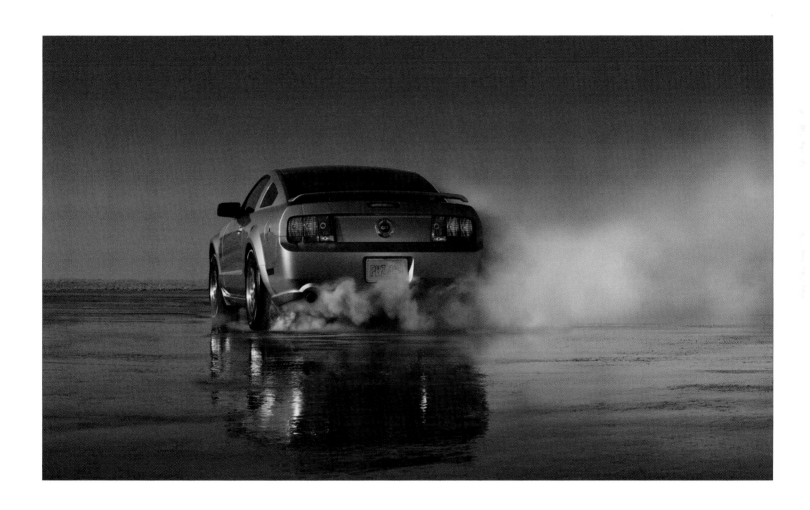

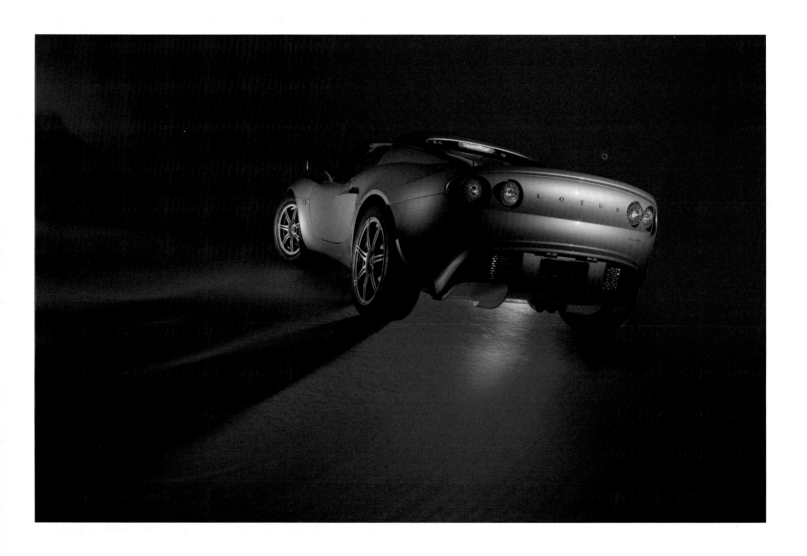

Well crafted and designed billboards in advertising can have that same kind of impact. He moved back to Los Angeles because he knew he needed a studio to be legitimate, and in NY that meant a tiny and expensive loft.

Back in LA, Gil was fortunate to find assisting work with James Wood, a big and respected advertising photographer. Gil was baptized in "sheet metal" photography, which fit perfectly with Gil's love of big productions. Some of the work they did was introducing the not-yet established Pacific Rim car manufacturers like Honda and Yamaha. For example, they shot the campaign introducing the first two-cylinder Honda Civics to the U.S. market. Gil also worked for legendary photographers Reid Miles and David Langley, which planted him firmly in the advertising world.

In 1980, he transformed an old taxi garage near downtown LA into a modern and fully-equipped automotive studio. Although Gil is well known for his dynamic auto work, he is a multitalented photographer, shooting everything from still life to portraits. He's won multiple awards like the Beldlings, Andys, CA, and The One Show. Gil's style is action-oriented, visually exploding off the pages. "I hate ads that appear to be plastic, so I'm looking for the viewers to experience the same thing that I feel, in just one image. I love getting cars dirty, so I developed techniques to bring reality to the shots with the SUVs or off-road vehicles. They should not be pristine or unrealistically clean." His motivation is to tell a better story, make page stoppers, not turners, with unique vision and great production. Because of his background in motion film, he started looking at their high-speed tracking shots. Gil took that technology, bought a $4,000 fluid head, and slowed down the shutter speed so the car would be in sharp focus and the background blurred, or sometimes both blurred. It effectively and dramatically shows the power and motion of the vehicles and has changed the way that cars were portrayed in ads.

Constantly in the reinvention process, Gil teamed up with respected creative consultant Ian Summers. They met just before Ian became art director of the Black Book and as Gil tells it, "It was manifest destiny." Gil bought an ad in the Black Book, and it was "the most horrible piece of crap that I ever produced." He got no new work, no phone calls, nothing. Gil says, "You have to admit to the mistakes you make, but just don't make them twice." Now he realizes it was the best thing that could have happened. Artists are sometimes their own largest enemies, so you need an outsider's view. He hired Ian as a consultant, and Ian tore him apart. Gil's business was growing, but not the way he wanted. Ian helped him develop his marketing approach, delineate his goals and business strategy, and refine the kind of work he was presenting so that he had a clear path to follow for his desired growth as both a businessman and an artist.

Gil co-founded the Advertising Photographers of America in 1981 to strengthen ties between photographers, to help standardize business practices, and to improve relationships with corporate clients. Back in the 80s, there was more parity with art directors, and the creative atmosphere on campaigns was respected. Gil fears that now with many of the art buyers, they are "compartmentalizing" photographers into categories. He cautions photographers not to become "an approved vendor," which

is demeaning to creative work. Gil collaborated with Chris John Margurie with the Cosmos L'Estace agency in Paris and spent 12 years traveling back and forth to Europe to work on campaigns. The European manufacturers greatly admired photographers from the U.S. With Gil's high energy, he became known as the "west coast hippy-wack and the prized puppy," a reputation he does little to dismiss.

Gil totally embraced the digital world and is one of Canon's prestigious "Explorers of Light." The Canon allows him flexibility in his quick world. He owes a lot to computers, too. It's very different from the film world where everything had to be done in camera. Now so much of the image making is in the post-production process. But Gil can have several computers running at once—location scouting with Google Earth, post-production processing, research, and more.

Gil's advice to photographers:

> Don't be afraid to admit that you have mentors. Don't claim to be the first original artist who has just dropped from heaven. Listen, and learn to listen. Get a solid grounding in the principles of business, which is the key to either making it or being broken by the ad community. Street smarts are not enough to survive. If you are secure as an artist and you develop creative new visual ideas, there are bound to be jealousies. You have to fight for your position and work to maintain that, so you need to elevate yourself. Try to preserve photography as an art. And have a life—enjoy your family and experience other art forms.

You can find Gil's work on gilsmith.com.

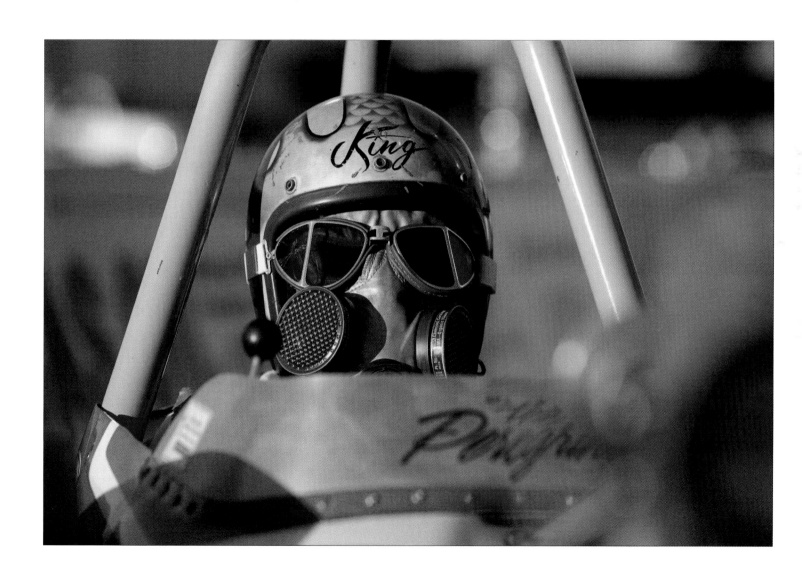

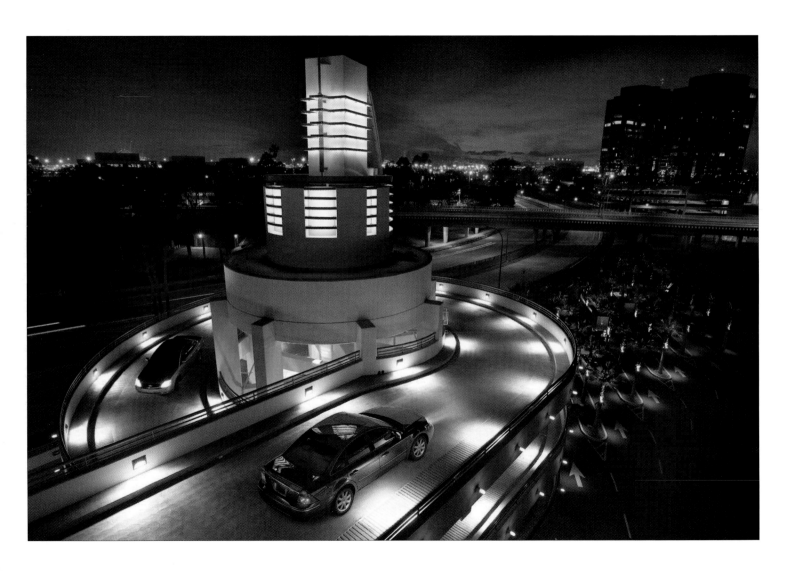

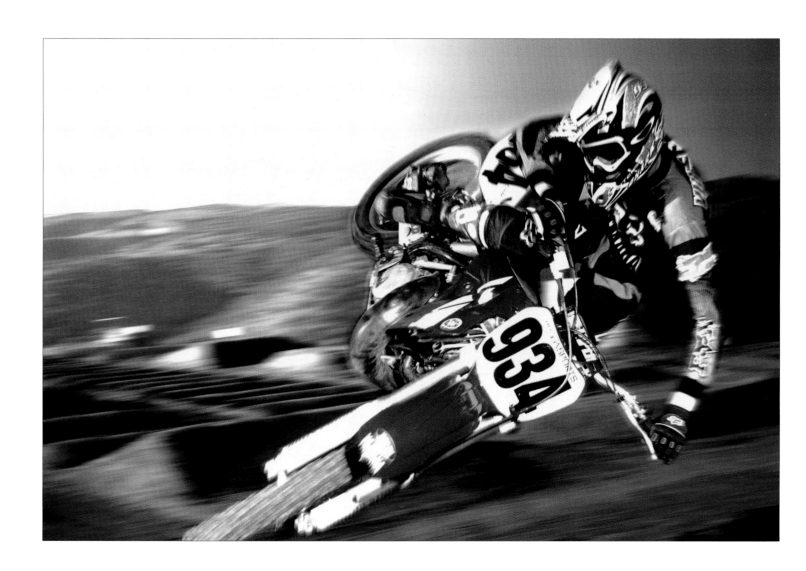

6

When the Job Awards

After all the drama of bidding, schmoozing, re-bidding, and schmoozing some more, you nailed the job. Congratulations, you did it. Now all you have to do is produce the shoot.

Good luck…

I'm kidding. Rather than dictate a method for producing a shoot, I'm going to take you through all the steps I went through to produce a fashion gig that was an ad campaign for a jeans line.

As you read through these next few chapters, keep in mind that there are many ways to produce jobs. This is just a blow-by-blow of a job that was a two-day shoot on two locations with props and cops. Also keep in mind that the shoot was large enough to justify hiring a producer, but not all your jobs, especially when you're starting out, are going to require a producer. If the jobs are simple enough, you can produce the gig yourself. (Which isn't a bad idea for gaining some insight for what it takes to get a job done.)

This shoot was done years ago. I chose it because it was a time in my career when I was just starting to get into bigger productions than I was used to. Just wet enough behind the ears to still screw up; just experienced enough to be competent. Also, to be honest, it was a brilliant time. I was a relative nobody desperately trying to be a somebody. I was living in the wonderful ignorance of relatively low drama, and low responsibility. It was sort of like being at the graduate-school level of my career. Also I think enough time has passed that I won't get into trouble for reproducing the ads in this book.

Bureaucracy and Paperwork

Before any of the pre-production starts, you need to get your paperwork in order. Some agencies will give you a *purchase order,* which is the agency's document. It lists the description of the shoot, the rights being purchased, the anticipated amount to be paid to you, the delivery date, and so on. In your hand, you have your bid with all your terms. You should get that signed. Be sure to get your Terms & Conditions sheet signed as well.

Okay, so it's only that easy some of the time. When you get a purchase order from an agency, it will sometimes say that the agency owns all the rights to the images, which should be a direct conflict with your usage license. Also, you have to watch for language that conflicts with your Terms and Conditions. Check issues like getting payed, weather delays, and the like.

Don't panic and don't be afraid to cross out the lines on the agency purchase order that conflict with your usage license. Put a line through it and initial it. Most times, the agency is expecting this. If you find that the purchase is in concert with your usage license, you are in great shape.

Each situation will be different, and each purchase order you get will be different. Always, always, always read through their paperwork before you sign anything. Do not, under any circumstances, be intimidated or be so damned grateful for the gig that you'll sign anything. If you're going to assume the role of professional photographer, part of that is being savvy. I am absolutely ardent on this point because I pissed away a lot of money in the past because of a bizarre, self-defeating attitude that I thought I barely deserved getting booked, let alone getting paid. It is easy to think that way early in your career. The sooner you don't think like that, the better off you'll be.

Some agencies and clients will not have a purchase order for you to sign. Yee haw! Less reading and a little less drama to get you on the path to doing what you'd rather be doing. Just make sure that the client or agency signs your paperwork. Do not flake on this. Your usage license is a primary component to your future success.

Terms and Conditions

I have to talk a little bit about the *Terms and Conditions* (T&C). This is typically one to one and one-half pages; it's discussed in more detail in Chapter 3. Some clients will look at that thing and get super nervous because it's an intimidating amount of legal conditions that pretty much favor you as a photographer. Ideally, everyone would sign this thing and life would be easy. The reality is it can throw some clients for a loop.

Some photographers use the T&C all the time. Some photographers use the T&C only occasionally. Some photographers have had the rare occasion to utilize the terms and conditions in a legal sense—in that it protected them. And some photographers have had decades of working without needing it at all.

All my life, I have heard you must use the T&C always. Unfortunately, I always heard it from photographers who were speaking with a theoretical, idealized rhetoric. In reality, it can sometimes be a tough call. Especially when you hand it to a client who has never seen one before, and the client hands it to their lawyers to sort it out, and then the lawyers hand it back to you, and the T&C starts being negotiated.

It is a good business practice to utilize the T&C as often as possible; it's just not always practical. Here comes the criticism. Several of my clients have never received a T&C document from me. It was a gut feeling, and I went with it. There are some clients whom I wouldn't shoot for without having them sign the T&C. There is no one perfect answer, and that is the reality that this book offers. The best thing that you can do is be knowledgeable about all the tools and principals—business and technical—that you have available to you. Then make your own judgments and take your own risks. Each experience you have breeds more knowledge and better judgments. But, like all businesses, small and large, the person making the decisions will never be right all the time. What you can do effectively is stack the odds in your favor and be in a position to absorb the mistakes.

Getting Your Advance

After everyone has signed everything, you need to submit an *advance invoice*. This is a document that mirrors your estimate/bid, but has the all-important word "invoice" on it. Accountants are very serious people with very serious mindsets. They don't like documents that they have to write checks for without the word "invoice" on it. So, if you think you can submit your *bid* and tell them to calculate 50 percent of your bid amount and pay that, think again. That won't happen.

Additionally, keep in mind that your job is technically still in the bid stage. So submitting an invoice and asking the client to give you 50 percent of the invoice as an advance isn't wise either. As you shoot, some of the line items of the invoice are going to change, and your final invoice might look totally different from the one you submitted for the advance. That's why you need the intermediary document known as the advance invoice.

Advance amounts vary from agency to agency. Some have no problem giving you 50 percent of the entire bid amount; some will only give you 50 percent of the below-the-line costs. In this particular instance, I got an advance for 50 percent of the entire job. This was great because I had to dig very little into my own cash flow to produce the gig. (You'll read more about managing your own cash flow in Chapter 10.)

Some agencies will hold up your advance for an extended period of time. Personally, I've had to wait for advances before, but I've never been exposed to some of the stories I've heard about shooting on the east coast where some agencies have held advances for 90 days. A lot of anger and discussion exists within the industry about photographers being the "bank" for the agency. That means you're completing their shoot and shouldering the financial responsibility. In essence, the clients are getting an interest-free loan from you.

I wish I had an answer or some path for you to follow to find your way through situations that seem untenable. But, alas, I do not. This is one of the scourges of the advertising photographer's life. You are somewhat at the mercy of the people with the money.

However, before you start thinking about setting up that kid's portrait cart at the mall, there are some encouraging factors to consider. Not all clients/agencies are that bad with their advances. Only some of them are. Ironically, the smaller, less glamorous jobs you shoot will typically have faster invoice paying. So don't hold your nose too high. Cash flow is cash flow. In my opinion, the most boring day shooting is leagues better than the best day at a real job with a real boss.

Also, if you adopt a savvy business lifestyle now, you will be able to mitigate most of the dreadful money delays. The concept of cash flow is covered in Chapter 10. It is one of the most important chapters in the book because the ability to manage cash flow is one of the most important concepts in running your photography business.

If you're wondering whether I knew about any of this stuff coming up through the heap, I didn't. In all honesty, I was exceptionally stupid with my money. My 20s were all about paying my dues and giving away all the rights to my work. My early 30s were about managing my rights well, making really good money, and then spending it. It wasn't until I hit my 34th birthday that I started to wise up and adopt smarter business practices.

If you're young, do what you can to go for the money now. If your friends rib you a bit for being too conservative with your cash or too focused on a capitalistic lifestyle—just smile. Because one day, everyone's college car breaks down and dies. If you're ready for that, or any other eventuality, you're on the path to a successful career.

If you're not young, it is never too late to make more money. No one is keeping score except for you. And unless you're inclined to go blathering the state of your personal finances at the nearest pub, nobody knows your business but you. The only challenge comes in the form of breaking old, detrimental habits.

If you're not young, but you're fabulously wealthy from shooting—well, um cheers. Well done! Thanks for buying the book.

Technically, you should not start producing a job until you have the advance in hand. This is a judgment call that has no ideal rule of thumb. I always push for an advance. No one is going to fire you for trying to collect what you're owed. In my experience, the bigger the agency, the more they'll dictate their own policy. Smaller agencies and design firms are far more amenable.

Now that the ink is dry on the usage license and terms and conditions, and the advance is (hopefully) in the bank, you're ready to start pre-production. The job I've been describing was for a jeans campaign. It was basically two women in various settings living life in their fabulous jeans. Although I'm using a fictitious client and agency name, the job actually occurred. So all the drama and problems you read about are true.

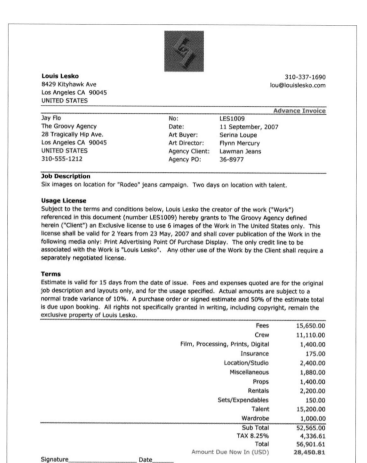

Figure 6.1 An advance invoice; the word "invoice" on the document is critical for getting your advance.

Issues to Settle Before Pre-Production

Money panic while you're in production is an absolute nightmare. It distracts you from your creative abilities and your resourcefulness. I cover a lot of money management issues in Chapter 3, but I include a few tips here to be sure you can get through the gig without revealing the fact that you may only have $100 in the bank.

Have a Credit Card (with Room)

Ninety percent of what you need to purchase, rent, or book can be done with a credit card. It makes sense to utilize a credit card to keep your cash free. Using a credit card is not a long-term loan; it's a short 20- to 40-day loan (see Chapter 10). Its sole purpose is to get your production off the ground and finished so you can invoice the job, pay off the card, and move on to the next gig.

You Need Insurance to Rent Equipment, Studios, Cars, and Get Location Permits

Without insurance, you have no production. There are many avenues to get the insurance that you need. One of the easiest is to become a member of the Advertising Photographers of America (APA) and utilize the special deal this organization gets on insurance for its members. Go to apanational.com for more information.

You Need Petty Cash

Petty cash is a necessity for any size shoot. Get this and give it to your producer so she can dole it out to your assistants and other crew folks. If you've never had to manage petty cash before it works like this.

When you give an assistant $500 in petty cash for the duration of the job, he or she signs a receipt for the cash. Then, at the end of the job, the assistant has to return receipts and the leftover petty cash totaling $500. The receipt descriptions should be listed on a sheet of paper, and the individual receipts should be taped up on 8.5 × 11 pieces of paper, as you can see in Figure 6.2.

Figure 6.2 Receipts are like cash to your assistants. The total amount of receipts and cash returned should equal the petty cash that went out.

The amount of petty cash you need to give your assistant is based on what the recipient will be doing. Try to imagine how much money you would think you need for the errands in question, and double that figure. Keep in mind that you also have to feed your people and keep them caffeinated while they're running around town. Most assistants will take care of their own gas because they will be charging you mileage for driving their own cars. It's always better to guess too high (within reason) for petty cash amounts. You're trying to get menial things done efficiently without your direct involvement; if your assistant comes up short, you'll have to go deal with it, which is always more of a pain than giving up an extra hundred bucks in cash.

A Good Head on Your Shoulders

Pull yourself together. There is nothing in the coming days that you can't handle. There will be things that you don't know or have never seen before, but just like you did when learning your craft, you'll pick up the unknowns quickly. For the next couple of days, it will be your job to make all the big decisions.

Keep these truisms in mind:

+ Be smart. Everyone around you should have the latitude to offer an opinion. You will never know where the next brilliant piece of information will come from. It's your job to consider everything and then distill the information down to a direction that everyone will follow.

+ Never let anyone see you panic. Trust your producer and collaborate with him or her. Everyone has the same goal in mind.

+ The buck stops with you. If your assistant screws up, it's your job to take the heat and come up with a solution. Do not point at your assistant or anyone else on your crew and start crying foul. Photographers who do that are cowards. Oftentimes, the person who caused the screw-up is already halfway to a solution. Have faith that they didn't want to blow it in the first place, that they already feel bad, and very much want to make the situation right. Assistants are on the set to help you get your shoot done and, sometimes, learn something about becoming a professional. They'll be watching you for those cues.

+ Treat your people well. I say this a lot throughout this book. If morale is high, the worst situations you'll encounter will clear up more quickly, because everyone is motivated to help you get through the problems. If morale is in the toilet because you went on some yelling tirade, when the poo hits the fan, you'll be on an island.

Let's go!

Spotlight Shooter: Cig Harvey

Cig Harvey lives a life of diversity and fullness. She is both a fine art and advertising photographer and a photo educator and loves the intensity of combining them all. "I'm glad I have all these facets going simultaneously. They are all energizing: fine art, teaching, and commercial. It keeps everything fresh by having the variety. I don't become blasé about anything; each day is new; nothing becomes routine, and I love that." Photography is a way for Cig to make sense of the world. She states, "I have always been drawn to times of fragility and use photography to explore and legitimize moments of struggle, uncertainty, and doubt."

Her fine art work consists mainly of self-portraits, and comes from personal stories of past and present experiences. They are fascinating images, perfectly constructed, with moments of emotion and fleeting glimpses of personal questions. The simplicity of composition and sophisticated use of color draw the viewer into the visual narrative.

Cig says she was lucky; she knew she wanted to be a photographer from the age of 12, when she became inspired by the *Sunday Independent* newspaper in her native England. "The editorial and documentary photography blew the top of my head off, and I realized what the potential of a picture could be. You can change the world by photography." She attended school in England and earned her MFA at the Maine Photographic Workshops/Rockport College. She started the self-portraits in Maine, which she did mainly because she didn't have the money to pay a model. Cig fell in love with the process of making these pictures and would put on a pot of coffee, start brainstorming and researching icons, symbols, and metaphors and then spend the day making images. She almost doesn't even need the film, because the process is more important than the product. "It's like making stew: choosing what to wear, the color palette, imagining the scene. The photo gives me a venue," she says. She's almost always anonymous in her own pictures, obscuring her face, thereby allowing viewers to identify with the person in the frame.

Expanding into commercial work came from hard work and many visits to New York city, hustling her portfolio to everyone from magazines to ad agencies and galleries to agents. Cig found people to be open and receptive to new talent, in contrast to what she had expected. One meeting led to another, and she followed up on every meeting with thank-you notes and a print. She went to every portfolio review she could, including *Review Santa Fe* and *Positive Focus, New York*. It was there that she had the good fortune to meet Anthony LaScala, Senior Editor of *Photo District News,* and Darren Ching, the Creative Director. Her big break came when PDN wrote the article on her entitled "Rising Star" for the fall 2004 issue and followed up by naming her one of the "Emerging 30 under 30" the following year. Since then she's garnered many awards and recognitions, including Hasselblad Reflections, Popular Photography, the Golden Light Awards, and 2nd place in *Venus* magazine's Artist of the Year 2005. Cig is represented by Robin Rice Gallery, New York; Joel Soroka Gallery, Aspen; and Watermark, Houston, and her work has been acquired by the International Museum of Photography at George Eastman House and the Houston Museum of Fine Art. She has held almost 30 exhibitions in the last 10 years.

Cig is represented commercially by Cadenbach and Associates. It took two years of conversations with Marilyn and a commitment by Cig to continue to refine her style, before they agreed to work together. Cig says how important it is to find the right rep, since it is similar to finding a life partner: They find the perfect jobs for Cig, based upon her look and style, including the recent Fall 2007 advertising campaign for Kate Spade. In the ad world, the lines between the genres of fine art and commercial are blurred—it's all about a good picture. Cig says, "Make the work first and foremost, then find the right client. Don't create a 'commercial' look; honor your work." She loves the collaboration and says there is an astonishing exchange of ideas with people. "I'm excited by the ideas, and I'd probably shoot them anyway." Cig finds that her clients are happy that she shoots only film and suggests that maybe it's a backlash against digital. Her work is traditional, and she develops all her own prints, enjoying the physical part of making something that didn't exist before.

Cig is also an extraordinary and gifted teacher, much in demand at the Santa Fe and Maine workshops. She's a full-time professor at the Art Institute of Boston at Lesley University, working under Christopher James. She has a blend of income, and it ebbs and flows with the commercial and fine art, but teaching is her bread and butter. Her students adore her dynamic and enthusiastic teaching style, and together they produce great work. "I teach because I love it; I love to laugh and students make me laugh. They teach you as much as you teach them. I like meeting people, and I believe that all people have goodness in them. It is a way to give back, to show the power of photography, and what a photograph can be. Teaching is a really wonderful experience, although it's utterly exhausting, completely draining, and I have to stare at the wall for a few days after. The workshops have such an accelerated pace; it's very intense and I love that, too."

For Cig, life is inspiration. She's inspired by light, nature, relationships, by the world, and the ocean. She's drawn to times of fragility and uncertainty, and photography helps her make sense of that. Cig gratefully lives in a state of receiving inspiration, and she uses visual source books, journals, colors, movies, brainstorming, and literature to connect to life. The present and past are all related. Cig says, "I move fast through the world; I work really hard all the time but don't consider my work a job. Photography allows me to retain a childlike wonder of the world. At midnight, I was out in a field of fireflies. I wouldn't have done that if it wasn't for photography. I enjoy every step in life's journey. I celebrate each step forward, and it's an astonishing way to live. I couldn't live life more fully. It's not the arrival, it's the journey."

Cig's advice to photographers:

> Work, work, work! If you want to do commercial work, make the work first and then find the niche market. Then you are making work you want to make. Making a good picture is really hard, so accept that responsibility and discipline. Do it when you don't want to, and show up everyday to start your creative life.

You can find Cig's work on cigharvey.com.

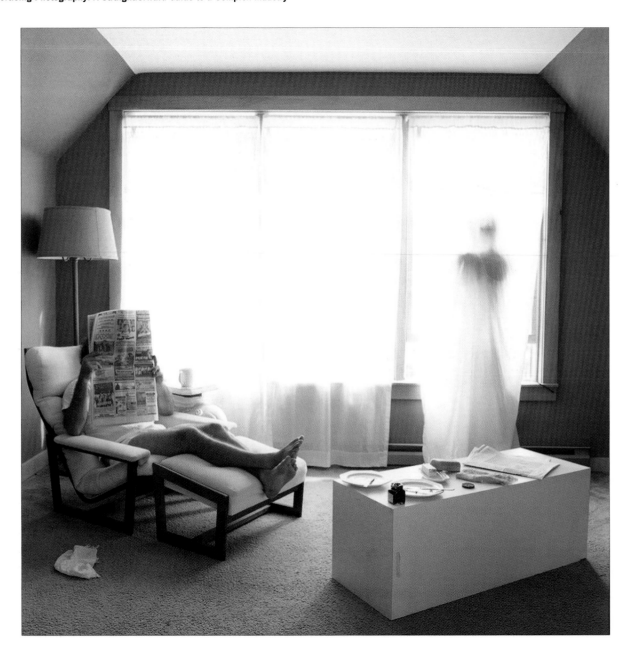

SHOP KATESPADE.COM

kate spade
NEW YORK

NEW YORK HONOLULU TOKYO SAN FRANCISCO

7

Pre-Production

Production is a sexy word. It looks good and sounds better. It's a lie. Production is chaos management.

This chapter goes through all the steps I went through to produce a fashion gig that was an ad campaign for a jeans line. The producer I chose for this particular gig was Emily Barclay. Brilliant, cool under pressure, and highly resourceful. Also, she knows how to deal with clients.

We had just arrived at the ad agency in Santa Monica, for a meeting with the art director, account executive, client, and art buyer. We had the *boards* (the art director's artistic rendering of the images), which were sent to us the previous week; the ones that we used to base our bid on.

I love the first day of pre-production; everyone is in a fabulous mood because, although there's a lot of work ahead of us, shooting on location is a blast. Or, as one art director put it, "Any day not spent in the office is an epic day."

The meeting involved the art director and I talking about locations and the look of the images. Emily gave me a funny look every time I started talking about executing the shoot outside of our budget. It's a bad habit of mine, but I think all location shoots should happen in gorgeous remote places. Suggestions were bantered about, and we all agreed on a vague idea for the location.

Next, we talked about the talent. The first stage of successful casting is discerning the "look" that the client is trying to convey in the ad. This will give birth to a string of adjectives that you never knew existed. Then, suddenly, in the name of keeping the client happy, you'll find that your response is equally bizarre. This mindless destruction of the English language will continue until someone finds a phrase that everyone in the meeting can get their heads around.

Casting

Armed with our talent description, Emily calls a few agencies and has them send out a *package,* which is a stack of *zed* cards of all the models at the modeling agency who come close to our description. When you call an agency, have the following details of the shoot ready:

- ✦ The client's name, address, and phone number
- ✦ The usage location
- ✦ The media type
- ✦ The length of time that the ad will run

The modeling agencies will ask you about money. Tell them the budget hasn't been determined yet. What they're trying to do is determine if your shoot is a low-budget gig. If they think that it is, you'll get a package of color copies exhibiting 14- and 15-year old models who have been modeling for five minutes. This is the "new faces" division of the agency.

Don't get me wrong, there is some wonderful talent in the new faces division of all agencies. You would be remiss to ignore those cards. Just make sure to keep in mind what you need to accomplish for the shot. If you have the time to give some direction, the entire field is open to you. But if you see the shoot as having to move fast because of lighting or location, you might want to consider models with a bit more experience.

Figure 7.1 Discerning the *look* for the client isn't always easy.

The second stage of a casting involves another meeting, this time with a huge stack of zed cards and fewer words. Feel free to use the following highly effective phrases:

- ✦ "Hmmmm"—Use this phrase when you really like a model, but are waiting for validation from your client.

- ✦ "Oooohhh, fantastic"——Use this phrase when you've previously worked with or dated the pictured model.

- ✦ "Uh huh, I do kind of like her (or him)"—Use this phrase when you find the model repulsive, but you saw client's eyes light up when they saw the card.

Casting from Cards

Occasionally, you will look at the cards of models who are not based in the city in which you are doing your casting. This usually happens when the model has been around the industry long enough that he or she can get represented in several markets. Or, as in the case of this job, the photographer calls in a *package* from a nearby city (San Francisco).

My reasons for doing this were only partially altruistic. On the one hand, I knew the talent pool in San Francisco pretty well. On the other hand, I was showing off a little. This was a nice job with a good budget, and I was looking to get a little name recognition in the city where I had started my career. I had not shot anything significant in San Francisco in years, and nobody gossips more than a talent agency.

If, when you are looking at your *packages* and you find a model you like who does live out of town, you can call in the model's book (portfolio) for the casting session. Keep in mind that some-times the measurements of the model printed on the card are not always accurate. So the best thing to do when considering a model whom you are not going to see in person before the shoot is to ask the agent what the model's true measurements are. They'll tell you exactly what's on the card. You see my point. Unless you see the model in person, you'll never really have a true sense of what they look like.

I've never had any major disasters when casting from cards and book portfolios, but, as you'll see, I did have a mild panic on this job.

Taking It to the Street

Although it wasn't remotely appropriate for this gig, there is another type of talent casting that you should know about.

Have you ever looked at any of your friends and said to yourself, "they've got an interesting look?" Write that person's name down in your casting files. Casting real people is called *going to the street*. Inevitably, because of an aesthetic requirement or budget restriction (or both), you'll need to pull from your pool of friends and lovers to get a job cast. This type of casting is not as glamorous as going to the modeling agencies, but is equally as fun. Especially when you get to book a friend. It is also a fantastic test to see how good you are at matching a face to a job.

My first experience with this type of casting was when I was shooting an ad campaign for Best Western hotels. Agency politics and a miscalculation by the account executive left us with very little money to shoot the last ad. The art director was desperate. I found the answer in my girlfriend's roommate—a slightly goofy looking guy named Dennis. It was a little nerve

wracking because you never know how someone is going to react in front of the camera. But once he got on set, it became immediately apparent that he was a natural. He was awesome. You just never know who is hiding talent underneath a mild mannered exterior.

Since then, the casting of real people has become a real business. Agencies like The Blackwell Files keep a photographic library of all kinds of different looking "real people" who are available for booking. Keep your expectations low and your directing abilities sharp. If things aren't going well, hide your disappointment and dig deep to make something happen. Remember, the ability to pull a performance out of a pedestrian is what separates the true shooter from the tired, belly aching, prima donnas who happen to own a camera.

That's Gonna Cost Extra

There are rare situations that can cause your model fees to skyrocket. For example, any shoots that require the model to permanently alter her current look will cost you a premium. This includes hair cuts and hair coloring. The extra fee is loosely based on how much the model's current look is making for the agency and how willing the model is to participate. For example, if you choose a model who doesn't work consistently, there will be more room for you to negotiate. In almost all cases, you need a plan to return the model to his or her original look. The fee is always negotiable; just be sure to weigh how badly you want that particular model against how much it costs. Another situation that will jack up your model fees is when the model is modeling lingerie or is partially nude. Some models won't do either; some do lingerie only. If your shot calls for any one of these, get the information upfront. You'll look better if you don't ask for a nudity clause late in the casting process.

The Go See

Eventually, a small pile of *selects* emerges. Now you call the agencies to set up a casting call (or a *go see*, as it is sometimes called). If you have models from a few agencies to look at, arrange to get a studio or hotel room and have the models come to you. Yes, it's perfectly legit to hold a casting at a hotel, just make sure it's a nice one. These are young girls and guys. Do not have them traipsing off to a Motel 6 on the side of a highway. If you don't have your own studio, most rental studios will give you a very decent rate to use the space for casting. My personal preference is a studio—it's just groovier. I have had castings at modeling agencies as well. This is pretty easy if you're looking at only one or two agencies. But if you're looking at more than two agencies, coordinating client, art director, and staff to multiple places can be time-consuming.

For the job described here, we rented a small studio in Culver City. The exercise of meeting the models and looking at their portfolios is fabulous. Their personalities almost never match what you expect. And you get to see how many other photographers in town are better than you.

At our casting we had the client, Emily (my producer), the art director, and myself. We scheduled the casting from 11 a.m. to 3 p.m. We saw about 20 models from three agencies. By 4:30 we had chosen our favorite two and made choices for four alternates.

It's important to choose alternate talent at this stage because you have the attention of all the people you need to get approval from focused on the talent. If we had only chosen our two favorite models and none of them was available, we would have had to go though an enormous amount of time munching logistics to

try to get everyone to agree on alternate choices. If you choose your alternates at the time of the casting call, it's a much easier sell when you can say "model *A* wasn't available, but the alternate we loved is."

Talent Availability

Emily called the modeling agency to check on the availability of the models. Our first choice, designated as "the blonde" on our casting sheet, was available on the designated shoot days. We put the model on a *soft hold*. A *soft hold* basically tells the agency that you're serious about using the model, but for whatever reason, you can't commit to booking her yet. These reasons can be anything from needing to get her rate approved or, as in our case, you don't have the locations decided yet, which as you'll see, has a lot to do with the price of the model.

Our second model, designated as "the brunette," was not available from the same agency as the blonde. This was unfortunate news for Emily and me because, when you book two models from the same agency, you have a better negotiating position. Our brunette alternate was also unavailable. That left us with alternate number two, who was secretly my top choice. Unfortunately, she was based in San Francisco, 500 miles north of Los Angeles. The client vetoed the idea of flying someone in and paying all their related expenses at our initial meeting. But I thought she was the perfect look for the ad. We never got to see her in person, but we had her book (portfolio), and it was great.

Location, Location, Location

One of the wonderful things about Los Angeles is that you can find almost any type of location you need within driving distance. On top of that, the city and the surrounding areas are incredibly *film friendly* because of all the feature film and commercial productions that are shooting all year around. Although getting permits for a film production can be costly, the permitting agencies cut a fabulous deal for still photographers. My peers and I have always wondered why that was the case, yet no one has wanted to ask for fear of calling attention to the fact.

I had a pretty good idea of the locations I wanted to use for this shoot, and I had explained them to everyone in our initial meeting. Everyone thought that my ideas were great, but as with everything in advertising, you need to get approval from the ones who cut the checks.

We had budgeted about $600 for location scouting. This was a little on the low side because a location scout gets $350–$450 a day, plus expenses. But, for this shoot, we had a pretty good idea what we were looking for, and $600 would have more than covered getting file photos from a location scout.

File photos are images of popular locations that location scouts keep on file. Experienced location scouts who have driven all over the state for themselves or for other jobs shoot gobs of photos of different types of locations. Using file photos is a lot less expensive than hiring them to go out.

Our first location was a long desert road in the middle of nowhere. This was our sunset shot. The second location was a no-brainer because it offered several different types of terrain that would cover us for our four remaining images. It was Malibu Creek State Park. (If you've ever seen the TV show M*A*S*H, then you've seen Malibu Creek State Park.)

Figure 7.2 This is model Aimee Wright, a friend who came with us to Malibu Creek to stand in for our location photos.

As awesome as Malibu Creek State Park is, it's also popular among production companies. So getting your shoot day is not always that easy. Emily left a message for the park representative who handles the permits. They are in the office from 8 a.m. to 11 a.m. daily.

Emily and I decided to do our own location scouting to preserve the money in the budget for the "Location Scout" line item. We took a trip to Malibu Creek and shot some pictures that I thought would work for the ads, and then we took a long drive out to the desert to find a long, lonely road. Both veterans of shooting out in the desert, we had a pretty good idea where we wanted to go. We found our spot almost immediately, shot some snaps, and wrote down the location so we could arrange a permit. We then found two alternate spots and shot those so we could present the client and the art director with a choice.

No Insurance, No Permit

Get used to this idea now. You cannot shoot a commercial photography gig anywhere on the planet without a permit, or permission. And no one is going to give you a permit or permission unless you have insurance. Even if you shoot at your cousin's house, if the job is a commercial job, you should have the owner of the house listed on your policy. This is done by having your agent fill out and fax an *insurance certificate* naming the parties concerned as covered by the policy. The insurance agent will charge you a nominal fee of $10 to $25 dollars per certificate. The certificate is good for a year or expiration of the policy, should you let the policy lapse.

Figure 7.3 An insurance certificate is required to get a location permit.

Many of the professional photographic organizations like the Advertising Photographers of America (APA) have deals with insurance companies; if you're a member, you can get a discounted rate. The insurance agent will know the coverage that you need and set up the policy for you. Keep in mind that insurance agents work banker's business hours, and it can take them a day or two to get the certificate to the permit grantor for the location you want.

If your set gets shut down because you could not produce a permit to any cops who happen to be driving by checking out the models, you are responsible for the entire cost of the re-shoot. This includes plane fares and hotel accommodations for the client and the agency people if they had to fly to the location. Worse than that, your reputation will be absolute crap.

Trust me, you do not want this kind of drama in your life. Guerilla style shooting is great for college and model tests when you're building your portfolio. But when you're getting paid by a client, get your insurance and permits sorted.

Crewing Up

While we were driving the four hours round trip to the desert location, Emily was making calls to *crew up* the shoot. Mark, my regular first assistant, has always been given the freedom to hire whomever he wanted to work under him. For this job, we were going to need a *second assistant* and a *PA* (production assistant). The difference between a second assistant and PA is that a second assistant needs to have knowledge enough to use the gear, whereas a PA just needs to take orders.

Emily sent Mark a *production sheet,* which is a list of all the line items below the line. This was so he can look at what his budget constraints were for the equipment we needed. I had a chat with Mark telling him the gear I wanted to shoot. Mark was budgeted for a *prep day* and *wrap day* plus two *shoot days.* When we *locked our locations,* we would let Mark know—which basically meant he was free to start reserving gear and booking his crew.

Prep and Wrap

One of the common pitfalls that photographers encounter when bidding jobs, is that they forget to take into consideration the additional days required to rent and prep gear, build sets, and get props and wardrobe.

The size and complexity of your shoot will determine how much prep time is needed. For this particular shoot, Mark needed one day of prep. He had to call in the rental orders and then do the pickups around town. Usually, we end up getting the gear all from one rental house. But, if it's car season in Los Angeles, rental gear can get booked up for weeks at a time by all the big production shooters. This will necessitate a search for the equipment that we need. If you happen to find the gear at a shop that you don't normally do business with, keep in mind that you need to get an insurance certificate to that rental house before they'll let any of their gear go out the door.

Because this shoot was on locations in the middle of nowhere, we had to have redundancy in our gear. Backup cameras, computers, and so on. And, although we didn't anticipate using artificial lighting sources for any of the shots, we had enough lighting to illuminate each shot in case we had bad weather. This included a portable gas-powered generator to power our strobes as well as our flood lights that we used so the crew could wrap the location sets after dark. All this equipment needs to be tested before the rental houses close just in case you need to replace something that's not working.

Your other crew people, such as the clothes stylist and prop masters, will need time to shop for the things that are needed for the shoot day. This typically involves them showing you and the art director the materials so you can approve what they've done. This requires that you leave enough time for them to go out and get more in case they didn't get your needs covered.

The people you hire for the tasks beyond the photo assistants will have a good idea how much time they need for prep and wrap. And they won't mind if you ask them even if you're only bidding the job. As you get more experience, you'll be able to estimate the time needed yourself.

Wrapping a shoot is usually not as time-intensive as the prep, but is still an important consideration. I've done studio shoots that involved building a set. In the final assessment, it is sometimes less expensive to hire a small crew to clean up the stage the next day, rather than cover everyone's overtime. All rental houses will negotiate a less expensive fee for a wrap day versus a shoot day.

You'll Have to Talk to My Agency

Emily was able to hire my favorite makeup artist and favorite hair person. They were both available, so we put them on a soft hold, with confirmation promised within 24 hours.

The makeup artist that I chose was one whom I had worked with for years. Dean is exceedingly talented and fast. He knows how to work on location well, and he's the type of person you can ask for what you want and then forget about it. Another wonderful attribute that Dean possesses is attention to detail while shooting. He always knows just how to time a brief interruption for a touchup without breaking the flow of the shoot. Beyond that, he's just funny. He brings a lot of energy to a shoot.

With all these wonderful things to say about Dean, it's no surprise that he went from working freelance on his own to being represented by an agency that specializes in hair, makeup artists, and wardrobe stylists. If we wanted Dean, we were going to have to go through his agency.

Dealing with an agency that represents specialized artists is very similar to working with a talent agency, only you don't get the barrage of zed cards. These agencies represent far fewer people than talent agencies. If you don't know who you want, they'll guide you through who they think would be right for you.

The hair person we booked *direct*. Booking direct simply means that the artist doesn't have representation. This is good in that you avoid paying agency fees and higher rates. But you have to make sure that the people you hire are up for that task. This all becomes apparent as you start moving in the circles of people who do this sort of thing.

Eventually, we found a clothes stylist. She was an ex-model who was pursuing a new career since retiring from being in front of the camera. Her rate was wonderfully cheap because she was looking for experience and *tear sheets* for her book. Emily and I both agreed that because of her background as a model, she knew the territory. She would probably be great in spite of the fact that she had not done a lot of styling in the past.

Locking Things Up

Emily received a call from the Malibu Creek location manager. There was another production shooting the same day we were, but they were going to be wrapped by noon. We wanted our call time to be 7 a.m. with our first shot at 10 a.m. It all worked out because our first two shots were in the creek and the other production company was going to be half a mile away in the back country area. We wouldn't need to go to that part of the park until the afternoon.

There was an unforeseen glitch, though. We wanted to drive a prop vehicle into the back country. When we bid the job, we assumed that we would just need to get permission to do so. Nope. Because of the extreme fire hazard, the State of California requires a ranger to be with the shoot the entire time. This was going to cost us $20 an hour. We had a 10-hour shoot planned.

Emily called our insurance person who faxed the National Parks Film Office in Hollywood our insurance certificate. Emily also FedExed a check for the permit fees along with a filled-out permit application that they provided us.

I had emailed the art director our location photos from the previous day. Malibu Creek was an easy sell. Everyone had been there at least once in their career, so people were already familiar with it. The images I sent of the angles I wanted to shoot were to confirm that we were all seeing the same thing in our mind's eye. Approved!

The long road location was a bit tougher. I had shot three different locations. My favorite was the one where the road elevated into a hill way off in the distance. It would really do wonders for the perspective of the shot. The art director was vying for the location that had a small mountain of boulders in the background.

We went round and round for a while. Finally, I said that with the lens I was shooting, the boulders would look like a bizarre anomaly because they would be out of focus, whereas the road would look like this stunning continuation of our location. The pitch worked, and I got approved for my road location.

Emily called the Antelope Valley Film Office to secure our "long desert road" location. Because we were shooting within 300 feet of a California highway, we had to pay two California Highway Patrolmen to be on the set. They cost about $40 per officer per hour with a minimum of three hours. This was something we anticipated and had planned for in our bid. Emily did the same thing with the insurance, check, and application.

With our locations locked in, I called the modeling agency and put *strong hold* on our blonde, Melissa.

Now is when you start to talk about money. A phrase you'll hear a lot is "plus agency." For example, the fees for your favorite

model will be quoted as $4,000 for the day and the usage, plus agency. The agency fee is an additional 20 percent of the model's fee. So. in our example, the total model cost was $4,000 + $800, or $4,800.

Negotiate! All fees are negotiable and agencies would rather have the work than not. Just be mindful of fair market value. You don't want to lose a great model by pushing too hard. But do push a little; it's all a part of the process. Also keep in mind that models get fitting fees if they have to come in before the shoot day to try on clothes. They also get travel fees if the shoot is a certain distance away from the agency. Finally, make sure to find out what the agency defines as a day. Overtime fees are per hour after the initial 8 to 10 hours.

I think the final deal I negotiated was $3,800 per day, which included a one-hour fitting and agency fees. As long as we provided transportation to the desert, it would be considered a *local* shoot.

Now the problem of our San Francisco-based model. I had been avoiding the issue with the art director and the client, because I hadn't figured out how to pitch the fact that I wanted to fly someone in from another city in spite of the fact that they had already killed the idea. In a way, I kind of screwed myself. Since I had waited, we were going to be financially responsible for another casting to find our brunette.

I started by talking to the agency in San Francisco. There was no way they were going to let me book Samantha as a local talent, which means that the model is booked as if she lived locally making her own arrangements to get to Los Angeles.

While Emily was arranging all the other details, I went to meet with the client. I started by saying that our first two talent choices were unavailable, but we were lucky because our second alternate from San Francisco was available for the shoot. Unfortunately, she wasn't going to be available for a fitting because that would mean we would have to put her up for three nights at a hotel, pay her fees, and give her a *per-diem* (a daily stipend you give cast and crew for food and drinks). The client looked at me and said, "Out of all of Los Angeles, you can't find another brunette that we can use?"

I smiled, "I love the look of this girl. I've talked to her on the phone, she has a great personality, and looking at her book, she can work that camera." The art director was looking at her zed card. He noticed her height listed at 5'8." Compared to our blonde, Melissa who stood at 5'11," Samantha was short. The art director wanted to know if that was going to be problem. "Not if we use lifts in her cowboy boots," I thought to myself. "No problem whatsoever," is what I said.

The client was shaking his head, and I was losing my pitch. Just as the dreadful words "Maybe we should do another casting" came out of the client's mouth, my phone rang. It was Emily. She had a question about something totally unrelated to my current crisis. After I hung up with her, I punted and told the client that we would be able to bring Samantha down without needing any more money. Oh, the smiles.

Now, you may be wondering why I was pushing so hard for Samantha. This was a shoot about telling a little mini-story while showing off perfect fannies in fabulous jeans. Melissa, our blonde stunner, was 17 and had only been working about a year. She was the perfect girl for the part, but I was a little concerned about

her lack of experience. Samantha was 23 and a perfect match aesthetically for Melissa. She had also been modeling since she was 15, and I knew by looking at her book that she could move. I figured that Melissa would pick up on Samantha's confidence and really bring her movement to a whole new level. This is all just a long-winded way of saying that in my gut the duo felt right, and I wanted to make it happen.

I went back to Emily to tell her I just screwed our budget.

In the end, it wasn't all that dramatic. The final deal with Samantha's agency had her arriving the morning of the first shoot day. She would stay overnight at a hotel and then spend the rest of the weekend (we were shooting on Thursday and Friday) with a friend in town. That took us off the hook for two nights at a hotel. We could easily absorb the rest of the additional expense into the budget. Unknown to me at this time, there was still one more surprise to come from the San Francisco model. But you'll hear about that on the shoot day.

Deal memos are one-page documents that model agencies have you sign to lock the model's shoot dates. They're basically written versions of the deal you made on the phone. Once you sign a deal memo, you're financially obligated to the agency's cancellation policies. Emily signed our two deal memos and faxed them back to the respective agencies.

In our search for a classic truck to use in the background of the long road shot, we got lucky. A friend of mine who worked for a feature film director was always telling me about how her boyfriend had restored an old Ford truck. His name was David, but everyone called him Cajun because he was from Louisiana and a master at Southern cuisine. He was a caterer for feature film sets. He was not only happy to rent us his truck, but he was between movies and would love to cater our shoot. Oh man!

My last meeting of the day was with the clothes stylist. She was in charge of bringing clothes and shoes (or in this case, boots) to accessorize the jeans. She had two clothes racks full of stuff in the sizes of our two models (she contacted both of them after we had them booked). We went through and tagged the things we liked so she could have them prepped for the shoot day. The client and art director were not necessary at this meeting because we were taking a large selection and paring it down to a reasonable one to choose from. The client and art director would be involved with the clothes choices on the shoot days.

24 Hours Before the Shoot

It was the day before the shoot. Emily was finishing the call sheets and the production books. A *production book* is a book containing call sheets, phone numbers, maps, location photos, and anything else having to do with the shoot. Samantha had been confirmed, so had her flight and her hotel. She was a great sport with a fabulous New Zealand accent. In the three short conversations I had with her, I could tell she was going to be brilliant.

Mark was officially on the clock. He was picking up gear and prepping it. His crew was hired and things were falling into place. Emily and I had one last meeting with the client to make sure nothing was forgotten—or if anything needed to be added at the last minute. This is sometimes called the *pre-pro* or pre-production meeting. I like to call them the oh-crap meetings, because a couple of times early in my career when I was heavily involved in the producing, I forgot stuff. And, because one of the purposes of the pre-pro is to perform checks and balances, the fact that I forgot something got found out at the pre-pro. In front of everybody. Oh crap.

My biggest screw-up was when we were shooting on the streets of Santa Monica. Everything was in place; all the details were getting checked off, until I suddenly realized that I didn't have a shooting permit. No permit, no shoot, big expense for stupid photographer. I promised up and down that we would have the permit sorted out in time for the afternoon shoot. I was down at the film office for the City of Santa Monica at 7:30 a.m. with wine, cash, and candy. I was on a mission to bribe someone to expedite a permit in an hour.

Our pre-pro went fabulously well. Mostly because I wasn't involved in any of the production details, and Emily is flawless at what she does. The crew call time at the location in the desert was noon. The talent call time was 1 p.m. and my call time was 2 p.m. Emily was going to have Melissa meet her at the office so they could carpool, and I was to pick up Samantha at the airport.

It's the night before a big shoot. Time to go home and get very little sleep.

Spotlight Shooter: Mark Leet

Mark Leet watched a beat-up rental car emerge from an almost unpassable road one night while camping in the middle of the desert. He and his friends had easily made the trek in large four-wheel drive trucks. But the person driving the diminutive car clearly had no idea the personal risk he was taking. If his car failed him, he would be stranded in the middle of nowhere.

Eventually, the small car parked, and the driver got out with an 8x10 camera. It was then that Mark realized the motivation for the dangerous expedition. The man was driving toward a location to take a photograph. That exemplified what photography was for Mark Leet—the relentless pursuit of the perfect image. That day became a turning point in Mark's career. A career that had started 12 years earlier, at 8 years old, with his father's purchase of an Argus camera from the local drug store.

Mark can vividly remember the first photograph he ever took. It was of his friend from a vantage point high up in a tree. "My friend looked like he was the size of a pea," Mark recalls. In high school, Mark was one of two photographers shooting for the yearbook. It was his first exposure to the power of photography. He was able to get access to people and places in the school that most students could not. Occasionally, Mark would get himself out of a boring class, unquestioned, by citing "yearbook business" as the reason for departing.

His senior year, Mark took advantage of an incredible opportunity offered as a program by his school. If you were able to get a job working in the profession that you planned to pursue after graduating, you were allowed to skip the second half of the school day for work. Mark applied to a company in silicon valley that had advertised a position for a photographer. Anticipating more competition, Mark was surprised at how easily he got the job.

He came to find that the job wasn't exactly photographic work as much as it was photographic processing. The company made silicon chips. Part of that process was drawing the circuitry on litho film which then needed to be carefully hand-processed. Mark was thrilled. He was 18 years old and making incredibly good money. The only thing that was missing was actually shooting. He remedied his situation by offering to shoot pictures of the employees for fun. Eventually, word got around about the quality of Mark's images, which resulted in the company building an onsite studio and creating a separate department just for Mark's photography.

It was during those years that Mark attended a photographic workshop at the home of Ansel Adams. There he met some of the legendary photographers of the day, all of whom were particularly interested in passing the torch of the "true craft" of photography. It is here that Mark says his career was launched. Guided by the photographers at the workshop, he discovered his obsession for the quality of an image.

Inspired by the workshop and the event in the desert, Mark opened up his own studio. The next 15 years proved to have peaks of incredible success and occasional moments of challenge. It was also a time that Mark went looking for his direction. To Mark, there are three elements that make up a successful career in photography—good money, good projects, and good people to work with. In his relentless pursuit for all three, Mark typically could only come up with one or two at a time.

Even though he couldn't quite find his ideal balance, there was no question that Mark's talent was becoming more and more refined, and his reputation was becoming more and more bankable. The magic element that would bring everything together came from a woman whom Mark would ask to become his wife. A fan of Mark's work, she was able to aide Mark in organizing the business side of his career. This resulted in whole new strata of consistent success for Mark and his work.

Mark has been absolutely dedicated to the quality of his craft—a lesson passed down from Ansel Adams and company. And it's always his intention to pass on the same philosophy to the next generation of photographers. Any given day in Mark's studio finds him incredibly generous with his time, experiences, and hospitality. And, even though digital post production encourages a leniency in shooting, Mark is absolutely adamant that the craft and the magic of photography happen at the time of the exposure.

You can find Mark's work on markleet.com.

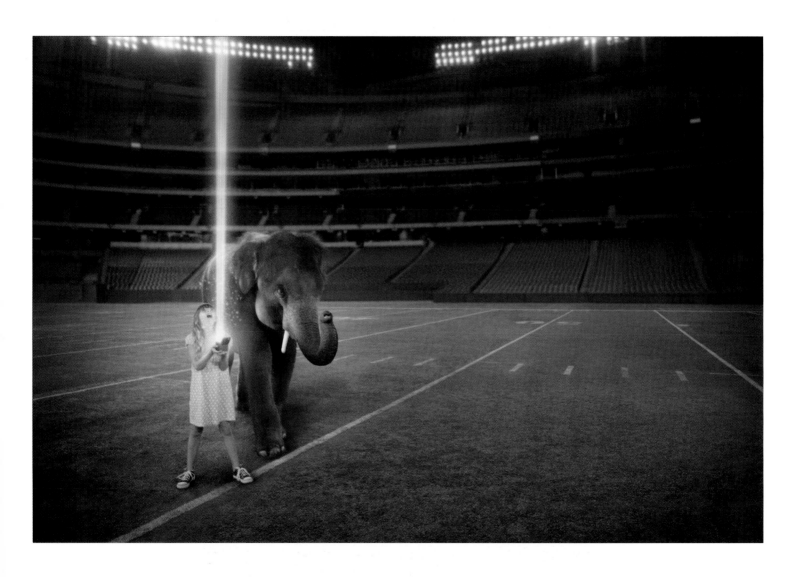

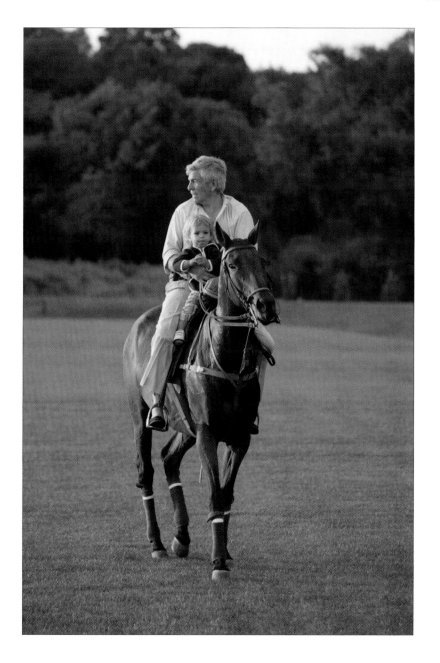

8

The Shoot

Shoot, Day 1

I picked up Samantha at the airport at 11 a.m., and we drove straight out to location. Two hours later, we were surrounded by desert. It was a gorgeous day. Everywhere we looked there was a vast nothing of differing shades of brown. Eventually, we pulled off the side of the highway at what looked like an oasis. There were 16 people milling around three large blue canopies, one of which had the smoke of cooking billowing out from underneath it. Ahead of us, also parked on the side of the road, were three SUVs, a bright red 1956 restored Ford truck, and two highway patrol cars.

I always get a nervous pang when I arrive on my own set. Personally, I think it's a healthy space to be in. We walked over to the makeup tent where Emily was on the phone. The makeup artist had his tall director's chair set up and all his makeup laid out on a table. The highway patrolmen were hanging out drinking bottled water. The clients and art director got up from their chairs that were underneath the other tent, which had already been designated "the lounge."

Mark came running toward me with a camera ready to start roughing in an angle for the shot, and his second assistant had his nose stuck in the back of Mark's SUV. If you're wondering where the PA was, we decided that the shot setup was simple enough without the extra hands—the PA would be more useful the following day when we had more complicated setups.

Because we were shooting just before sunset, we had the luxury of having an easy start with a brilliant lunch. So, after some initial chitchat and a few quick photos of the scene, we all visited Cajun at the food tent. Things didn't start hopping until after lunch. Makeup got started on our two girls, and the art director, client, and I started accessorizing the jeans with the clothes that the stylist had brought.

The action of the shot involved two girls standing on the bumper of their classic Ford truck, putting up rodeo posters on a telephone pole on the side of the highway. With fannies toward the camera, of course.

The highway patrolmen's job was to make sure I didn't get walloped by a car doing 90 miles an hour on the back highway. We had decided on three angles, all of which the art director approved or *signed off* on when he looked at them on the laptop screen that we had sitting in its own little mini-room made with c-stands and medium-size solid flags (the black ones).

With the girls' makeup and hair done, we still had an hour before it would be our ideal lighting for the hero shot. So I started shooting all kinds of great stuff in and around the truck and up on a bunch of boulders about a quarter mile away. It was totally unscripted and free form. My favorite. The client was loving it and started to talk to Emily about licensing the additional stuff I was shooting. Our position was, take all the images with you, if you find one you'd like to use, we'll make you a great deal on licensing. Basically, I was giving them a library of stock images that fit with the overall theme of the jeans line. It was a win, win. I was thrilled to be shooting all this great fun stuff, and the client was going to have images that might work for them for other applications while the jeans were current in their line. Licensing from the additional body of work would cost them less than setting up another shoot, and I would make extra bucks on stuff I did because I felt like goofing off instead of sitting and waiting for the sun to set.

Finally, it was getting time to shoot. The girls got touched up, and we shot our first angle. Fabulous. But as the sun was going down, a problem was discovered because I almost backed into oncoming traffic while I was looking through the lens.

We were shooting direct light, which meant the sun had to hit the girls dead on or the shadows would have looked crappy across their faces. Yours truly, when scouting the location, didn't notice that the sunset angle would put me square in middle of the traffic lanes. Oh shit. As the sun was going down, Mark and I were thinking quickly how we could reorient the shot. With everybody looking on, we put on our best acting skills to make it look like everything was under control.

Divine intervention came to town wearing a badge. One of the CHP officers came over and politely said, "Hey there, I don't mean to interrupt, but my partner and I were wondering if you wouldn't mind if we shut down the road while you were shooting. We saw that last move you made, and we sure would hate to have to fill out an accident report after such an easy day." I would have kissed him if I didn't think it would get me shot.

Emily gave one of the CHP officers one of our walkies, and off they went in a roar of V8 engines a hundred yards behind me. We finished the day having caused a traffic jam in the middle of nowhere, but the images were fantastic. We wrapped the set and went back to LA to get ready for the following day.

Shoot, Day 2

Base camp was set up in the parking lot at Malibu Creek State Park. Unlike the day before, we were close to civilization. That meant a tall, hot, triple cappuccino for breakfast. We lost Cajun to a Tony Scott movie, and so Emily had our PA make a run for all kinds of great stuff. She took all the diets of everyone involved into consideration. It didn't matter what religion or gastronomic sensibility you were—she had you covered. Lunch was going to be a *run*, meaning that Emily had procured menus from the food establishments close by, and we would be taking orders and sending the tireless PA to pick up the food.

Figure 8.1 Base camp.

In stark contrast to the really cool, fun CHP officers from yesterday, our accompanying ranger was a very mellow, quiet dude. No coffee, bagels, or decadent pastry—just a bowl of fruit thank you. Rumors began to circulate that he actually lived in the hills of the park.

Our first shot was in the creek itself. Mark and his guys had to *fly* a 20 × 20-foot silk over the water because the sun was going to be high enough that we needed to diffuse it. This is where Mark shines. Give him a difficult logistical issue, sit back, and watch with amazement the solution he conjures up.

With the silk in place, the lighting was still too...hmmm...too bright and happy, and I wanted moody. I suggested some negative fill off one side of the silk frame. Soon, we had light ghosting down on the water, and we were ready to shoot.

While we were shooting the creek shot, our stylist was back at base camp rigging boxes and pieces of canvas to look like pioneer provisions for our last shot of the day. The clients stayed up at base camp, and the art director was on the set with me. When the clients are more interested in hanging out and having a good time instead of looking over your shoulder, that's a sign that you've won their trust.

Figure 8.2 On location at Malibu Creek State Park.

The first two shots went smoothly. We broke for lunch and then headed out to the backcountry with the Land Rover prop vehicle. Our ranger, who all day looked bored out his mind, suddenly came alive and gave us a fire safety talk focusing on cigarettes and the Land Rover tailpipe. Mark, our man of action, produced a small shovel and a fire extinguisher and placed them near the tail pipe of the truck, the potential flashpoint. Meanwhile the makeup artist was talking to the ranger with a desperate tone.

"So what you're saying is I can smoke, but I need to be careful, right?"

The ranger spoke with a cadence that was about half the speed of anyone on the set. "Extremely careful!" he said. Mark grabbed the extinguisher and shovel and placed it next to the makeup artist. Even the ranger laughed at that one.

As we were shooting, we could see a rustic cowgirl campground emerge in the field about 50 yards behind us. Emily, the stylist, and part of the crew were building the set for our last shot, which was pioneer campground. (The client liked the idea of calling it somewhere in the Outback of Australia; personally I think the pioneers of the old west were cooler.) We finished the truck shot with 30 minutes to spare until the sun was going to drop into the perfect position.

Mark and I walked to the campground location while the models got touched up and changed. We basically swapped positions with the second assistant and the PA. They went over to wrap the truck location while Mark and I forged ahead with the last shot. Moving people around like that is an important part of managing all the shots you need to get within the time period afforded by the natural light.

We needed a massive fill on our set so Mark flew the 20x20 silk just in time for the wind to kick up. You haven't lived until you've been at the end of a rope connected to 20 square feet of material held taut by a large tubular 100-pound frame. There is no priority over safety. All the gear, the vehicles, everything is insured, which is a polite way of saying everything inanimate is expendable. A good first assistant will go to the photographer and tell him or her that it's time to shut the set down for safety's sake. Today's gusts were only slightly challenging, and eventually they subsided.

On a multi-day shoot, or when you're shooting a campaign, there will always be one shot that will really make you feel good. It could be the location, the people, the light—anything. It will be the one that is your favorite. The pioneer campground shot was the one for me on this shoot. I think it was because the shot unfolded exactly as I imagined it. It was one of those shots that from a distance looked like a bunch of stuff in the middle of a prairie, but through the lens, the scene looked absolutely genuine. It was flawless.

As the sun dropped down behind the hill, the light just got better and better. Eventually, the light was too dim to have any motion in the shot. This is when you find out just how good your models are. "Look natural, like you're moving around the campground, just do it while holding still." They were brilliant. As they were holding still while acting like they were in some sort of natural motion, the flap of our rustic tent was blowing just enough to give the shot a real sense of…I dunno, something! The whole thing was stunning and everyone—most importantly the client (who was on the set for the last shot)—was excited.

Calling the Wrap

Sometimes it's the client, sometimes the art director, or maybe your producer. You'll get a vibe for whom you think should call the "wrap." It should never be you. I'm not sure where the tradition came from exactly, but I remember being the lowliest of low assistants on a shoot, and the photographer asked me to call the wrap. It was fun declaring the end to all the hard work and chaos. It's like being *the one* to end everyone's pain. Handing off the responsibility gives the person a thrill and casts you in a good light. I guess by rights the photographer is the person most apropos to call the wrap, but I think the tradition of handing it off is a blast.

Figure 8.3 The story of two fabulous women as they look good living life in the jeans. This job helped me afford a car that year.

Once whomever you choose yells those magic words, "that's a wrap," you'll see everyone crack a smile and find a bizarre second wind to pack everything up quickly. On bigger shoots, I always like to open a bottle of champagne, unless I'm shooting in Salt Lake City or for a rehab hospital.

Depending on everyone's schedule, it's nice to have a *wrap* dinner. Sometimes you want to invite the client, and sometimes you don't. The idea is to treat everyone who worked hard to make your vision happen.

On this shoot, the client and art director took off. Which left me with my guys. I love walking into a restaurant with two gorgeous models and a rough and tumble wind-burnt crew. No one knows what to make of us.

Running a Set

Having a good producer and a good crew goes a long way to having a well-run set. But, ultimately, the responsibility is with you. Especially during a crisis. In the shoot that I just recounted, we had a pretty easy time, with no major gaffs. I wish I could tell you that I learned how to run a set just by experience. I didn't. The best lesson I got for how to effectively manage a shoot came from Hollywood.

He sat behind a large 35mm movie camera with his eye glued to the eyepiece and a cloud of cigar smoke floating above his worn red baseball cap. There were dozens of other people on the set—extras, crew members, and cops, all milling about a respectful distance from the man with the cigar, who kept popping his head up from behind the camera to look at the cordoned-off street of downtown Los Angeles in front of him.

Director Tony Scott took the cigar out of his mouth as the first assistant director (First AD), James Skotchdopole approached him. They had a brief conversation, and then Skotchdopole walked toward the milling masses and started giving instructions. Everyone snapped to the job, and the setting went from casual chaos to a tightly choreographed routine.

The movie was *Enemy of the State* with Will Smith. I was there in a very minor capacity to shoot photos that were going to be used as props in the movie. As the day unfolded, I watched James Skotchdopole deftly manage the location, droves of people, me, and about a thousand other elements crucial to the shooting of the scene. It was evident that the set was moving with military precision under the leadership of Skotchdopole.

The military-style hierarchy translated into an effective well-run set. It had to. There were too many elements involved in the shot for it work any other way. As nice and approachable as Skotchdopole is, there was always a buffer of respect between him and the rest of the crew. He had found a balance of congeniality and command—attributes that my photography sets could benefit from.

Let Me Give That a Try

Inspired and emboldened by James Skotchdopole's style, I approached my next shoot with the intention of running my set the same way—just distant enough to be respected, but still personable.

I walked onto the set the day of the shoot with just a hint of attitude, anticipating that it would garner me the respect I was seeking. What I got was a pat on the ass from the makeup artist, a

first assistant who was on the edge of an emotional breakdown because his girlfriend was dumping him, and a recounting of the "shoot I just did in South Beach" from the model that was so long-winded it almost put us behind schedule. Try as I might to move the production forward more quickly, I could see I was having a very minimal effect with my pleadings. It became obvious that there was a lot more to Skotchdopole's leadership style than copping a little attitude.

Wanna Talk About It?

I confess, I've never been much of a dictator. Probably because I started working very young (19 years old) in an industry full of enormous personalities. When I started, I didn't possess the talent that granted the aristocratic right of the tantrum. So I did the opposite and tried be everyone's friend. This actually served me well as I was learning the ropes.

But as my career started to evolve into better, more complicated, higher-paying jobs, I was beginning to notice that my sets were becoming increasingly disorganized. Also, there was this bizarre, constant undercurrent of drama. The drama was effectively masked from the client, but I was starting to feel like Dr. Phil with a camera. Minor conflict resolutions, tirelessly understanding when crew members showed up late mumbling something "my baby, my sweetie, my honey." It was exhausting and felt unprofessional. If my career was going to continue on a successful path, I needed to change some things about how I ran my sets.

Let Me Tell You Why I've Asked You All Here Today

"Everyone on the set exists for the vision of the director." That's a quote from James Skotchdopole. And it's true. As a photographer, you have to come to terms with the fact that you've been hired for your visual abilities, not because you know what end of the camera to put a compact flash card in.

With that in mind, you need also to understand that everyone on your set is getting paid by you, to aide you in executing your vision. That's the only reason anyone showed up at the designated call time. It's a mindset and a responsibility that you need to get used to. Confidence in your own abilities and position in the hierarchy is paramount in garnering respect. Even if you find yourself shooting a gig that's way over your head, no one else needs to know that.

Hire Good Captains

James had great people working for him. They respected and supported him and his decisions. When you're working with a producer, they should have the same respect and loyalty for you. But, by the same token, you should create an environment where your producer can raise a question if he or she thinks you're making a mistake. All of the producers that I've worked with had the freedom to do this, but they did it quietly. Always taking me aside, out of the earshot of everyone else. Even their body language was subdued. There was nothing audible or visual that ever conveyed the fact that we were trying to sort out a problem, or that one of my decisions may not have been the smartest.

Hire Good Lieutenants

An advertising shoot is the culmination of a lot of different types of talent: production staff, makeup, wardrobe, and props. These are departments. Your first assistant handles production issues and should be allowed to hire his or her own people. If a second assistant perceives a problem or has a suggestion, it should be brought to your first assistant, and then, if they think it's worth your time, he or she will bring it to you. Trusting your people is an important part of setting up a chain of command that will shield you from really ridiculous questions like "have you seen the left-handed cable release?"

The same goes for the other departments on your set. Makeup, props, wardrobe—all these areas should have smart, experienced people in charge. They'll handle the little stuff, which allows you to focus on the overall vision of the shoot. Your demeanor should be one in which the people working for you have the latitude to make suggestions (you never know where the next great idea is going to come from), but ultimately the final decision is yours and should be enacted without question.

One Voice to Rule Them All

When I was on the set of the movie with James, the director was trying to get a complicated shot in the can. The shot involved the movement of traffic, extras walking on the street, and a myriad of other elements. Somehow Skotchdopole had to coordinate all this at the same time. He was doing brilliantly until a wardrobe stylist with nothing to do decided to lend a helping hand.

A group of extras that were set to walk into frame when they were cued could not hear their cue when James yelled it. To compensate for the problem, James had arranged for a PA with a walkie-talkie to stand near the group and flag them on when the PA heard the cue in his earpiece.

The "helpful" stylist was in position between James and the extras and decided that she would flag the group at the appropriate time. She totally screwed the shot. James very sternly and directly told her to back off and leave the job to him. He made his point quickly and effectively without resorting to a tantrum of swearing. He was focused on one thing, shooting the scene.

On your own set when directing talent, lighting, or any element of the shot, there should only be one voice and one voice only yelling directions. Personally, I like to tell my first assistant what I want from the production people. He usually knows the fastest way to get things accomplished because he knows his crew and their assets.

I'm the only one who directs the talent. Even if the client starts chiming in, I usually stop shooting and ask them not to yell direction from behind me. I ask the client what they want and then I translate that to the models. In one or two cases, I've threatened to stop shooting all together if the extraneous dialogue didn't subside. A cacophony of voices will only serve to disrupt and confuse things and should always be discouraged.

Sometimes You Have to Be a Jerk

Throughout your career, you're going to have to make tough decisions. Not all of those decisions are going to make everyone happy and that's okay. Get used to the idea that you're not on the set to be everyone's friend. The reason you were hired is to create images. Your absolute loyalty is to the job and your reputation. If there is a person or situation endangering that ideal, do not compromise because you're worried about hurting someone's feelings.

It was then she learned that she needs to ask better questions of each potential client. This is a mistake that she's not made twice as her career has moved forward.

Caren made a name for herself very quickly. In fact, in a recent presentation at their flagship store in San Francisco, Apple chose Caren's images to showcase their image-editing suite, Aperture. However, I'm not sure that was the wisest move for Apple. Mostly because Caren does such beautiful work, I was never quite sure if the audience was drooling over the software or the images it was presenting.

You can see more of Caren's work on carenalpert.com.

9

Post-Production and Delivery

Before digital, there was a class of printers that was so good that they could make photography careers. Indeed, Herb Ritts' work, as good as it was, really came alive in the printing done by his printer. With the advent of digital production, printers have become post-production artists. And like the printing before, post-production is an art unto itself. I've seen some work so flawless that it makes me think that the original photograph to a master post-production artist isn't unlike good light is to a photographer.

Because of the freedom afforded by digital, and the growing population of extraordinary digital artists, photographers have had to adapt. Merely knowing the technology well enough to capture an image is no longer the market standard. Photographers are required to employ their imaginations to what will best suit the image or message their clients are trying to convey.

This leaves you in a wonderful position of conceptual freedom. Photographers are approaching the realm of film directors in that their primary purpose has become the visual execution of an idea or storyboard. And the limits of that execution have been vastly diminished with post-production available as its own industry. As a photographer, you have to be extremely honest with yourself when it comes to the post-shoot details.

Are You a Post-Production Photographer or Not?

If you are a photographer who is particularly adroit with Photoshop and you are passionate about using it, you may be able to add a lot of money to your bottom line. The ability to be savvy with image-manipulation tools is a highly desirable and marketable talent. Unfortunately, most shooters who are starting out, and who have this talent, don't recognize it as separate from their abilities to shoot. This is a mistake. If, in your discussions with an agency or client, the subject of you doing the post-production work on the image is broached, please, please do not sell yourself short.

Bid the job with your post-production fees. Do not give away your post-production talent as a bonus for hiring you. Photographers who are in the running for post-production work should think of the shoot and usage fee as a separate negotiation from the post-production work. Also be prepared to bid the job with and without the post-production category. The agency might have a different, more affordable avenue for post-production. If you get too hung up on providing the service, you may shoot yourself in the foot. I know it's hard to have the idea in

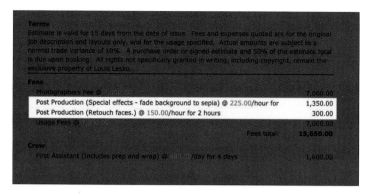

Figure 9.1 The bid from the earlier shoot with the price for the post-production. The client ended up doing it in-house.

your head of how you want the final image to look, but in advertising, you typically don't get to see the whole process through. If you do, you are in a fabulous position.

I am not what you would call a Photoshop genius. What I am good at is directing people who are truly talented. So occasionally I get hired to see the execution of the photo through the post-production phase. I hire a Photoshop god, and I sit behind the poor person, sipping cappuccino, articulating what I want. And I get paid for this time. It's nowhere near as much as I get paid for shooting, but it's not too shabby either.

I have to emphasize that these situations are pretty rare these days, mostly because agencies are more than capable of handling the post-production themselves. Paying for my expensive fanny to sit in a chair and bark instructions is usually not worth it to most clients.

That's where the middle ground comes in for the non-genius Photoshop person. If you know a talented Photoshop guru, and you've been commissioned to deliver a truly final, post-produced image, hire them and mark up their rate. There is absolutely nothing wrong with hiring a post-production artist for $150 an hour, and charging your client $200 or even $250 an hour. Remember, you are bidding a job, and if they accept the price of the bid, the only thing you have to focus on is delivering the final product for the money.

One question this practice does raise is what if you're asked to supply receipts for your job to the agency's accounting department? There is a difference between a hard-cost purchase like 15 cases of Evian water and what is considered an *in-house* labor charge. Even though you subcontract the work out, the post-production, for all intents and purposes, is coming from your shop. You know the right people to call, you handle the pick up and delivery of raw files, you supervise and approve the work, and so on. It may seem like hiring a makeup artists from whom you might have to submit their makeup artistry invoice, but it is not. This is a direct manipulation of the image, which justifiably comes under the purview of the photographer.

The last type of post-production to talk about is the non-post-production. If your client is going to select the images that they want from the thousands that you took, there is a reasonable expectation that the final selects have good exposure and good color. For example, if your usage license covers the licensing of five images, your client may select 50 that they want to *play* with before they make their final choice. Try to talk them into dropping the raw files into their layout. And when they finally do make their final selects, take their choices and clean up the color and exposure on them.

Digital cameras are not perfect in delivering final images. Part of the DSF or digital services fee that I covered earlier in the book should include manipulation of the images to make them look like they were shot well. We are proud of what we do, so it will be impossible not to deliver good *processed* finals. Just be careful to avoid the trap of giving more than you are getting paid for.

Finally, and this is happening more and more, you'll just be asked for all the original files. When I was first asked to do this, it freaked me out. How will they browse the images. Do they have the proper software to do that? Do they know what they're doing?

It turns out if your client asks for all the images, they know what they are doing. Keep in mind that they can only use the number of images that they licensed, so if they want to take all your shots and choose their own, let them do it. It's less work for you. The only anxiety-provoking thing about these situations is that the client will get to see how many times you missed the focus or beat your flash, stuff like that. Turns out they don't really care. But I can guarantee the first few times you hand over a hard drive of all your work, you'll lose a little sleep. I suggest celebratory cocktails to get you over the anxiety.

Delivery Methods

One of the wonderful things about a digital photography world is that technology constantly changes. A few years ago, the way to deliver images was to burn lots of CDs, which gave way to burning lots of DVDs, which I now rent from Netflix and use for watching moves.

Now there are three primary ways to transfer digital images around the globe—FTP, which stands for *file transfer protocol,* hard drives, and online storage services like Digital Railroad.

FTP

FTP is a standard protocol for transferring files over the Internet. There are a few very good *FTP clients* available for both MAC and PC. On the MAC, I can highly recommend a product called *Transmit* from Panic Software (panic.com). They have the easiest product to use, and it is exceedingly reliable. I've been using *Transmit* for years without a single problem. Panic, the company that make Transmit, has solid employees who consistently upgrade and maintain their products to keep up with the latest Mac operating system and processor. Also, their tech support is fast and incredibly patient.

Don't be intimidated by the FTP concept. The first time you get a file from someone's FTP server, which is really easy to do, you'll understand the concept immediately. The easiest way to think of it is opening folders remotely on another computer via the Internet. This analogy is visually replicated by Transmit, which is why I recommend it so highly.

Figure 9.2 Transmit FTP client in action.

As you get more familiar with the concept of FTP, you'll learn how you can store files on your own server for other people to access and download. And, as you'll see in a minute, there are simpler alternatives to FTP that you should be at least mildly familiar with it, because it is guaranteed that you'll have to use them more than a few times in your business.

Hard Drives

It was absolutely thrilling when the price of hard drives came down low enough that they became a viable option of job delivery for clients. Life became simpler, more reliable, and faster. The majority of my gigs end with delivery of all the images copied onto a portable hard drive that I give to the client at the end of the shoot. The company that we've come to rely on is

G-Technology (g-technology.com) and their G-Drive mini. This drive does not require a separate power source; it runs off of the power of your computer when the USB or FireWire cable is plugged in. This makes the drive brilliant for location shoots. The drives are fast and run very cool (a must to prevent failures). And they look sexy. Which believe it or not, impresses art directors every time we pack one of these drives in its own included leather case and send them home. G-Technology is an American company with a wide range of products designed specifically for the creative community.

When you are bidding your job, you should always budget for a portable hard drive. Even if you intend to deliver the images in another way, having an additional drive to back up your images each shoot day is extremely cheap insurance. If your client gives you grief about having the portable hard drive as a line item on your bid (which they shouldn't), include the price of the drive in your digital services fee.

Figure 9.3 One of the G-Drive Minis that we use for our jobs.

Online Storage Services

Digital Railroad is a photographer's best friend online. For a monthly fee, you can store, distribute, and sell your photography. The appropriate aspects for this book are the storage and distribution. After wrapping a shoot, you can effectively set up a viewing area for your clients to access from anywhere in the world. In a password-protected area of your Digital Railroad account, your clients can easily create a list of their selects using the lightbox tools. If you're working with a client who has offices in different parts of the globe, Digital Railroad is a fantastic collaborative solution.

Figure 9.4 Digital Railroad.

There are other ways to set up viewing solutions on your own server by using software-editing tools like Adobe Lightroom, Apple Aperture, and Camera Bits Photomechanic. They require a bit more knowledge about how your server works, and they lack the user-interactive functionality that Digital Railroad provides with its service. Because the goal is to get out of your own way and keep your client happy, Digital Railroad offers a versatile service to augment your business model.

It Absolutely Positively Has to Be There

Getting the job to your clients quickly in a form that they can access easily is an absolute necessity for a successful business. The Internet and the speed of digital photography have established expectations. Please do not compromise on storage and delivery methods. There is nothing to be gained by cutting corners in this arena—and there is your reputation to be lost.

Invoicing

The appropriate time to send the final invoice to your client is about 15 seconds after you've delivered what your deal indicated you would deliver. Granted, you may need a day to reconcile all the receipts and expenditures and all that paperwork. But whatever you do, do not wait to get it done. Your business operates on cash. The sooner you ask for your money, the sooner you'll get it.

Check Your Work

As much as I advocate a quick invoice submission, you absolutely must check your numbers first. Ad agencies are bureaucracies of paperwork. Your invoice has to get signed off by the art buyer, the account executive, the art director, the creative director, the florist, the coffee cart guy, and the second floor janitorial staff. Then it goes to accounting. If there are any mistakes to reconcile, your invoice will get held up until someone can get in touch with you and sort out the problem. So find out what the invoice-submission requirements are and follow them to the letter.

Include All the Required Information Only

Following the invoice-submission requirements to the letter is smart. Volunteering information is not. No one cares that you were able to save $12 on carbonated water by shopping at Wal-Mart. Additional information gets people thinking about the oddest things about your invoice, when in reality they should just be smiling and making out a check.

One piece of information that you should absolutely include is your tax ID number. It should be on your invoice, easy to find. Without that number, your clients will not pay you. The whole key here is you want to make it as easy as possible for your clients to give you money.

Late Fees and Collecting Your Money

Thirty days after the due date of your invoice, you can start charging 1.5 percent in penalty fees. If you ever collect on those fees, please email me and tell me how you did it. Corporate clients and other direct clients may go in for the late fees, but magazines and ad agencies won't. And even though it says right there in your estimate terms that you do charge late fees, it just never works out that way.

So your invoice is submitted, and you're patiently watching the mailbox for your check. How often should you call the accounting department of the agency or client about your bucks? Every single day. I'm kidding.

After two weeks, it doesn't hurt to send the art buyer an email making sure that he or she got the invoice and that it had everything he or she needed. Most art buyers I know are pretty cool about moving the paperwork out their office pretty quickly if there are no problems.

Two weeks after that, check in with the accounts payable folks. If they have the invoice in their system for processing, they'll tell you. If in two weeks you still haven't been paid, give the payables department another call. Don't ever lose sight of the expectation that you should get paid in a timely manner. It's easy to be intimidated by a big agency. You might have an irrational fear that if you bug that accounts department too much, *word will get around.* It's not true. As long as you're not phone stalking anyone, no one is going start any malicious rumors about you. Everyone in this business knows how hard it is to get paid on time if you're a photographer. No one is going to fault you for reasonably timed inquiries about your money.

Be Nice, It's Not Their Fault

Large ad agencies funnel millions of dollars through their companies. The accounting people have to deal with an enormous amount of bills *and* protocols. Some of those protocols are totally unnecessary and silly, but remember that, in most cases, the account people did not implement them.

Smaller agencies are usually juggling funds. In as much as you're waiting to get paid by them, they may be waiting to get paid from one or two of *their* clients. Again, it is out of the accountants' hands. They can only pay the bills with whatever money they have in the bank.

If your check is delayed beyond a reasonable amount of time, your enemy is the system and not the people picking up the phone. Please be nice to them. They are not malicious people looking to screw you over; they're just trying to get through their day. One tactic that has always worked well for me is asking if there is anything else I can do to help them. If your invoice was lost, they may need another copy, but were hoping to find your original before they had to admit that it was lost. If your invoice had a problem, it might be in the Friday morning problem file, but if they have you on the phone with an opportunity to get all the answers, they'll be happy to get your file, get the details, and have one less call to make Friday.

Also keep in mind that in a lot of agencies, big and small, the checks may only be issued on one day of the week. Another typical reason for a delay, especially at smaller agencies, is that the person approved to sign the checks is unavailable or didn't get to the pile of checks in their inbox.

I'm not offering any of these reasons to excuse not getting paid quickly, but, rather, I want to give you an idea what's really going on with your check so you have an informed perspective when you're making your inquiries.

When the Money's Not There

It is my sincere hope that you never get put in an uncomfortable financial position because a check has not arrived. But you probably will, at least once. This will put you in a funny, desperate mindset. Please, please look at your other options before setting out on an almost justifiable tirade to get your money.

There is absolutely nothing wrong with shooting small jobs, headshots, or weddings as you're building your advertising career. Just because you wrapped a nice ad campaign doesn't mean you should hold your nose up at easy money while you wait for your next ad gig. Eventually, what happens is that you find yourself with less and less time for the small stuff because you're too busy with the big stuff. But until that happens, don't hang yourself by becoming too dependent on one check.

Spotlight Shooter: Mark Leibowitz

Mark Leibowitz graduated from Stanford with a degree in Economics and Spanish. Not your normal background for starting a brilliant career in photography. But that's where Mark is headed. He's spent time travelling the beaches of Brazil, South Africa, Hawaii, and Las Vegas, so when I say his future's so bright he's got to wear shades, I mean it literally, too. Mark is a man with a plan, and it's impressive.

I first met Mark when I was teaching photography classes through UCLA extension at my studio in downtown Los Angeles. He struck me at first as a young surfer-dude, fun and likeable, but devoted and passionate, as well. Not at all like someone who was involved in the dry world of financial consulting, and now leaving for the lure of the creative world. He started shooting for the yearbook at Stanford, and then studied at UCLA, the Bobbi Lane Master Class, and then became the studio manager at the Santa Fe Workshops.

Mark returned to LA with two specific goals—bring up his high-end technical skills and learn how his business background could translate to photography. He set his sights on assisting to improve his technique and went for the best—Art Streiber, Matthew Rolston, and Steve Meisel. He tried a variety of photography styles, including portraiture and celebrity, and developed a keen interest in reportage. However, his biggest challenge was learning about the creative and conceptual, where he felt he was lacking compared to his fellow assistants who had attended photo schools. No stranger to hard work and research, he looked at and studied other photographers and sought out people in creative fields with whom he could develop a creative exchange. He met Darren Ransdell, a set designer and prop stylist who worked with high-end photographers like Rolston who helped him work on concepts. Mark also contacted Ian Summers, renowned creative and business consultant who helped him focus, no pun intended, and develop his personal style. Mark also credits Art Streiber for spending many hours critiquing Mark's work guiding him to become a better photographer.

Mark's lifestyle work is very real, honest, and intimate. His interests in photography came from wanting to capture the things and events he saw in the world and share them with his friends and family. It was the need to express and communicate his life experience and feelings that brought him to making photographs. Living in Brazil for a year as a young man brings lots of fun, parties, and everything was bright and peachy keen. Shoot what you know, they say, so he did. Look at his work; young couples on the beach holding hands, photographing themselves with cell phones, hanging in cafes, dancing, high energy and quiet moments of reflection, enjoying life, loving each other. It's so frank and innocent—no attitudes or pretensions. He's totally involved in the photo, yet the camera is invisible, sneaking a confidential view into private lives.

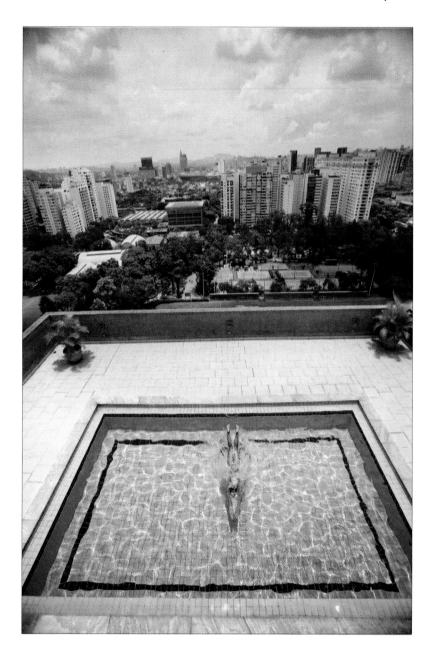

Speaking of pretensions, Mark photographs backstage at Fashion Week shows in New York, Paris, and Milan for *Glamour* magazine. His candids are insightful, sometimes amusing and not all about the glamour. He shows off the mundane, the frenzy of preparation, the humor, and the absurd sometimes, of the world's top fashion models. They are fully developed stories in themselves, not paparazzi flash-on-camera shots.

Mark is also devoted to giving back to his community and world by doing pro-bono work. One of the projects he photographed was YouthAids, accompanying Global Ambassador Ashley Judd to the townships of South Africa. This means much more to him than the glamour and excitement of the fashion shows.

Mark recently spent a month in South Africa photographing a coffee table book for a luxury travel company. He's worked for Bloomingdale's Magazine, *Cosmopolitan, InStyle, Health, Teen Vogue, Glamour, Wired,* and *Men's Health.* His photographs were recently featured on the cover and in 40 pages of Max Germany's *Red Hot Rio* Issue. Mark's photographs have appeared in advertisements, catalogs, and brochures for dozens of companies including American Express, Bank of America, Proctor & Gamble Beauty (Clairol, Crest, and Oil of Olay), Verizon, Cadbury Adams, Colgate, Amtrak, Lava Life, the Canadian Tourism Commission, Chase Bank, and IBM. Not bad for a young man with just four years working and no rep.

The secret of Mark's success, however, is his valuable background in economics. Most photographers start from the creative side and struggle to get the business end together. Mark was completely out of debt after less than three years shooting, and has plans to aggressively market his work to advertising agencies and design firms. Mark works closely with professional photography consultant Debra Weiss, who helps brand, develop marketing plans, create a cohesive body of work, and move him in a direction that he wants. They are a powerhouse together and also have a lot of fun. Mark's growth every year, both in business and creativity, is phenomenal.

Stock and syndication play a huge part in Mark's overall business plan. He consistently shoots between 10–14 stock productions a year and currently has over 5,000 images at work between Masterfile and Icon International. Mark only works with rights-managed stock, believing that it also helps keep a high profile with the ad agencies. He aggressively responds to editors requests, quickly turning them around, so income continually grows, now accounting for about 1/3 of his income. It certainly helps pay the bills during the slow months of ad and editorial work. His plan is simple—the more you shoot, the more you make.

Mark's marketing strategy is consistency, new work, new promos, email promos, updating portfolios and getting them out, and using repetition to increase his name recognition. He's still early in the game, so he's not looking to reinvent himself. The challenge is to keep his Web site and book up to date to reflect where he is now as a shooter, and to make those changes quickly and easily. He knows it takes planning and years to make your career what you want. You know the real estate saying, "Location, location, location?" In Mark's photography world it's "Marketing, marketing, marketing."

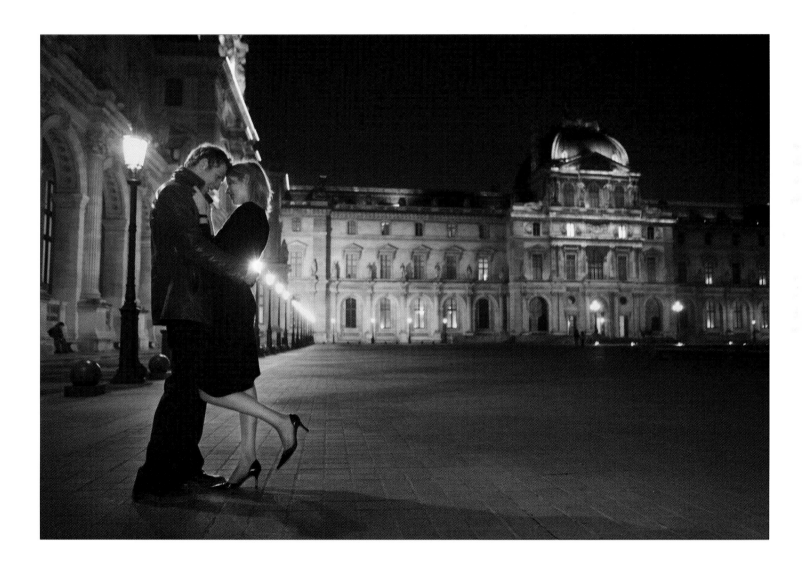

Mark uses research online for inspiration or for specific or general ideas. He says, "You can't underestimate the importance of pre-production." You never know what will give you a great idea. His personal life is intertwined with his professional life, where travelling provides personal experience that results in new work and directions, which help him share his life experiences and stories. He's particular about the kind of life he wants to live, and he is using photography as a tool to make that happen. One of his teachers taught him early on that photography isn't a job; it's a way of life. Mark's life is one of integrity, honesty, passion, and fun.

His advice to photographers:

> Shooting advertising photography doesn't mean that you have to sell your soul. You can market yourself and choose to work for companies that you believe in. And you can turn down work from companies whose policies you don't agree with.

You can find Mark's work on markleibowitz.com.

10
Cash Flow and Good Business Practices

I don't subscribe to the notion that artists should be starving. Unless, of course, that's your look. But beyond that, the market concepts that shape the most successful businesses in the world can also shape the business that we build as photographers. Understanding basic concepts like cash flow can go a very long way to adding some bucks to your bank account.

The idea behind *cash flow* is essentially managing your cash effectively so you can keep more of it to operate and grow your business. The key is keeping a mindset that you're always trying to build more wealth than you had yesterday. If you're about to skip this chapter because you have debt instead of wealth, wait. A critical part of business growth is understanding debt. This includes having the knowledge of the nasty little tricks that credit card companies employ to separate you from your cash, as well as utilizing debt to make you more profitable.

Waste Not, Want Not

This year the credit card industry will make $16 billion in penalty fees. If you paid a $29 fee this year because of a late payment, you added to that profit pool. Additionally, the credit card companies have taken to increasing your interest rate if you pay any of your bills late. The practice is called "universal default penalties." Simply put, if Bank A reports my late payment of my Visa credit card to the credit bureau, Bank B will get wind of it and probably hike the interest rate of my Master Card. The practice is frustrating, but legal. A lesson to learn early on is that there is no way to outwit the credit card companies. However, if you are smart, you can take advantage of them to aide you in the efficient running of your business.

Most local businesses that you set up an account with won't ding you with late fees. But the secret is to pay on time anyway. This puts you in a fantastic position to ask for the occasional discount when you need it. Also, you're more likely to get a quick positive

response when you ask to increase your credit line (when you land a really big job). Although it might seem daunting to manage those bills, it's not.

Make a list of all of your monthly bills. This should include labs, photo rental houses, business and car insurance—everything. Next, determine which of your payees will automatically charge your credit card each month for money owed. Most major vendors, utilities, labs and rental houses are happy to do this. Give these vendors a credit card number that's connected to an airline rewards program so you can earn travel points as you're paying your monthly expenses. You've just consolidated many payments into one. You have also made a significant step toward savvy cash flow management. A rental house will usually charge your credit card about 30 days after the rental. Then, depending on the grace period of your credit card, you'll have another 20 to 30 days to pay off the charge without accruing interest. That's a total of 50 to 60 days of free money, as well as the added benefits of building a solid reputation by keeping your local vendors happy, increasing your credit rating, and accumulating airline miles toward the vacation that I'm sure you're going to need after finishing this chapter.

The key to all of this is *to pay off the credit card;* as soon as you start paying interest, you negate the benefits I listed previously.

Utilize the online payment Web sites offered by your bank for any remaining bills. By the time you're done, you should be paying all your recurring bills automatically. Some bill payment sites like Paytrust (www.paytrust.com; see Figure 10.1) will actually give you a mailing address for all your vendors. Based on your instructions, the service will pay all or part of each bill that comes in. The important thing is you're paying on time and not paying late fees, ever.

Figure 10.1 Paytrust can help you pay on time, every time.

Another hidden interest rate that many people don't consider is car and business insurance. Because I live in Los Angeles and because I've had a few roadside discussions with the highway constabulary, my insurance is high enough that paying it off monthly seemed like an attractive option. That was until I read the fine print. If I pursue monthly payments, I get charged 19 percent interest per year, an amount that makes it worthwhile to pay the annual bill all at once or within two or three payments. The same goes for my business insurance—it cost me bucks to pay monthly.

I'll Pay You Back on the Second Tuesday of Next Week

Understanding your debt is absolutely crucial to expanding your profitability. There are some of you reading this who will be carrying school loans; others will have accumulated debt on credit cards from big purchases of camera or computer gear. Maybe you are making your monthly payments and randomly throwing more money than the minimum required at one debt source or another. There's a smarter way to make your payments.

Make a list of all the sources of debt that you have. Now you need to make a determination as to which one is costing you the most money. Most school loans have a decent single-digit fixed interest rate. As much as you might want to separate yourself from your school experience, just keep paying the required minimum amount of this loan on time. The interest rate is great. It looks good on your credit report, and your cash will better serve you in other ways, like for paying off your credit cards.

Credit card companies have created an environment of legalized stealing. Beyond the "universal default penalties" and brutal late fees described previously, credit card companies have started to compute interest based on the average daily balance over the last two billing periods. Unless you pay off your balance for two months in a row, the two-cycle method will include the prior cycle's average balance in calculating your finance costs even though you paid off that cycle's balance in full. Simply put—if you charge $10,000 in May and pay it off on the due date, but still carry a balance, and only charge $10 in June, then your finance charges for the end of cycle in June will still be, in part, based on the $10,000 balance you had back in May.

Use one credit card for your living expenses, and *pay it off fully* every month. Then, if you need to finance equipment consider, the following options:

+ Almost all camera companies have some sort of lease-to-own program. Don't listen to the pitch from the camera salesperson—he or she makes money on selling you stuff. Get the information and review the terms.

+ If that option isn't available, look at your credit card situation. If you have access to a credit card with a low interest rate and that card has a zero balance, you may be able to use that. But beware. You might be okay buying a few thousand dollars worth of gear at 2.9 percent because of a special limited time deal, but don't put anything more on that credit card. As soon as you charge more on the card, the additional charges will be charged at a higher rate. Any payments you make go to the charges with the lowest interest rate first. For example, say I charge $3,000 at 2.9 percent and then make an additional $1,000 in purchases that is assessed at 12 percent. Any payments I make are applied to the amount at 2.9 percent, which allows the credit card companies to charge me the higher interest rate for as long as possible.

If you are in significant credit card debt, you need a plan to get out. A simple method of doing this is to start paying as much as you can toward the credit card with the highest interest rate. Try to quadruple the minimum payment. Live without cable, eat quesadillas for a few months, and just focus on diminishing that balance. With the other credit cards, pay the minimum due and then move onto the next highest interest rate. Your goal is to stop giving away money.

Of course, as soon as you get rid of your cable TV and convince your significant other that tuna canned in Chile is every bit as gourmet as eating Chilean sea bass at a fancy restaurant, you'll book a major advertising job. You have no money to produce the gig because you were silly enough to take the advice of this article, and your parents are climbing Everest without cell phones. Oh crap.

Creative Financing or Financing for Creatives

A photographer I knew would occasionally hock his camera gear at a pawnshop to pay his rent. When he picked up a model portfolio shoot, he would ask for the fees upfront and in cash. Then as the makeup was being applied, he'd run down to the pawnshop and collect his gear with the cash.

My first major production I ran up $3,000 on credit cards and borrowed $5,000 in cash from my dad. If you ever meet him, he'll be sure to tell you the story of how his benevolence launched my career (the story he tells every girl I've ever dated). It was my first experience with creative financing. Although not desperate enough to start hocking camera gear, I did a lot of scrambling to make it seem like I had my act together and was ready for the big leagues.

Today, because cool people like Everard Williams, the co-chair of the photography department at the Art Center in Pasadena, are willing to share their secrets of success with me, I can give you scoop on one of the best industry services available to photographers.

Fred Kaufman runs Photo Associates, INC, a financing partner for creative professionals. Say you get booked by a major advertising agency to shoot a fabulous campaign but you're a little light on cash flow. Once the job awards, you can go to Photo Associates with your PO number and make arrangements to borrow some bucks to produce the job. After the job is finished shooting, you fill out paper work to "assign the account" to Photo Associates. This gives them the legal right to collect on the invoice you issue to the ad agency. Because Photo Associates has maintained a fantastic reputation for 25 years and because they know a majority of the account people at all the agencies, they do a great job of getting you paid quickly. Once they collect the funds from the agency, they issue you a check in 24 hours minus their fees.

As of this writing, they were charging 10 percent of the borrowed amount over 30 days and 6 percent if they get paid within 30 days of you borrowing the money. Provided that your credit record is in good shape and you're dealing with a known advertising client or magazine, Photo Associates offers an incredibly savvy way to do business. They can be reached at www.photoas.biz. See Figure 10.2.

Figure 10.2 Photo Associates offers an incredibly savvy way to do business.

Everything Is Negotiable, Vendors

Setting up accounts at labs and rental houses is standard practice and incredibly important for managing your cash flow. If you shoot a job on May 1 that requires $1.500 in rental equipment, the rental house isn't going to bill you for that until June 1. If you've given them a credit card, you won't be responsible for paying that amount until anywhere between June 20 and June 30, depending on the "grace period" extended to you by your credit

card company. (If you use an American Express "charge" card, this process is a lot easier to keep track of because they don't allow you to carry a balance from month to month.) This leaves you a little breathing room as you wait for slow-paying clients to come across with the money they owe you after the shoot is done.

If you hire assistants, makeup artists, and other talent-oriented individuals, pay them right away out of your advance. Having a reputation for paying within seven days of the shoot wrap will put you in a fantastic position to negotiate rates for future shoots, which will add to the profit margin of later jobs. The same goes for your lab and rental house vendors. Develop a solid reputation for having your bills paid on time, and you'll be able to negotiate 10–20 percent discounts on a rental package every once in a while. This is an important benefit when you're trying to squeeze a little profit out of a fun, yet low-budget job.

Everything Is Negotiable, Clients

Some clients will write you a check upon delivery of the images. Some will try to hold off your final payment for 60 days or more. The ones who are holding you off are manipulating their cash flow in much the same way you are. For those clients, it may be beneficial to give them an incentive to pay you early. A one to three percent discount off the balance due for payment within seven days of delivery is a standard practice. Your decision should be based on your cash flow. If you have a good amount of cash in the bank and the interest you're paying on your debt is small, it might be worth it to hold out and wait. But if you're trying to get rid of a credit card balance with a nasty interest rate, you'll benefit more financially by giving up a few points on your final bill.

Know Where You Stand

One thing that can affect your business more than anything else is your credit record. It is updated once a month by all the creditors with whom you have an account. I cannot stress enough the importance of paying your bills, even if it's only the bare minimum, on time. If your credit record is in good shape, you always have options for expansion. You can go to creditexpert.com (see Figure 10.3) to get your credit report and see where you stand.

Figure 10.3 Use CreditExpert to check on your credit.

If you've read this far, you're smart enough to grasp the concepts outlined previously. Indeed, I have full confidence that you can immediately take them to the next level. The days of assuming creative types aren't financially savvy are dead and gone. Your work, brilliant as it is, is a negotiable commodity subject to the same business ideals as any other product. Once you open your mind to incorporating some solid business planning into your bohemian existence, and start to see even the smallest financial results, you'll become empowered. All you need to do is think a little bit more with the left side of your brain.

Six Tips for Optimizing Cash Flow

Here are my best six tips for getting cash flow in:

- Send a final invoice within a day of completing the shoot.
- Consider accepting credit cards from your clients.
- Offer a discount for payment within seven days of delivery.
- Track your past due receivables and communicate with the client when they go past due.
- Track all your expenses and re-evaluate what should be cut every six months.
- Use good software to manage your accounts.

Managing Your Money

For a seemingly bohemian profession, we photographers have to do a lot of money managing. Thankfully, we live in an age where software can do all the work for us.

Our core existence comes from generating estimates, creating invoices, and managing shoot budgets. Blinkbid (www.blinkbid.com), Fotoquote (www.fotoquote.com), and P/IE Software (www.piesoftware.com) are three software applications that are designed specifically for photographers. Each of these applications has a demo version available so you can try them out and decide for yourself which one best fits your needs.

Accurately managing your overall financial picture is absolutely crucial to running a successful business. There are no shortcuts. For the end-of-the-year tax filing, I highly recommend hiring a tax accountant. Seek out one who specializes in helping creative types so you can maximize your deductions. But keep in mind that a tax accountant is only as good as the information he or she is given. To manage the day-to-day record-keeping, I can strongly recommend two products:

+ MYOB (www.myob-us.com) is accounting software for small businesses. A global company, MYOB is a cross-platform application that is better known on the Mac in the United States. MYOB has an incredibly easy-to-use interface and extensive reporting. It is very highly regarded and well rounded. MYOB also offers a free limited version that your accountant can download and use to access your data file if they have not been using MYOB. See Figure 10.4.

+ The other accounting software available is Quickbooks from Intuit (www.quickbooks.com). Intuit also makes Quicken, personal accounting software, but I would recommend that you get into Quickbooks if you go with Intuit. It is designed for small businesses. Like MYOB, Quickbooks also has a remarkably robust feature set and is also highly regarded in the accounting world. Their files are cross-platform as well.

Both companies have Web sites with an amazing amount of resources. And both companies have been around a very long time with enormous user bases, so committing to one or the other is a safe move.

Figure 10.4 Mind Your Own Business!

I'll confess. During the first 10 years of my career, I was delightfully ignorant of my overall financial picture. That was until I got a call from my bank politely inquiring how I was going to cover an $800 overdraft. That phone call caused me to change my pants and my attitude. Maintaining my financial records requires about 45 minutes a week. It's easy to download bank and credit card statements straight into the products I mention in this section. Also Blinkbid is currently developing a feature that will allow you import your photography invoices into MYOB and Quickbooks.

Pursuing sound money practices might not be as glamorous as shooting. But making a good living as a photographer is; give yourself every advantage you can.

Good Business Practices

There are three primary reasons that photographers clash with their vendors during a shoot:

+ When you're in a remote location and rental gear is missing from your package, or the gear doesn't work.

+ Final prints or digital post-production look like garbage.

+ A post-production house misses a deadline, causing you to miss your deadline to your client.

Crisis is a very large part of the business. You need to accept that when you sign on. But there are ways that you can reduce the number of failures in your network of subcontractors.

Checks and Balances

You or your first assistant should always double-check that your rental gear works properly before leaving the rental house. Always! If you show up on location and something you needed is not in your package, it is your own damn fault. Rental houses, especially during busy shooting seasons, are taking care of a lot of different orders. It is not out of the realm of possibility that they might have missed something. These guys and gals are usually in a mode of multi-tasking while trying to hear every word that you or your assistant is saying from a cell phone. Sometimes it doesn't all make it to the order form.

It is not that the rental folks dislike you or are bad at their jobs. (Actually, people don't typically get hired at rental houses unless they know their gear.) There was a glitch somewhere, and the onus to make sure that everything makes it to location is on the people picking up the gear (that's you). Believe me, if you're at the rental house going through your stuff and something is missing, just ask; they'll get it for you. If the gear you need is rented out, they'll find a solution. Whatever you do, don't get to location and start screaming at the rental house because you don't have a camera.

Equipment malfunctions all the time. If you're going to a remote location, you should check your gear before you get out of the replacement radius of the rental house. Also, you should have camera backups. I really don't care if you don't have the rental budget for a backup camera, re-shoots are your responsibility if the equipment explodes.

Test Your People

One thing I learned (by completely blowing it) that when you're starting up with a new lab, bring your own work to them a couple of times before depending on them for a job. This is immensely important and seems like common sense in hindsight. Whatever you've been wanting to get done for yourself—portfolio pieces, favors for friends, apartment art—use these pieces to test a new lab. It's a lot easier to explain to your parents that the lab screwed up the print they wanted for the living room, than it is to your client who is paying you and typically on a deadline.

Be Cool, There's a Solution

When you're having post-production work done, or anything that requires the services of an outside source, you're at the mercy of their ability to deliver on time. Not surprisingly, the occasional deadline will get blown. Getting pissed off will just delay the final outcome. Get focused and get a dialogue to solve the problem.

The vendor might offer whatever they can to remedy the situation: accelerated service or messengered delivery. Who knows what they have available to offer or what ideas they'll conjure up.

From your end, you should thinking about what you can do to mitigate the situation to your client. Has the deadline moved? What is the ultimate destination for the work, and can you have it sent there? Get creative.

You can bridge the chasm of disaster more quickly by coming at it from both sides. Everyone respects a professional who is more concerned with getting the job done than berating some poor soul who is working behind the counter somewhere.

This is not to say that I've been a perfect little angel. But after a few times of acting like a jerk early in my career, I noticed a far more successful disaster-recovery rate by keeping my disappointment to myself. There are solutions to everything. On more than one occasion, we've hired someone to pick up a disk and get on a plane. This is an extreme case to be sure, but I just want to illustrate that when your reputation is in jeopardy, or there is an opportunity to enhance your reputation, there are no limits.

Take Care of Your People

If you're sitting on a vast amount of frequent flier miles, you might consider using a few to send your producer somewhere. Bring the rental house a six-pack now and then. Bring your lab people something to eat.

In this business, there is no success without the talent of a lot of external people. Think of small ways that you can show your appreciation. It usually doesn't cost a lot or require a lot of effort, but it goes a long way to encouraging people to give your jobs just a bit more love.

Pay Quickly

I mentioned this in the cash flow section, but it is an important point. Figure out how to manage to pay the people who work for you quickly. It will do wonders for your business. Many of the people who work for you are much more dependent on the check they're expecting from you than you realize. Nothing makes people happier than getting paid fast. If you have a reputation for paying quickly, you're in a position to get favors and deals when you need them most.

Many of you reading this will undoubtedly have some work experience in an ancillary job. When you graduate beyond that, try to keep in mind the things that you hated that people did, and the things that you loved. Trust me, if it made your day, it will make someone else's. There's nothing better for morale than doing something unexpected for the people who make you look good.

Be Bold, Then Follow Through

There are times in your life when free from cost also means free from inhibition. In the early 90s, Bobbi Lane won an ad placement for her own work in one of the source books. Because the ad was free, she wasn't shouldered with the crystal ball anxiety that goes along with spending thousands of dollars to place the *just right photos* that will capture the attention of potentially new clients. With a *nothing to lose* mindset, Bobbi chose some naturally lit portraits from a trip she took to India.

Meanwhile at the Saatchi & Saatchi agency, a young art director was throwing her hands up in the air. She was trying to find a photographer for an ad depicting baseball great Johnny Bench and his family on a red carpet in front of a United Airlines airplane at the Palm Springs airport. She was tired of all the usual shooters that shot that sort of ad. On a whim, she contacted Bobbi to bid on the job based solely on Bobbi's photos from India. The art director figured that she would call someone based on the fact that she liked the shooter's work.

Out of all the bids submitted, Bobbi's came in the highest. A week after submitting the bid, Bobbi called to follow up with the art director. It was a simple voicemail message asking if the bid made it to the art director's desk okay. Bobbi was the only one who called to follow up. She was awarded the job.

There are times when your instincts are going to tell you one thing, and all the practical indicators are going to tell you another. Go with your instinct. This is a business where individuality is lauded. If someone recognizes your individuality with a phone call, make sure to follow through. Being bold is only half the journey.

Setting Up Shop—Basic Advice for Starting Your Business

There are a few foundational business practices that you should implement as you embark upon being a professional freelance photographer. These are not opinions, they are absolutes that will save you money, time, and IRS entanglements. If you think that because you're just starting out, you're not ready for these types of things yet, you're dead wrong. I'm not asking you to incorporate yet, I'm just asking you to expend a little organizational effort:

+ *Create a separate bank account for your business.* I don't care if you are like me when I started as a shooter and the damn account only has $28 in it. You must have a separate accounting of the money you make as a photographer. Deposit money into that account that comes only from your freelance gigs as a photographer.

+ *Use a separate credit card for your business.* Do not use it for anything else except for photography expenses. Keep in mind that if you travel anywhere with any camera, you're working. So that and situations like that constitute a business expense. Any sort of tests for your portfolio, things like that, all business expenses. Your cell phone is a business expense.

◆ *At some point you'll need to incorporate.* My opinion is to wait until your gross income (not your take-home money, but all the money you receive as a photographer) makes it past the $50,000 mark. (Incorporating is expensive, and the tax benefits for incorporating don't benefit you until your making upwards of $50,000. This is not an absolute and pertains to California. If your business is in a place where you're thinking about incorporation, ask an accountant about the benefits and possible drawbacks.)

◆ *Get business insurance.* Do not monkey around with this. You can't do anything in this business without insurance. No rentals, no permits, nothing. Join the Advertising Photographers of America (APA); they offer their members a great deal on photographers insurance.

◆ *Get health insurance.* You are the only asset to your income. Protect it.

◆ *Get a Web presence and an email account.* (I know, everyone reading this already has this covered, but there, I said it anyway.)

◆ *Get it into your head right now that your photography is a business.* You are a creative entrepreneur and therefore subject to market fluctuations and global economy hiccups. Get your head out of the local cafe and into the worldwide business scene. Keeping in touch with the business world can and will make a difference. If you think, at least partially, like an entrepreneur, your creative mind will reveal new ways to make a buck from your work.

◆ *Keep up with your own industry.* Magazines like *Digital Photo Pro* (whom I write for often) and *Photo District News* are dedicated to the latest goings on in our business.

◆ *One day a week, do your accounting.* Use software to help you. If you dedicate one day a week to entering all your expenses and deposits, I guarantee you it will take you 15 minutes a week.

◆ *Pay your taxes.* The IRS is on a freelance witch-hunt lately. So don't muck about. Even though it can cost a few hundred bucks a year, have a professional do your taxes. Tax laws are complicated for people like us. Get them done by someone who knows. If your business takes a loss your first few years out there, it's not anything to worry about. It's just business.

These are just some very basic tips. There are a surprising number of resources on the Internet, such as bankrate.com, which offer credit card information, loan calculators, and ratings of the major banks. If you have questions, do a Google search and go get the answers. As much as it might be hard to believe, most photography businesses that fail do so because the photographer didn't think of them as businesses in the first place.

Spotlight Shooter: Paul Elledge

Paul Elledge has an edge. His exceptional and emotive portraits portray the range of humanity in all its glory. Nobody's normal in his pictures, so there are no simple or forced smiles. The range of emotions is expansive—happy, sad, angry, enthusiastic, bored, high energy, weird, confused, silly, introspective, mysterious, peaceful, intense, passionate, self-assured, and, well, you get the picture. Paul's talent is the ability to reach into a subject, bring out the depth of the person's soul, and create a stunning visual display. His images are arresting and intriguing. I want to know everyone he's ever photographed, because they seem like they are fascinating people.

Paul's dad was a photojournalist, and Paul went with him on an assignment to photograph Richard Nixon. Being a typical in-and-out of trouble kid, he thought it was great that his Dad could go anywhere he wanted and not get yelled at. This is when Paul started considering photography as his career. Growing up with a passion for rock and roll, Paul loved the theatrical productions of the concerts and that helped develop his dramatic and colorful style. Paul attended Southern Illinois University at Carbondale, a well-respected photo school, and then began assisting Richard Izui in Chicago. Izui was a high-tech product photographer. The skills and special effects that Paul learned served him tremendously later. Paul's real education came from the couple of years assisting the remarkable portrait photographer Marc Hauser. "Marc is my guardian angel. I was just a dumb kid from a small town, and he taught me business stuff, how to communicate and stand up for yourself, and how to negotiate." Marc would bring in jobs, and Paul would shoot what Marc didn't want to. The technical skills he acquired with Izui made him a valuable asset on complicated assignments. Eventually, Paul opened his own small studio and found his own clients while Marc would still give him referrals or pass along smaller jobs.

In the past 20 years, Paul's hard work has resulted in working with top creatives and ad agencies to fulfill their needs with his vision. He's won national and international awards. The agency list is like a "who's who" of the best creative shops in the country: DDB Chicago; Fallon; Foote Cone and Belding; Goodby, Silverstein and Partners; Pentagram and VSA Partners, to name a few. Elledge has also worked with celebrities ranging from AC/DC to Willie Nelson, and top executives as well as many other people ranging from the fabulously wealthy to those on death row. Much of the ad work is collaborative, but the art directors hire Paul for his unique and individual input and how he visually interprets their ideas. "The best work comes from people wanting your opinion, because they consider who you are and your ideas." Occasionally, the ADs call looking for creative input and want to know what personal projects he's working on, or they see something in his portfolio that is the tone or mood of what they want. "You can't get good work without showing good work. Be careful what you put in. It's like picking friends when you're a kid, the choices will come back to you, either good or bad," Paul says.

When you first look at Paul's images, there seems to be a great dichotomy. On one hand, we have the creative and edgy portraits of business leaders. He's done three cookbooks with James Beard award winner Charlie Trotter. From photograms to food to environmental portraits, the photographs are as sumptuous as the recipes. Then we have the raucous, moody, tough metal musicians, such as Ministry and Anthrax, for whom he's also created rock videos. "I don't photograph reality; I shoot more of the perception of what's it about," Paul says. "Most of the heavy metal rockers are really sweet people." And finally the sepia toned, romantic portraits of Italians from Paul's book, *Luna Bella Luna*, almost reminiscent of Julia Margaret Cameron. The truth is they are all great portraits crafted from an individual style suited to each subject.

Luna Bella Luna is about Paul's warm, emotional connection with Italy and its people. He admits that he puts these people on a pedestal and is enthralled with how they honor family and hard work, and the love that's put into preparing food, and the honor and respect for family. Their passion for living and living well and the depth of their integrity make Italy Paul's dream land. The romantic and dreamy quality of the photos comes from the use of a Deodorff with a pre-WWII lens that blows out the highlights when opened up more than f8. Working with a 4x5 also slows things down quite a bit, so the process of creating the image is more considered. Paul speaks a smidgen of Italian, enough to be able to communicate, learn about his subject's lives, and build relationships. Paul found that using the big camera helps people be more cooperative because he's obviously serious and is creating images that are more significant than a tourist's. This is an ongoing personal project that stems from his art background, and Paul feels he has more work to do there.

Although Paul is now 80 percent digital, he still shoots film for certain effects that he can't achieve digitally. All his 4x5 work is film, and quite a bit of his black-and-white work is film, but he does say that Lightroom works well for him because the way it works is compatible to how he works in the darkroom. He has certain actions that he applies to create color palettes, but he doesn't do any complicated layers or advanced Photoshop techniques. He treats digital the same way as film, creating the look with the lighting, design, color, and composition as he shoots.

Paul's inspiration comes from living his life with attention. "I'm relaxed and comfortable with myself, just living life and aware all the time what's going on around me in relaxed way, like the quality of light, or the gesture of a person in an airport. Boom! That's a photograph. Things just come to my head, so I always carry a notebook with me. I've been very lucky to meet most of my photographic goals. I just want to keep making portraits, connecting with people from all walks of life, and keep growing and evolving. I just try to be myself."

Paul's advice to photographers:

> Stand up for yourself. It's just as important to say no, as to say yes. Turn down the work that's not you; otherwise, it's the direction you will head. You will attract that into your life, and lose your way. What you show is what you get, so be picky about what you put in your portfolio.

You can find Paul's work on paulelledge.com.

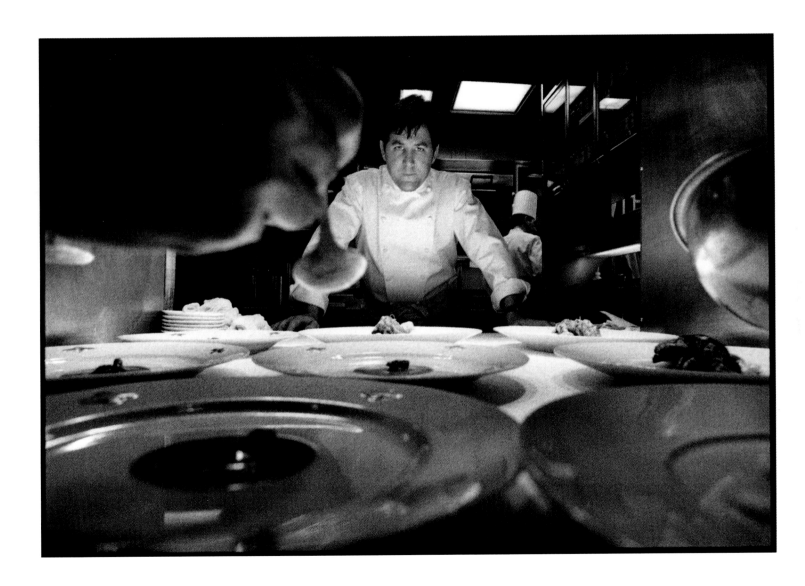

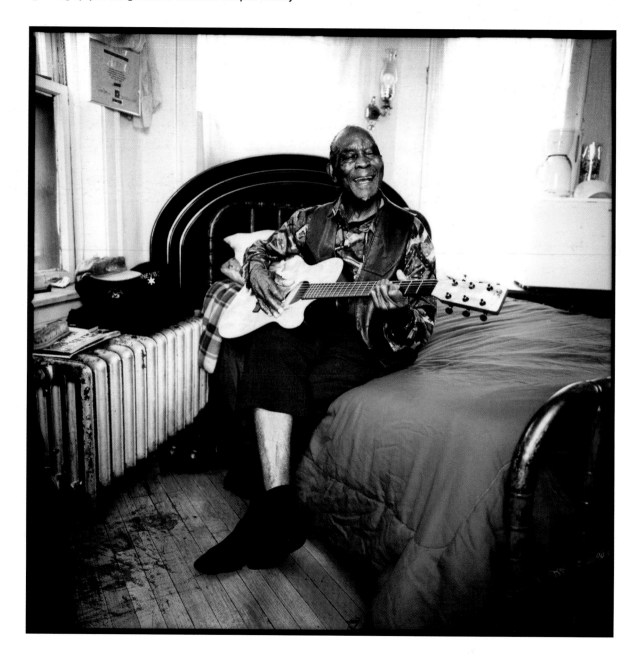

11

Sex, Money, and Drama

Think of yourself and your name as a brand. Maintaining the relevance of your brand identity throughout your career is as important to your reputation and career as is actually having access to a camera. Aside from the obvious and evolving visual aspects of your style, building a good reputation should be an absolute imperative.

This business that we are in as photographers is bizarrely crowded for how lonely it is. On any given production, you, or your people, will interact with dozens of other people whose services you'll need to deliver your shoot. As vast as you think the sea of personnel occupying all the jobs that you depend on might seem, it's a small, small world when it comes to gossip.

There are three universal topics of conversation that people like to blab about no matter what industry you're in—sex, money, and drama. One or all of these topics will affect your career at one point or another. The secret to surviving a few malicious words or a full-blown scandal is having a consistent reputation, as well as learning the art of self-control.

As soon as you throw your hat in the ring as a professional photographer, you are entering an illogical world of politics. This isn't all together a bad thing. Believe it or not, surviving the occasional transgression or embarrassment will bolster your ego and give you a bizarre confidence that looks good alongside a martini at a social gathering.

My First Magazine Cover Shoot

My first magazine cover was for *Diablo Magazine*, a periodical based in northern California. The cover was to feature Marion Cunningham, a famous chef and author of the Fannie Farmer cookbook series. Personally, I didn't know a thing about Miss Cunningham, but my friend and legendary food stylist Susan Massey did. I asked Susan whether she would work way below her day rate so I could have friend on the set who could offer Miss Cunningham a culinary conversation beyond my, "I can make a killer chili-cheese omelet if you're ever hung-over."

Figure 11.1 My first cover; oh, the drama of it.

Because of budgetary concerns, the magazine mandated that *they* would supply the clothes stylist and the makeup artist, which on this shoot was one person. The location was set for Miss Cunningham's house. A brief conversation the night before the shoot revealed Miss Cunningham to be exceedingly nice and accommodating.

Blah, Blah, Blah

When I'm nervous, I talk a lot. This was my first magazine cover, so I was yammering up a storm while I was walking around Miss Cunningham's house desperately looking for my shot. It was the middle of the day, so a natural light style, which I was supremely confident with, was not going to happen. So out came the strobes, with which I had very little experience. Susan, the food stylist, my assistant, and the wardrobe/makeup artist were all standing around waiting for direction as I was going from room to room *still* trying to find a shot.

I could sense the makeup artist, who drove up in a Jaguar and an attitude, giving me the evil eye like "I can't believe I have to work with this idiot." She started barking suggestions at me as if I worked for her, not because she wanted to be helpful, but because she wanted to get to some social event. Apparently, my inexperience was extending her time on the job. I somewhat pathetically tolerated her attitude.

Finally the shot went off, and went off well. Everyone seemed to have a great time. When I turned the film in to the art director at the magazine, she was ecstatic. That is until she got a call from the wardrobe/makeup woman a few days later who slammed me as *arrogant* and *upsetting* to Miss Cunningham.

What?

The art director could have called me and yelled, but she was too cool for that. She very diplomatically told me the situation as it unfolded to her, and then calmly told me that she couldn't use me anymore.

I was devastated. I paid a lot of dues shooting a lot of low-level gigs at that magazine. I had finally worked my way up to a cover only to get fired because some bleach blonde, Jaguar driving, Starbucks-drinking bored housewife—probably forced on my shoot because her husband and the editor play golf together—stabs me in the back.

I had to do something. But what?

Was I Really That Bad?

The first step if you're ever in such as situation is to take a reality check. Did I really come off as poorly as I was described?

I called Marion Cunningham and threw myself on my sword. "Hello Marion, did you hear the photos came out great? The reason I'm calling is that the magazine received a complaint about my behavior on the set. I don't want to get you involved in the middle of anything, but if I in anyway said anything that was offensive, I'd like to apologize..."

Miss Cunningham was amazing. She explained that she thought I was a bit inexperienced, a little cocky, but a lot of fun once the shoot got going. She also reassured me that the complaint to the magazine certainly wasn't initiated by her, and she was sorry to hear about it.

I ran back to the magazine and pleaded my case with the art director. She told me that she believed me, but, unfortunately the stylist was in tight with the editor of the magazine. There was nothing she could do.

It was my first exposure to the nasty side of politics. And it stung. In hindsight, I count it as the least dramatic political situation I've been involved in. Or, in other words, it got way worse as my career progressed. But this particular story was the most memorable because the effect was incredibly far reaching. Mostly, because my client list had only six names on it at the time, and now it was five. Also, it blew my mind about the malicious nature that some people were capable of just because they didn't like my personality.

Politics Happen

Unless you're on the fast-track to a monastic shooting career, there is no escaping gossip and politics. If, after reading this article, you email me and tell me in some highfalutin tone that you don't ever gossip, I'm going tell everyone you're an elitist.

Behind your back.

Gossip is actually an integral part of our being. Studies have demonstrated that gossip is a large component of a democratic society because it encourages free speech. However, there is a significant difference between idle gossip and judgments, as compared to pernicious rhetoric and politics. The latter usually has an agenda or a psychotic person attached to it.

What They Don't Know Can't Come Back and Bite You

In the early years of my career, I had an unbearable propensity to wear my heart on my sleeve. If it was going on in my personal life, the entire set knew about it by the end of the day. This didn't matter a whole lot in the early days, but it eventually caught up with me. My problem was that I thought no matter whom I met, I was supposed to be their close friend. And the way to befriend someone quickly was to share something really personal about yourself.

All that personal stuff started getting around town fast, which wouldn't have been so horrible except that the facts got twisted a little bit every time the story was retold. So what started as "my girlfriend's gay roommate introduced us and that's how we started dating," became "I was sleeping with the gay roommate, and the girl was just for show." This was reinforced by, "just look at how well he and his girlfriend get along; there is no way they're a real couple."

Keep Your Mouth Shut

People will find enough stuff to say about you without you actually providing dirt that's factually accurate. What will inevitably happen in your career is you will work with people whom you dated, slept with, got drunk with, spent some time in prison with, whatever. Keep those details to yourself. When you're on the set, keep things professional. I work with my close friends all the time. It's called nepotism, and it's alive and well. The thing is that no one knows that we know each other beyond the fact that we've worked together in the past. No one. Even if either one of us is approached about the matter. The standing rule is fib and evade. No one out of your inner circle should be privy to your personal life.

Be Aware of How You Are Seen

I would sometimes offer to pick up a model who lived on the way to a shoot just to be a nice guy. Upon arrival at the set, there was an immediate assumption that I was sleeping with the model, even though I wasn't. This didn't bother me so much when I was younger. But when I got older, those types of rumors can be highly problematic. "Oh yes, are you shooting with the dirty old man?" Hmm, not so good for business, especially when you're working with teenage models.

Be Aware of Your Dramatic Actions

I was taken to a commercial set by the executive producer of a commercial production company I had just signed with. He wanted to show me a "director in action." I wasn't there for five minutes before the guy had a full-on tantrum. I thought, who screwed up the lighting, or who missed their mark. Oh no, it was, "who gave me a luke warm cafe latte." Apparently, he wanted it hot. The director made a complete jerk of himself over the temperature of his coffee.

By the way, I'm not perfect. I was on location on a cliff over-looking the ocean trying to nail a shot that I kept missing. The useable light was almost gone, and I was clicking up a storm trying to make the shot work. Meanwhile, someone who had gotten lost was calling the cell phone in my pocket incessantly. The smart thing would have been to give the phone to my assistant to deal with. And that's the exact thought I had as the phone was flying through the air toward the ocean. It took me years to shake loose of that one.

Money, Money, Money

The only people who should know how much money you're making on a shoot are your producer and your agent. On the agency side, the only people who should know your fees are the art buyer and account executive. Keep it that way. Money is universally seen as a gauge for success. I've been on a few jobs where the model was making more than I was. I don't want anyone to know that. The people you hire don't want their day rate floating around the set either. Fortunately, there is an unwritten code that no one talks about money. Even when you're buddying up at the bar at the wrap celebration, keep your finances to yourself.

When Do You Fight, and When Do You Walk Away?

I shot a Best Western ad campaign. The first two ads I did went over so well that they brought me back for one more. Unfortunately, the agency had lost the account, and they were just fulfilling their obligation by finishing the campaign. So, in comparison to the first two shoots, the budget was cut way back, and the overall morale was in the toilet.

To save money, I produced the job myself. At 4 p.m. on the day before the shoot, I realized that I forgot to arrange for a location permit. I had a plan to get one the morning of the shoot, but if it failed I was screwed. I took the account executive into my confidence and told her about the glitch. She promised to keep it to herself.

At the pre-production meeting with everyone in the room going over details, the account executive threw me to the lions. She very proudly told everyone that I had not procured the permit yet and if I couldn't get one the next morning, we would have to cancel the shoot and re-schedule.

I desperately wanted an adult diaper and shot of hemlock for my coffee. She was doing something that you'll see a lot of in the business. Aside from the backstabbing part, she was lighting a fire so she could put it out. She very proudly offered to, "take one for the team" and go to the Santa Monica film office first thing in the morning and pick up the permit. All this was to make her look like a hero.

I decided not to fight. The account was going away, and the agency was going to lay a bunch of people off. The job was going to happen, and I was going to get paid. There was nothing to fight for.

Knowing when to fight is a judgment call based on your gut feeling. Always take the heat if you or your team screws up; that's just professional. But if you're looking at having your reputation screwed up because someone is being malicious, dig in and fight. And be prepared to kiss the job and the client goodbye.

Which is okay to do. Knowing how to walk away from a nasty client is as important as knowing how to get clients in the first place. Standing up for yourself in a bad situation may cost you in the short term, but in the long term, the industry needs to know that you'll be adaptable and professional, but you will not be a punching bag or a pushover to accommodate someone's ego and malicious behavior.

Occasionally, You Get a Bone

A year and a half after the Best Western drama, I was out with a friend who was working at an ad agency in a recruiter roll. She took a phone call, and after she hung up, she apologized and told me that an account executive was lobbying hard for an open AE position in her agency. I asked my friend what the person's name was. Then I told my friend what she did to me on that Best Western shoot. I paid for the drinks that night.

Spotlight Shooter: Anthony Nex

Anthony Nex quite possibly has the coolest story about how he got started in this business. If you've ever seen Stacey Peralta's documentary *Dogtown and Z-Boys* about the birth of skateboarding, you've seen Anthony Nex. He's in the background in one of the shots, skateboarding.

Anthony Nex grew up in Santa Monica, California, and was part of the group of guys who took skateboarding to the next level by skating in empty pools. Anthony and a couple of his friends were hitchhiking one day when they were picked up by James Garner. Yes, the television/movie actor James Garner. Mr. Garner offered a few words of safety advice to the boys as he dropped them off at their skating destination. "You boys should wear some pads or something."

Anthony, 15 and invincible, kindly dismissed the suggestion. A couple hours later he had a broken nose, arm, and chin. Because Anthony was absolutely hooked on skateboarding and the scene that surrounded it, he didn't want to stay at home and recuperate. To have a reason to hang out, in spite of his convalescent condition, he borrowed a camera and started shooting his skateboarding friends.

After the cast came off, Anthony continued to shoot. His efforts got him published in skateboarder and surfer magazines. He became convinced that this was the career path for him when he learned you could make a living at it. When he graduated from high school, his parents laid down the law and told him the only way that he could continue to live at home rent-free was to enroll in school as a *full-time* student. He became a full-time *photography* student.

To further his education and make a few bucks, he started knocking on the doors of other photography studios. He asked if he could sweep floors or any other menial task so he could get in the door. Eventually, he worked his way up to assisting. That's when he started to establish himself as the man who could handle anything.

Anthony was working for a photographer who was shooting catalogs. The photographer was approached to document a new fashion designer launching a fragrance. Anthony's boss passed on the job and made it available to the assistants to shoot. The other assistants were daunted by the prospect of an 18-hour workday, but not Anthony. He took the job in stride. The designer was Gianni Versace. Still living at home at age 19, Anthony was able to save the money he needed to break out of his parents' house and into his own career—with a full complement of gear.

His first major client was shooting catalogs for the May company department store. This turned out to be his bread-winning client for years until he started his own studio.

Anthony has always remained highly independent and close to his work. He never likes to have his agent, or anyone else, deal with the client in his stead. He prefers to interact with the client directly. To him, the process of shooting any photography job is better served when there is close collaboration between the client and the photographer. This philosophy is evident in his work and his reputation. It has also served to bring him a lot of repeat business. Anthony's client list only seems to grow, never diminish. While most of us are bouncing around from agency to agency, Anthony's reputation and talent has clients coming back season after season. This consistency seems to work well for him. Every time I drop by his studio to mooch a cappuccino or to interview him for a book I'm writing, he's about to begin construction to expand his studio space.

When digital started to make its way into the photography world, Anthony was an early adopter. "Not too early," he remarks. "I wanted to be on the bleeding edge, but I didn't want to open a vein." As his career evolved, he found himself shooting more campaigns with children in them. Because of

the limited attention span of children, there is a narrow window of opportunity to get your shots. Digital proved to be an amazing asset for Anthony. By setting up a screen that the clients can view, the client can approve the shots as Anthony is shooting—maximizing the short time span that each child has to offer.

There are a few of Anthony's business practices that I've adopted over the years. Mostly because he is the consummate photographer, and his business practices work well. He has taken the creative aspects of our industry and merged them perfectly with a solid business acumen. And then he goes on to adapt as the industry and market change.

If Anthony had taken the advice of a well meaning celebrity when he was a teenager, none of this would have happened. But it's not just the serendipity that gets me. It's the fact that he had the serendipity while being part of a crew that was making history. That is just cool.

You can find Anthony's work on anthonynex.com.

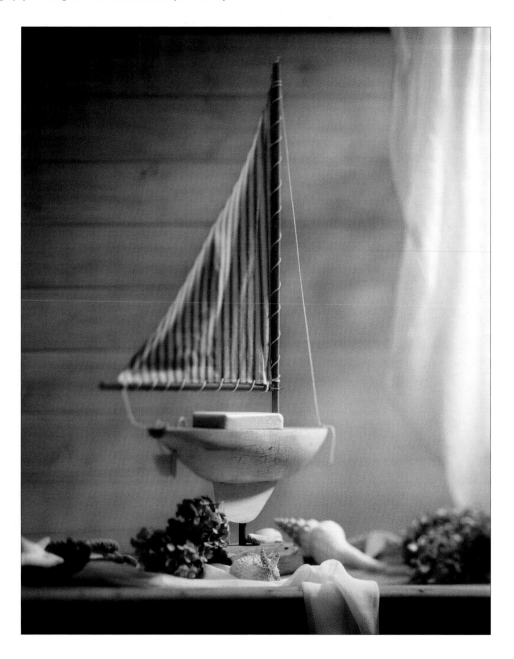

12

It's All in Your Head

There are situations inherent to all photography careers that will provide mind-numbing psychological boundaries to your success. These conditions hide under the innocuous labels of *free time* and *digital lifestyle*. The former is a wonderful payoff for the freelance existence. The latter is a necessary component to competitive self-employment. But that's only part of the story. There is a darker side that, if left without explanation or understanding, will serve to slow down your career aspirations.

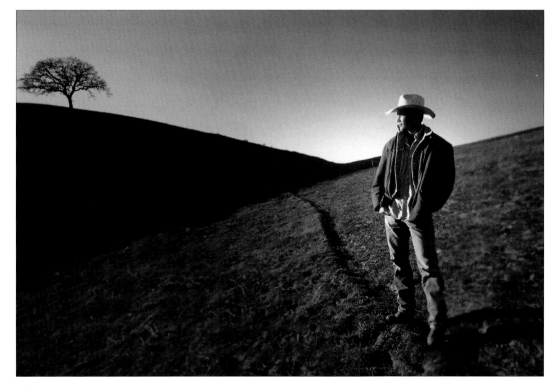

Figure 12.1 Even cowboys sometimes wonder if they're good enough.

What Do You Do All Day?

"What do you do all day?" she asked.

It was a loaded question. She was a 23-year-old upwardly mobile, fabulous-clothes-wearing corporate mover who made a boatload more money than I did. Obviously, she assumed that a young photographer like myself did very little during the day and was consequently always broke and destined not to become successful. To dispel that notion, I immediately ordered a round of fancy drinks. She was impressed and, for the moment, I had quelled her condescension. I quietly excused myself, and then called my credit card company from the bathroom to make sure I had enough room left to cover the pending tab.

Appalled by her assumption about my career, the next morning I set out on a path of creative denial. (At this point, my "career" consisted of a lot of model tests. Some of them I even got paid for.) With renewed purpose, I made the killer to-do list:

1. Steal ideas from magazines to expand portfolio so I can get more paid jobs.

2. Call model agency about more paid-model testing.

3. Call model agency about shooting free model tests to try new image ideas.

4. Location scout for new image ideas (see item 1).

This is what actually happened:

10:15 a.m. Cafe Trieste, Sausalito, California—Order one medium triple cappuccino and sit down with a stack of magazines to get image ideas. Without hesitation, I decide that I'm better than 60 percent of the photographers whose work I'm looking at. Smile at my self-appointed status.

Figure 12.2 Coffee and good intentions only take you so far.

11:30 a.m.—Wonder aloud how these hack photographers get published. Pray credit card doesn't bounce when paying for cappuccino.

11:32 a.m.—Tip liberally to celebrate successful credit-card transaction.

12:30 p.m.—Talk myself out of calling the model agency by assuming they're at lunch. Straight to item four on the list: location scouting.

12:35 p.m.—Receive call from model friend who wants to have lunch.

3:00 p.m.—Finish lunch; tip liberally to celebrate successful credit-card transaction.

3:30 p.m.—Accompany model friend to model agency to theoretically schmooze agents for work.

3:35 p.m.—Gossip with receptionist while waiting for model friend to finish talking with her agent in the other room.

5:00 p.m.—Accidentally find great location in downtown San Francisco.

6:00 p.m.—Have drink with model friend to discuss shoot at newly found location.

8:15 p.m.—Promise model friend headshots for life as a thank-you for picking up the tab when credit card gets declined.

9:15 p.m. Cafe Trieste, Sausalito, California—Celebrate conquering item four of to-do list with a glass of wine. Pay cash.

Avoiding the Freelance Pitfalls

The difference between them (the office dwellers) and us is that we have don't have bosses handing us a bunch of tasks to be completed. Although being your own boss might sound heavenly, self-motivating is infinitely more work than a real job. The most significant hurdle to pursuing any sort of career-forwarding agenda is the wasted day. Cleverly masked beneath a flurry of seemingly meaningful activities, the wasted day never feels truly wasted. Instead, it feels like you're working a lot and accomplishing very little.

There are two steps to having a more productive workday. The first is recognizing the pitfalls that can lead you to squander your time on the planet. The second is adopting better time-management skills.

Pitfall: Shooting Everything Except What You Need

Don't get me wrong, I'm an enormous advocate of constant shooting. But if you're a fashion photographer and you're spending your days shooting semi-nude photos of your significant other, who's already in your portfolio a dozen times, you should take a moment to re-evaluate your shooting schedule. Remember the idea is to show potential clients how talented and diverse you are, not to present them with a photo essay about the person you're dating.

Pitfall: Soon I'll Be an Expert

Next to the camera, the computer is the single most important tool for digital photographers. It is also the absolute number-one time waster. If you find mornings turning into afternoons as you tool around with the more arcane features in Photoshop, as you spend hours tweaking your spam filter, or as you devote gobs of time to downloading and testing 25 five different types of Business Contact Manager, these are signs that you're not getting anything useful done.

Pitfall: Well, Now That It's Thursday...

Cold calling for work sucks. So you might put off a really ambitious list of Monday-morning calls until Tuesday, which magically becomes the list for Wednesday. By Thursday, you can easily justify waiting until the following Monday, because you and I both know that no one wants to talk to photographers looking for work on Fridays. Before you know it, several weeks have passed without a single cold call made.

Figure 12.3 Good shot, but be sure your portfolio shows your diversity, not (just) your obsessions.

Pitfall: The Meetings

Take a brutally honest look at your last 10 "work" meetings. How many of them actually resulted in any sort of career progress? Now, here's the clincher: Out of the 10, how many did you know ahead of time weren't going to do anything for your career? Finally, think about the past two weeks. How many times did you say you were attending a meeting that really wasn't a meeting, but instead was a social event? As a freelancer, it's easy to do, because we have no set work schedule, so in our minds, we're always working. Unfortunately, this thought process doesn't always mirror reality.

As you make connections, stop and think about whom you're networking with. Will this meeting ultimately bring you results? Does the magazine or agency often assign the type of work that you shoot? Are you sending out promos to the world in general, or are you actually targeting your efforts? Do the research. It's easy to do a bunch of useless things under the auspices of getting things done. Don't get caught in that trap.

Pitfall: Your Portfolio Is Still Not Done

Neither is mine, and I've been shooting for 22 years. Waiting to show your portfolio until you think it's finished is the kiss of death. Accept the fact that you will be happy with your portfolio for only a few brief moments in your career. It's an axiom of the business. If you have enough images in your book to win the approval of your close friends and parents, you're ready for prime time.

The common misconception many photographers have about showing their books is that it's your one and only chance to break into the biz. Absolutely not true. The only thing that gets you

noticed is repetition and connection. And connecting is the most challenging aspect to getting in the door.

Consider this: The average time between your first call attempt and actually seeing an art buyer at an agency is three to five weeks. So, even if your book really is not finished, start calling now. By the time you get your meeting, you will have had plenty of time to fill out that portfolio.

Time Management for the Bohemian

Brooks Ferguson is a consultant who specializes in maximizing the time and creative efforts of some of the top writers in the entertainment industry. She was kind enough to share some time-management insights.

The first step to time management is understanding your intellectual efficiency. Everyone is different, so I experimented on myself for the sake of this piece. The key here is honesty. When you answer the questions below, remember there are no right or wrong answers. There is just the reality of who you are and how you operate:

◆ When is your up time?

◆ When is your down time?

◆ When is your creative time?

My up time is first thing in the morning, from 9 a.m. to 1 p.m. I've got that first cup of coffee, I'm well rested, and my mind is sharp. This is a fantastic time to take care of things like bills, cold calls, and anything else that requires quick thinking and efficiency. You'll find that because your mind is moving quickly, you tend to get the stuff you hate done really quickly. This leads to a sense of accomplishment, which gives you the confidence to get even more of the mundane stuff done. Also, when you're feeling sharp, your wit tends to be more ready, so this is a great time to call on people you need to schmooze.

My down time tends to be from 1 p.m. to 4 p.m. This is the time to do the mindless stuff. Run errands, go to the lab, drop off your dry cleaning. Take the time that would be next to useless in front of the computer, and give yourself some external stimulation instead. Remember, you don't work in an office, so there's not a lot going on around you when you're not in production. This is also a great time to work out. If your higher faculties are going to abandon you, do something that doesn't require too much thought and gets you in shape. Physical activity is proven to greatly aid the creative process, and it has the added benefit of making you feel good.

My creative time is after 4 p.m. I don't know why, but this is when the visual ideas start happening; it's a great time to shoot for my portfolio or post-produce the work I've already shot—anything that is creative and enjoyable. This is also defined as "sacred time" when you shouldn't be distracted by the phone or email, if you can manage it.

Everyone's up and down times are different. The most important thing here is to recognize when they are and apply your tasks accordingly. The major anxiety for freelancers is that they aren't in sync with the 9 to 5 world. You never will be. As soon as you accept this fact, you give yourself permission to get things done when it's best for you. I have friends who sleep until 10 or 11 a.m. during their down time and then work until 1 or 2 in the morning. They operate in a highly effective and successful manner. Just don't call them before 10!

The Dreaded To-Do List

Ferguson defines the to-do list as your "achievable goals." When you make a to-do list, you should be able to cross everything off that day. So don't put too many things on the list. It's far more effective to start with four items on your list and actually complete them, as opposed to an ambitious 10 items when you actually finish two. Carrying over a list of things to do from day to day can have a negative and slightly anxiety-provoking effect on the psyche. So make lists that can be accomplished easily. Also, don't put stupid things on the list like "pick up laundry." We all know we need to get our clothes washed. This is not a career-enhancing goal, but a necessity we've been aware of since childhood.

So What Do You Put on the To-Do List?

There is no one "right way" to get new work. Every photographer I know had a different path to success (a fact you can read about in the "Spotlight Shooter" sections at the end of each chapter). The one commonality among us is persistence. The belief that you will become a success is enough to drive you to getting there. Identify what you want, and then pursue it relentlessly. What inevitably happens is that you pick up great assignments along the way. Let me explain.

I always wanted to make into the bible (Italian *Vogue*). Just once I wanted to see my photo credit in that magazine. As I pursued this goal, I ended up with a whole bunch of smaller magazine covers as well as diverse editorial experience. All the networking I was doing resulted in a fantastic client base and some good

bucks. In the midst of one of the busiest seasons of my life, I forgot all about Italian *Vogue*. Then my agent got a call. It seems that a connection I made years earlier led to someone who loved my work and had been waiting for the right time to use me. It just so happened they were doing a bit for the bible.

As photographers, we have a great lifestyle. But if you think we have it easier than the rest of the clock-watching workforce, think again. Yes, we sort of have the freedom to define our own hours—but then again, we don't. We delude ourselves into thinking we're busy when we can't figure out what to do next. This is the tough part. No one is telling you what to do, and coming up with your own personal strategy is difficult because you have nothing to compare the strategy to. My best advice is if you think it will work, try it. If your idea hits, you'll start to see strategies grow from the success. If it doesn't work, pick yourself up and try again. Nothing is easier than procrastination, but nothing is more powerful than persistence.

Technology Stress

The other seemingly innocuous force in our photographic existence is technology. Personally, I'm a whore for technology. Computers, cameras, communications, and spaceships—I am fascinated by the technological leaps that are constantly occurring. Recently, I was shooting a job in a very remote part of southern France. It was thrilling to have the ability to download maps and maintain email contact with my mobile phone. Granted, the price for all this remote access was exorbitant, but it was cool. However, as I learned from one of the foremost experts in the business, technology can be a serious hindrance to creativity.

There is a special indignity in taking a fabulously-shot digital image and transforming it into an overprinted disaster. I did that. But rather than accept my failure and start again, I decided to completely embarrass myself. I sent the image out to a few of my good friends. Funnily enough, they all wanted to see the original shot.

This singular event is not that significant. What is significant is that when I used to print in the darkroom, these types of things never happened. I began to wonder about how technology was affecting photographers. Listing technology's good points is easy, but what about its hazards? Does the same technology that enables us to create beyond our wildest dreams also threaten to cripple our creativity?

Figure 12.4 Technology can inspire and cripple you all in the same swipe.

Any Given Monday

It had been an auspicious day. It started in front of my computer with the intention of multitasking myself through a to-do list as long as your arm, including several emails, phone calls, writing this book, and making the final print I mentioned before. I got started at 10 a.m., feeling lucky that the digital age enabled me to efficiently handle all my responsibilities from my computer and mobile phone. By 2 p.m., I had only just opened the image file, answered zero emails, answered four phone calls, and read three sections of *The New York Times* online. By 5 p.m., my photograph had a disastrous printing halo, and my email inbox had another 15 messages to add to the 10 I still had not answered.

The Sign of the Times

Raise your hand if you check your email right before you go to bed. Keep your hand up if you get sucked into surfing the Web, even though you swore you were only going to check your email for a minute and then hit the hay. If you find yourself feeling fatigued the next day, congratulations; you've become a member of a rapidly growing club afflicted with NEDS (New Economy Depression Syndrome), a condition with a constellation of symptoms ranging from sleep deprivation to anxiety and depression. The disorder goes hand in hand with the technology that photographers have come to completely depend on. Information overload, multitasking frustration, and anxiety are three negative side effects to using technology that may be seriously hindering your creativity.

Give It to Me Straight, Doc

Dr. Larry Rosen is a research psychologist at the University of California and co-author of *TechnoStress*. While he is an advocate of technology, he feels that we need to control technology instead of allowing technology to control us. "Technology has holding power," he says. The multi-sensory, fast-paced nature of media is addictive. Almost every time we get on the computer, we get sidetracked. It's so easy. When you're online, you have access to an unbelievably vast amount of information. Just how vast? Annually, the world is producing over five exabytes of data, enough to fill 37,000 new libraries the size of the Library of Congress. According to Dr. Rosen, the amount of information on the Internet doubles every three months. Combine this with your email, cell phone, text messaging, and instant messenger all trying to grab your attention at the same time, and you have a lifestyle that's based on distraction.

The digital hangover kicks in when you realize just how much time has disappeared and how little you've accomplished. If you find that technology is replacing your personal relationships, you may be in trouble. The folks at Carnegie Mellon University have begun studying our diminishing social network and its effects on society. If the relationship between humans and technology stays its course, our disposable society may include unintentionally disposing of human relationships. To me, all these dire predictions sound like a lovely reason to get together with your friends for a cocktail in the name of saving the world. Of course, planning this event will undoubtedly occur by email.

Walking and Chewing Gum, and Printing Pictures, and Answering Email, and Buying Plane Tickets...

Technology has made multitasking easy. Unfortunately, humans aren't wired for multitasking. Dr. Rosen maintains that multitasking is "awful" for us. It is very easy to get seduced into doing it, but because of the way our brains work, multitasking diminishes our effectiveness at each task. The result is that many things are completed at a mediocre level, much like the print I embarrassingly screwed up. Still, our digital lifestyle comes with an insidious underlying feeling that the only way we'll ever catch up is to multitask. Don't start reaching for that bottle of Xanax yet; it gets worse.

Ever make a call from a your cell phone and lose the connection? When you finally reconnect, the person you were talking to is unavailable. Ever send an email and not receive a response within a day? This sets up a quandary: Did the person choose not to respond, or did my email mistakenly get caught in a spam filter? Of course, if you follow up to confirm receipt and it did go through, you could get branded as annoying, or worse. Now that I've stirred up this frenzy of anxiety in your head, go be creative! The fact is, all these open-ended tasks start to wear on your psyche. Given that the creative process requires a clear mind, technology can really be a detriment to your creative instinct, which, by the way, is why you get paid.

That Sure Is a Big Toolkit

Like most software, Photoshop has an ever-increasing suite of tools. Now, I don't want to sound like an old-timer, but back in my day, we would dodge and burn photographs using a piece of heavy black cardboard and a handful of oddly shaped cardboard pieces attached to long bits of wire. I can honestly say that I've never tried to dodge and burn a print using a sponge. But with so many tools available in Photoshop, we sometimes feel compelled to use them at the expense of our creative gut reaction. Dr. Rosen says it is imperative that you do not lose sight of your craft just because you're presented with a fascinating array of tools. I interviewed 10 of my peers who are not heavy special-effects photographers, and asked them how many Photoshop tools they used in the course of their business. The average number was six. The elements of a good photograph haven't changed that much; the method in which we capture and deliver the photograph has.

Hope on the Horizon

I decided to make myself a guinea pig and apply the following rules to my own life to see if they made a difference. I followed these rules religiously for a week:

- ✦ Check email no more than three times a day: morning, mid-afternoon, and late afternoon. Unless you're in production, forget about your email after 6 p.m. Do not look at your email before going to bed; Dr. Rosen says this can activate networks in the brain that will keep processing when you're trying to sleep. I was amazed when he told me, "I'll bet on the nights you check your email before going to bed, you wake up between 3 and 4 in the morning." He was dead on.

- Cancel subscriptions to email alerts. I had email coming in from a weather bureau, news headlines, travel deals, and the ridiculous tech news from CNET. (Do they ever shut up?) I canceled everything and, somehow, survived.

- Unless you're in production, turn off your cell phone during lunch, dinner, movies, and especially at night if you need to sleep in. Don't put it on vibrate; turn it off.

- Set a time limit for browsing the Web. The computer will suck up your time. If you're in the mood to surf (does anyone say that anymore?), pick a stop time in advance. If you're seeking a specific piece of information, locate it and move on with your life. Don't get distracted.

- If you have to trade emails with someone more than twice on the same subject, pick up the phone instead. A 10-minute chat can be infinitely more productive than a terse email exchange.

- Get in touch with new contacts by phone only. If you leave a voicemail and they don't call you back, they just don't like you.

- Take a day off. Pick one day a week to not look at your computer. Trust me, all the stuff you're worried about missing will be there the next day.

On the eighth day, I did my best to re-create the monastic serenity of the darkroom. No cell phone, email, or IM, nothing but music, cappuccino, and Photoshop. I opened the original file of the image I had overprinted. The final result took about 45 minutes, versus the three hours it had taken me before. The difference was so profound that I found myself wondering how I had ever considered the first version good enough to show anyone.

Since then I've been pretty good about keeping to the rules. The interesting thing is that when I break a rule, the result is fairly predictable. So take control of your technological lifestyle and tell your computer and cell phone who's boss. And if you ever catch yourself actually talking to these inanimate objects, please contact me solely by email. I have a psychologist you might want to see.

Your Ego

If you're a photographer, you need to have a healthy ego. You need it to survive and move forward. I have a healthy ego. Just ask any of my friends. Of course, they'll never say it's healthy; they'll say I'm cocky. But however it's perceived, from a psychological perspective, you need a truly firm belief in yourself and your abilities. You're creating something from nothing in an industry that has no obvious or direct path to success. In fact, this industry has no obvious or direct anything.

Dropping down into the wrong side of arrogance is exceedingly easy to do considering the tightrope you're walking. When I got back from Russia in 1989, I got a lot of attention for a photo of a group of Muscovites walking into a steam cloud. I was constantly getting told how good I was. Everyone liked me. I liked myself. And for a brief moment in time I thought I was infallible. That is until I completely screwed up a shoot. I was young, inexperienced, and lost in a cloud of arrogance that completely unseated me. I believed that I was as good as everyone said I was and I didn't have to work at shooting anymore. In this business, when you're coming up through the ranks and establishing yourself, you're a hero one minute and a loser the next.

Everyone goes through at least one altitude drop in their career. When it happens to you, recognize it for what it is and move on.

Figure 12.5 However good it is, I realized I'm not infallible.

Open Your Mind

Not everyone is going to be affected by everything described above. But it is important to know what can affect you. This is a highly competitive business. If you find you're not moving forward as rapidly as you would like, keep your mind open to all the factors that might be taking a toll on you and, ultimately, on your career.

Reinforce your objectives by asking yourself the following questions from time to time:

+ What do I want?
+ How do I get it?
+ Is what I'm doing right now helping me get it?

Stay focused on what you do, and make sure that the world knows that you do it. That is where the money is.

Spotlight Shooter: Ross Pelton

When I was starting out as a photographer, I kept hearing one name around the fashion industry in San Francisco—Ross Pelton. He was my age, he had started shooting about the same time I did, and he shot on location, just like I did. Except for the fact that he started at a different agency than me, we were competitively neck and neck in the model-testing world. I didn't see his work until about a year and half after I first heard about him. And wouldn't you know it, he was really good.

It's 20 years later. We're meeting today for the first time.

Ross has made a huge name for himself in the music industry by creating iconic images of rock legends like Ozzy Osborne to country legends like Leann Rimes. But getting to that level required a long road of being resourceful.

Ross started out fascinated by fashion editorial spreads in the foreign fashion magazines. He loved the models, the light, and the locations. Ross began by shooting anyone and everyone who would get in front of his camera. When he exhausted his pool of beautiful looking friends, he sought out model testing. Fortunately, his friend's mother happen to own a model agency in San Francisco called *Stars*.

He had an in and he utilized it. And that's about the time that he started stomping on my turf—um, that is to say, that's about the time I started hearing his name around town.

Ross was having a good time in fashion, but he also loved music. So he started sneaking his camera into music shows. Careful not to get thrown out for possessing a camera, Ross snapped pictures of the performers on stage. Then he would, as he puts it, "call every music magazine on the planet and send the images to them."

The magazines responded favorably to his pictures, but they were powerless to publish them because Ross didn't exactly have permission to be shooting at the show. So one magazine remedied the situation by procuring a shooting pass for Ross. The pass allowed Ross to shoot the first three songs of the set only. Rather than see this as a limitation, Ross turned it into an opportunity. He began making friends with the promoters and tour managers. Eventually, they trusted him enough that they allowed him to go backstage and shoot images of the artists.

The magazines were blown away by his access and the images he was getting as a result. One thing that Ross very strongly points out is the importance of relationships and respecting the wishes of those who are in a position to do you a favor. There were times when tour managers would turn Ross's requests for access down. It wasn't personal; it just was what it was. Ross never pushed

beyond that point nor did he try to circumvent the wishes of the manager by trying another avenue. This earned Ross an awesome reputation as a nice guy who could be trusted. The doors that might have been closed at the moment opened up in other ways down the line.

Ross practiced his craft by shooting all the time. He didn't sit around and wait for the big bands; he shot all the unknown bands as well. He would even lend a helping hand by carrying music gear after the show. His investment and decidedly unpretentious attitude paid off. Some of the unknown bands broke big and guess whom they called for photos.

Just as things were cruising for Ross, he hit a rut. The 80s ended sometime in the early nineties, and Ross had absolutely no connections to the emerging grunge rock scene. Lying on the couch trying to figure out how he was going to re-invent himself, Ross fell asleep watching a story on some young girl singer named Leeann Rimes.

He was awakened the next morning by his telephone. On the other end was a gig to shoot a young emerging artist named Leann Rimes. "Ever heard of her?" the voice on the phone asked. Ross, convinced of divine intervention, went to the newsstands and bought every country music magazine he could get his hands on. He quickly became acquainted with the country music world.

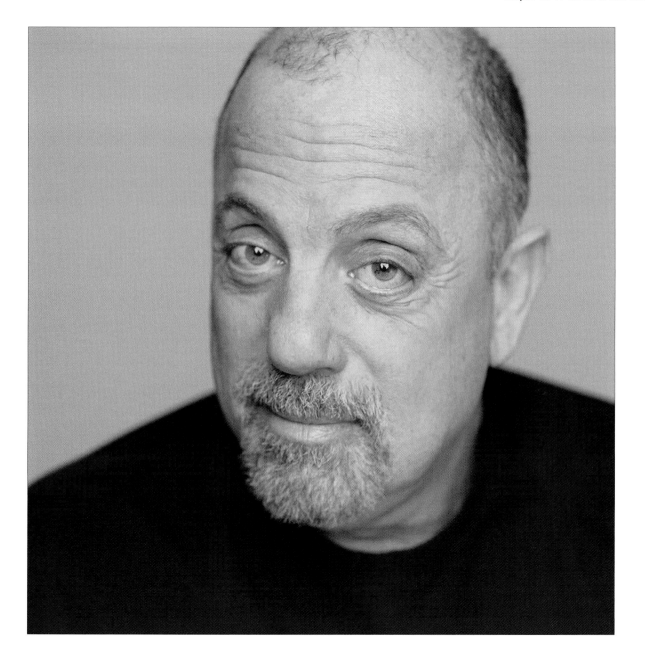

One day a friend, who was a merchandiser for music shows, called Ross and asked if he wouldn't mind being introduced to a group called the Dixie Chicks. The girls loved Ross and loved the idea of behind the scenes photos for their tour book. In a matter of hours, Ross was living on the tour bus with the three stunning women of country music.

Ross took these photos and leveraged them for other gigs. His images, combined with the fact that bands trusted Ross enough to invite him to their tour bus, meant a huge rise to success. He parleyed relationships, trust, tenacity, and good work into a reinvented career. Only this time he eclipsed his first run, working with Tim McGraw, Faith Hill, and a huge list of other music legends.

As you've probably sorted out by now, Ross is probably one of the nicest people in this industry. He is passionate about good work. He doesn't act snobby in spite of the celebrity status of his career. His unique, personal access to some of the musicians he's shot has revealed opportunities for making a fortune from the tabloids. I have personally never seen anyone so resolute about never violating the trust of the people who have opened their lives to his camera.

In a world where the ever-increasing aggressive nature of the paparazzi and photographic opportunists have cast a bit of shadow on our industry, it's amazing to know that people like Ross have an absolute integrity that is immovable. People like Ross make us all look good.

You can find Ross's work on rosspelton.com.

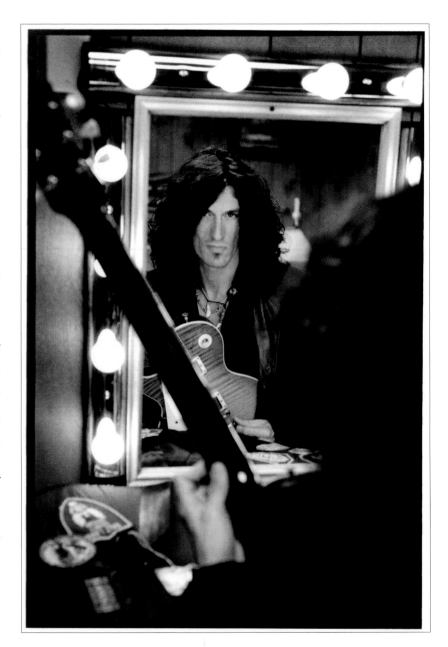

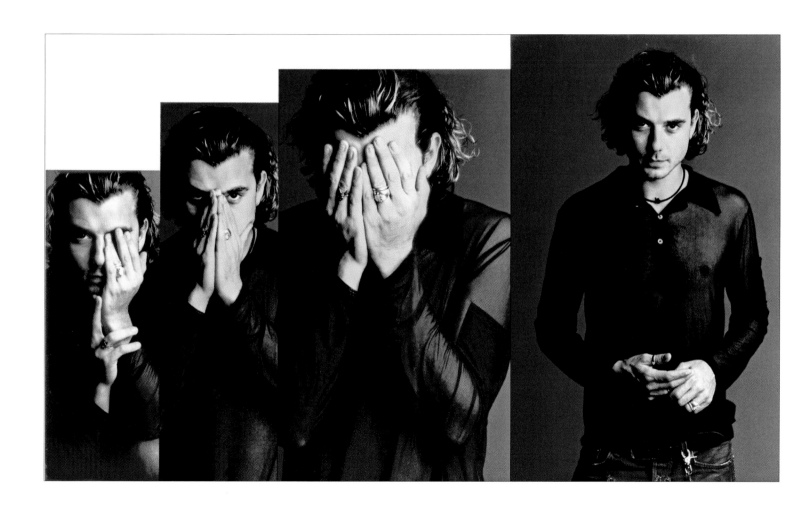

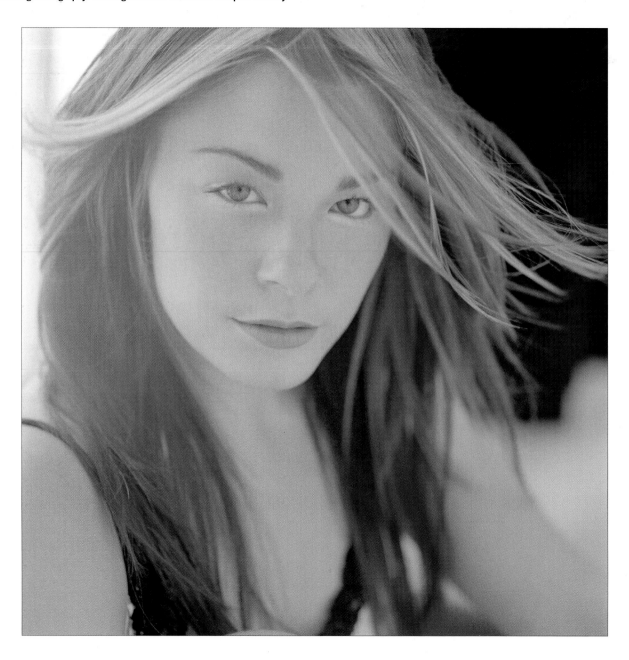

13

Brand Identity

Now that you've avoided ending up on the cover of the tabloids, your cash flow is in order, and your psyche is straightened out, you can start focusing on your brand identity.

Ideally, we should all be recognized for the unique style of our work. Indeed, part of your brand identity is showcasing your work.

You are delivering fabulous photographic talent wrapped up in a marketable package—just as with the movie business or the music industry. Think about how a movie is marketed—from the movie trailer to the bus-stop posters. The movie has a consistent look and feel before the first frame is projected onto a theater screen. You should be thinking in the same terms.

Some would argue that this sort of thinking degrades what we do. I don't feel that it does as long as you remain ethical. Packaging yourself is an extension of your ability to be creative and clever. We are, after all, talking about making a living in an industry that is pure marketing.

Oh Look, It's a Brand

I became aware of my own brand identity when I created a logo for my second Web site.

Figure 13.1
My first real logo.

LOUIS LESKO

In my opinion, and this is by no means an absolute, your Web site should be the center of your brand. It is dynamic and inter-active. Your brand identity can be repeated with each redraw of the computer screen. It is the one element of your identity package that will receive the most attention because it is easy to access and available 24 hours a day. Some photographers book 90 percent of their jobs exclusively through their Webs site without submitting a portfolio. As technology improves, the idea of booking jobs from a Web site will become more prevalent.

With that said, you'll always need a portfolio. You're shooting for a printed medium; showing your work in that medium is cru-cial, especially when you're starting out. But you can plan on the fact that 99 percent of the people who call you to submit your portfolio will have had a glance at your Web site. If your port-folio is called in, there is a 99 percent chance that it will be one of many. So, having an identifying visual element that ties your portfolio to your Web site helps potential clients remember where they saw you before.

Remember, It's Still about the Work

Creating an image for yourself is fun because it truly smacks of legitimacy. It doesn't matter where you are in your career—a hot-looking Web site with coordinated promos and portfolio is sexy and gratifying. Building the look of your brand is an important piece of your overall business. But it should in no way cast a shadow on your photography. It is incredibly tempting to go crazy with design, color, and logos. You probably will. Just be sure to reign in your obsessive tendencies and stay focused on what you do for a living.

The identity you develop should be complementary to how you see your photography. I'd like to emphasize the *how you see your photography* part of that sentence because in pursuing your look, you will most likely seek the opinions of others, and they will have a lot to say on the matter. Listen to everyone's opinion, but remain loyal to your instincts. It is easy to get sidetracked, espe-cially by a good designer. Even though this may be your first time designing, deep in your psyche, you have an idea of how you want you and your look to be portrayed.

Try It Yourself First

Look around the Internet and see what other photographers are doing with their Web sites. Everyone has their favorite photog-raphers and photography style. See what your peers are up to. If you come across one of your favorite photographer's sites and your initial reaction is, "wow, that sucks," have the confidence that you are probably right. Don't convince yourself that you're looking at a brilliant design just because it happens to be attached to a big name.

Then do a Google search for "best Web design" or something like that. Check out the Web sites that are winning awards for being Web sites. Take note of the colors, the graphic elements, and the fonts. What works for you? What feels good on your eyes? Will the designs you're seeing on the screen translate well to print?

Do all of this without asking anyone's opinion. Expose yourself to a lot of different input and then over a day or two, keep track of what you liked. If something you see inspires you, open your copy of Photoshop and start playing around with shapes and colors.

Always remember, though, that when someone views your Web site, they typically do so very briefly. Your contact information, or any information on your site you deem important, should be insanely easy to find and read. Never make it difficult for anyone to hire you. This seems like common sense, but you would be shocked at how many photographers feel that it is cool to have a minimalist design that results in a rousing game of "find the contact info."

The Primary Element—The Logo

A primary brand identity element is your logo. Before you go crazy and start spending gobs of money having a graphic designer create a new logo for you, consider the following points:

- You probably have enough artistic skill to conjure up your own logo.
- Choosing a font that reflects your style and sensibilities is as effective as a full-blown graphic logo.

My first logo was based on a font called Sand. It looked kind of Egyptian. Okay, so it wasn't genius, but the font opened my portfolio, and was on my business card and my promos. Even if it was awful, it was consistently awful throughout.

Your primary element should comfortably convey how you want to be seen. Or, in other words, do you think it's cool? It should also be simple. It should not compete with your photography. Employ your visual prowess. Grab one of your favorite photos and create a quick mockup of a promo with your new logo. If the logo is competing with your image, you'll sense it immediately. (When I say a quick mock up, I mean don't dwell on perfecting the promo. You're focusing on a logo right now. Trust me on this; it's easy to get distracted. It's in our nature to obsess.)

When Are You Done?

If you like what you've created, go with it. Refine it and finalize it. Remember, it has to work onscreen *and* in print, so make sure the resolution can handle both mediums. If you are really pulling out your hair, it might be time to call in some help.

You live in the creative world. Someone you leant money to, or dated, or bailed out of jail is probably in graphics. Call in a favor. Or, if you've got the bucks, hire someone. But be sure to keep focused on what you're doing. You are a photographer trying to get work. If you spend money on a logo, it should not be in place of spending money on an effective portfolio and Web site. It should be in addition to it.

The Secondary Element—The Color Palette

The secondary brand element could be your color palette, or perhaps the lack of a color palette. I knew a photographer who was heavy into the color white. His Web site, promo, and portfolio were awash in white with the exception of a medium gray line that he used to frame his images in his portfolio and promo. The gray line then showed up as a graphic element in his business card. It was slick.

Even if you were to take the idea and run with it for yourself, your interpretation would be different than his. So go for it, if you like. In the current iteration of my brand, I have all my images on rectangular pages in my portfolio with the images placed toward the outside edge. I repeat the composition in my Web site, my promo, and my portfolio.

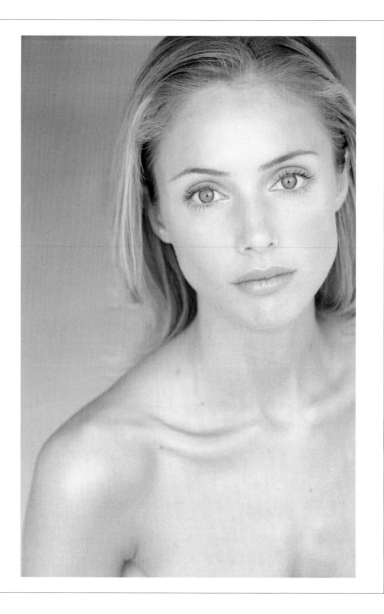

Figure 13.2 A page from my portfolio.

Your secondary brand element should be relegated to the background and be easy to reproduce in all the mediums that you plan on representing it in. And, I'm sorry if I sound like a psychotic sitting in the corner saying the same thing over and over again, but your secondary brand element is a touch, not an overwhelming facet that casts your work in a shadow. Getting your work out so potential clients know you exist is absolutely the most important goal here.

Bringing It Together

Before you go racing off to the printer, or start talking to a Web designer, make sure you like the look and feel of what you've created. Even if you had someone create a logo for you, take the time to really look at it before committing to the Web design and any printing. Mock up the look of a Web site in Photoshop. You don't have to have all the buttons and technical elements, but a rectangle with a background color and your logo or type face and one of your pictures will be helpful. (This has the added benefit of having something to show your Web designer or the designer at LiveBooks if you go that route.)

Grab a beer and squint your eyes, talk to it, look at it with the lights on, and look at it with the lights off. Good job. It's done. Now walk away from it for 48 hours. I'm serious, don't even peek.

After 48 hours have passed, look at the elements again. If you still like it, it's time to get it out there. If you don't like, now is the time to make the executive decision to change things around. This is why it's good to take a break—a fresh set of eyes is always more discerning.

There is a fine line between perfection and obsession. A perfectionist looks for the subtleties and strives for a flawless result, but ultimately makes a decision that a project is done. Someone obsessed watches time slip by under the guise of perfectionism. It is important to be happy with your brand and wait until you think you have it right, but it is disastrous to obsess on it for too long. If you spend more than a week doing *minor* tweaks, you're obsessing. If you kill off more than six reasonable attempts at a brand look over the course of two months, you might want to take a look at your commitment issues.

Keep these points in mind:

+ You were thinking about the look of your brand before you sat down in front of the computer to play around with graphics.

+ You are inherently creative, have some confidence in that.

+ You do not have to seek the approval of 15 levels of management for your brand. You just have to make sure your parents and significant other dig it.

Change Is Good?

When I interviewed the agency art buyers for the "Getting Noticed" section of Chapter 1, there was a comment that was consistently volunteered without any prompting by an interview question. Everyone liked photography promos that showcased new work in a consistent layout. I never knew that until I wrote the piece. There is something highly effective about choosing a layout or, as I'm talking about here, a brand identity and swapping out the old work with your most recent photographic endeavors. There is something good about someone looking at

your promo, portfolio, or Web site and registering a recognition of the brand, because it will compel them to notice the new work. It is inherent in all of us. We want to know what people we know are up to. Even if we don't know the individual personally. It goes along the lines of, when someone noticed your work before, and then they recognize your layout, they'll want to see what's new with you. The payoff comes if they look at your work one time and make a mental note to keep an eye on you, and then the next time they recognize your brand and see that your work is better, they will go looking for more.

So when is a good time to change your brand? This question requires instinct. I came to the concept of branding late in my career. Previous to adopting a branding scheme, I was putting promos out left and right, each one different in design than the previous one. The first time I had any consistency between my Web site, promo, and portfolio it looked like Figure 13.3.

My brand image stayed the same for four years. Looking back, that was probably one year too long, but when you have your

brand identity in place it's easy to leave it alone, especially if it's working. But, eventually, it started looking long on the tooth. It was time for a change.

The re-branding efforts consisted of a new logo design and a new color scheme. Personally, I liked the logo that I had in terms of its shape; it was the color that looked dated to me. Also, I had moved into directing commercials, so I wanted a way to add that information to my brand identity. My agent was an advocate of a whole new logo and a big "launch." I appreciated her enthusiasm. She had a friend of hers put together some new logos for me. (The money for the new concepts came out of my pocket.) After a few rounds of logo ideas, nothing was striking me with full force. It wasn't that the design concepts weren't good, I just had a gnawing feeling that re-design was a bad idea. In the four years of the previous brand, the current logo had become recognizable, and I hated the idea of trying to build a new visual association between me and a new logo.

Figure 13.3 My first Web site on the left. My first branded Web site on the right.

Just about the time I was getting talked into a whole new look, I sought the advice a friend who was a branding expert. She told me that once you have any sort of reasonable brand recognition, it's sometimes better to *update* the look of your existing brand. This concept seemed to echo what the art buyers were talking about when they said they liked a consistent layout.

Figure 13.4 The new and improved Lou Lesko brand. Now with less trans fat.

I went back to the people who created my original Web site. I gave them two criteria—keep the logo foundationally the same and add the fact that I was directing commercials. Figure 13.4 shows what they came up with.

I loved the result and adopted it for my portfolio and promos. I liked the idea of a "launch," which is an agent's fancy way of saying "announcement." We made a set of four promos out of my most recent images and sent one out every two weeks for four cycles. We then went back to the normal mailing schedule of once a quarter. It was the first time I had ever utilized a mailing list service like Agency Access. But my agent really wanted to make a splash. Agency Access provides a fantastic set of tools for targeting your mailings. You can check them out at http://agencyaccess.com.

Currently, we're working on another minor update that involves changing the color palette a bit. Figure 13.5 shows one of the first efforts as we start to work on the minor update.

Figure 13.5 The most recent update. Still working out the details.

Change Is Bad?

One of the pitfalls you want to avoid is constantly changing your mind about the look of your brand identity. I made this mistake for some years. Honestly, I really didn't have much of a brand identity. But I was definitely prone to two major mistakes when promoting myself—sitting on a promo design for too long and changing the look of my promo too often (almost monthly!).

Once you get a brand image into circulation, you should commit to it for a few years. There are a few exceptions to this advice:

+ If you're in the first part of your career and you're still finding your way, changing things around a bit isn't going to kill you. Just be sure to not dally too long before settling on something that you can live with.

+ If for some reason you discover your brand image conveys something that you don't want it to convey, it's time to change it. For example, if for some reason your color scheme reminds people of a serial killer, it's a good time for an update. The rule of thumb is if one person tells you that your brand image reminds them of something negative, it's just an opinion. If three people tell you your brand image reminds them of something negative, it's a problem. Listen.

Don't get too self-righteous about your brand image. It is one thing to stand up for the vision of your photography when accosted by dissenters. Do not ever compromise your work. But be more flexible with your brand image. See it for what it is: a marketing platform to get you jobs.

There may be other exceptions that pop up in your life that are just as valid as the ones I state here. Follow your instincts. But definitely avoid constantly changing your brand because you're indecisive. Brand identity is important, but it doesn't matter if you don't have strong work to pitch.

Complete Makeover

A complete makeover of your brand identity can be brilliant and fun. The danger here is that you can't just change the wrapper. Make sure your content is new as well. If you're creating a whole new look, make sure that there are new images on your Web site, too, as a payoff to potential clients. Makeovers can spawn requests to see portfolios as well, so make sure you have the new images printed and ready for a portfolio presentation.

Staying Relevant

Photography goes through trends. One year, the trend is desaturated color, the following year it's highly saturated color. One year, it's all about boy models who look androgynous, the next year it's about boys who look like rugged men. Staying relevant is an interesting balancing act between maintaining your artistic integrity and keeping your work viable for the marketplace.

At one point in my career when I was working a lot for magazines, I started to see images utilizing cross-processing. These were the days before digital when the cross-processing effect had to be done in the lab. As the name implies, the process took shot positive film and put it through the development process for negative film, or the other way around.

The effect went from showing up in a few places to showing up everywhere. More and more variations were evolving, and it became the cutting-edge trend in shooting. It was also the antithesis to my style. I distinctly remember trying my own version of cross-processing, only to abandon it after the first few attempts.

The cross-processing look just wasn't for me. I couldn't get passionate about it, so I never got good at it. I just kept going with the clean, simple natural light look that I liked, thinking that it was *classic* and *classic* never goes out of style. My work dropped off precipitously. So much so that I had to fall back on model tests and head shots to make up for the loss of income.

Fortunately, the cross-processing trend was an extreme look that quickly saturated and overwhelmed the marketplace. In spite of the predictions of the death of classical lighting, there was a huge backlash to cross-processing, resulting in a huge pendulum swing back to natural light and clean composition.

It was the first time I had ever been directly affected by a marketplace trend. If you're wondering whether I regret not getting on the cross-processing band wagon, I don't. In hindsight, if I had tried, I would have done more long-lasting damage to my career in comparison to the short 13-month hit I actually took. I was never going to be good at cross-processing; I just didn't get it, and I was far too lazy to experiment with it enough to get good at it. If I had put cross-processing images in my book, they would have really brought down the overall quality of what I had to offer as a photographer. I was slowly starting to build up a good reputation; had I gotten on the cross-processing train, I would have shot myself in the foot.

Years after the death of cross-processing, a more subtle trend began to emerge in photography that made my portfolio look positively dated. This time the trend had a bit more to do with the use of color. And this time I thought it looked great, so I adopted a version of it that complemented the way I like to shoot. The result was a happy agent and a portfolio that maintained its relevancy.

Market relevancy can be a interesting balancing act. Which trends you decide to chase are decisions that you'll have to make as they come up. The one bit of advice that I can give you is, if you try a certain style of photography that doesn't feel right, don't push it—it's not for you. You are far better off going with what you know and trying to match clients to your natural style.

Another more effective method is to come up with a unique look. Lisa Wiseman is a student whom I met when I spoke at the Academy of Art in San Francisco. When she graduated, she asked if I would have a look at her portfolio. There was a piece in her book that completely took me by surprise. It was unique in its style and viable for the commercial market. I was so inspired that I offered to show her book to two art directors I knew so she could get some input on her work. Without prompting, the art directors responded to the same image.

Always try to stick to your style, but at the same time don't be averse to change. One of the most well-known photographers of the our time was Herb Ritts. Sadly, he is no longer with us. His work is extraordinary. But, at the same time, even though I consider him iconic, I can distinctly remember seeing one of his editorial spreads advertised on the cover of a magazine and then opening the magazine and being really disappointed. In my opinion, Mr. Ritts had shot the well-established celebrity running on a Malibu beach just one too many times. It was definitely time to explore new territory. I think he would have probably thought the same thing, and I'm truly saddened that the world won't have an opportunity to see what new direction he would have chosen.

Staying relevant means staying abreast of all the aesthetic changes that happen in our industry. It also means making a decision about whether you want to chase the trends, or just skew your

style a bit to stay in the game, or dig in and stay resolute about what you do. There are no wrong answers here. Always keep in the back of your mind that your ultimate goal is to establish a style that is uniquely yours—a style that will be in demand based on its own merits.

The Art of Reinvention

Brad Mollath was a photographer I knew in San Francisco some years ago. He was a fantastic fashion shooter who had crossed over from shooting food. Years later, after I had moved to Los Angeles, I ran into a model's agent I knew from my model testing days. We had one of those nights of lots of wine and reminiscing about the *old* days. I asked about Brad, and the word was that he went back to shooting food because the money was better.

Most photographers, even though they are typically associated with one genre of photography, are usually very good at two or three. About this time, I was experiencing a complete burnout on the fashion industry. I was tired of shooting editorial campaigns for art and clothing catalogs for money. I needed change. My agent at the time was all in favor of supporting me in my reinvention as *location shooter dude.*

I changed my portfolio, my Web site, and my promos to all location photos. I had no idea what the market was like, but I did know that I didn't have to hire a whole bunch of crew and talent to execute a shoot. It was bliss for the first few months. I had booked a job from an agency handling the Anderson Windows account. I got paid $5,000 for two years of usage for a sunset picture of El Matador state beach in Malibu, California. The shoot itself took 20 minutes, and I didn't need an assistant. Sadly, that was the only job that came my way as *location shooter dude* with that kind of money associated with it. I picked up a few small jobs, but art directors were calling me to see what I had that was already shot that they could license. My reinvention experiment lasted 10 months before I decided that I had spent enough of my savings account. I started rebuilding my people portfolio.

There was an interesting effect that occurred as a result of my foray onto another genre. Since I had dropped out of the fashion/lifestyle scene, people were calling me up wondering what happened to me after apparently being gone for a year. I wanted to tell them about my riveting experiences shooting beach fronts for window ads, but I chose to casually evade the question instead.

Reinventing yourself in a different genre is definitely an attainable goal. You just need to consider a few issues and plan your move wisely. Start by getting yourself in a position to build a financial cushion so that, when you make your move, you'll be able to afford the dry spell you'll be faced with when trying to establish your name in the new genre. As you're building your new genre portfolio, keep shooting in your original field, and keep your mouth shut about your plans. You don't want to scare off your current clients. They're eventually going to find out what you're up to, and you'll never be able to predict how they will respond. Don't feel compelled to chase their paycheck away too quickly.

Utilize what you know. You're not just graduating from art school here. You've been in the trenches. Embrace your experiences from your first round and plan a sophisticated marketing assault on your new industry. You know what works and what doesn't work. Choreograph your launch so you hit the new genre hard and fast. See how quickly you can start getting a response in comparison to your first time out. Whatever you do, do not be lazy and waste your existing intellectual and experiential assets.

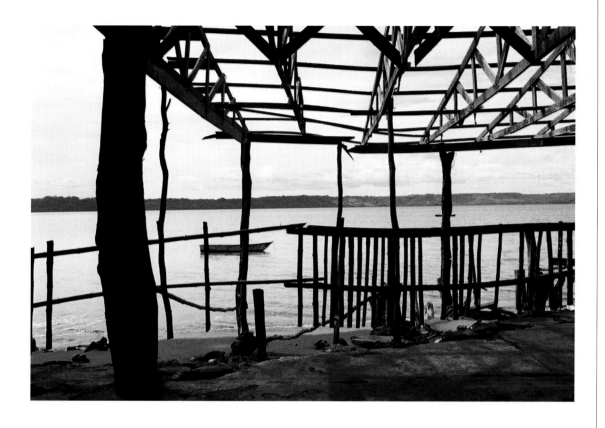

Figure 13.6 One of the pieces from the newly reinvented portfolio.

Some people I have spoken to about this idea of reinvention are advocates of *going dark,* which means dropping out of your current scene for a period of time and then popping up in your new one. I'm not sure that that is so helpful because you're typically moving over to a whole new group of people who have not heard of you anyway. And, like I mentioned previously, you don't want to cut off your current cash flow. You also have to realize that none of the people advocating the *going dark* method have actually tried it. It sounds dramatic and Hollywood as hell, but being broke sucks.

Because you are committing to your new genre, make sure you are absolutely passionate about it. This was my biggest mistake when I tried my train wreck of a reinvention. I love shooting location photos on my terms—when the mood strikes me. To me, the worst day shooting the type of stuff I shoot now is still a pretty fabulous day.

When you're ready to launch into your new genre, throw a party. Invite all your friends from the advertising world. There is no quicker way to launch onto a scene than by throwing a party with your new genre images hanging on the wall. Gossip moves like an Australian bush fire in the summer. Don't let the word get around slowly and by itself. People will invent reasons why you're genre switching. Throw a party, get them drunk, and tell them yourself why you're switching. You can't control gossip, but you can go on the record with an accurate version of the truth. In general, people love bold moves like this. Nothing says you're more confident about your choice than a fabulous gathering.

Which brings me to my final point. Be confident in your choices. This industry has very little tolerance for genre confusion. People like to categorize photographers. I'm not saying it's right, but it is an absolute truth about this industry. If you're going to reinvent yourself as a new type of shooter, under no circumstances should you do it half way. Embrace your decision with everything you have!

14

That's a Wrap!

A little while back, I was shooting an ad campaign for Microsoft. It was scheduled for three days in three different cities—Seattle, San Francisco, and Detroit. The campaign featured portraits of designers of cool things. The first shoot day was in Detroit, Michigan. I was shooting one of the engineers responsible for the Audi TT automobile, Marc Trahan.

Because of an insane deadline, the art director wasn't going to have the time to fly across the country from Seattle to meet me in Detroit. So we arranged to get shot approvals via email and FTP. One of my favorite assistants, Denise, was in her home town of Chicago visiting family, so we agreed that she would rent gear in Chicago and fly down with it for the day to Detroit, returning to Chicago and her vacation at the end of the shoot day. My only responsibility was to bring my laptop and a nine-foot white seamless.

The day before the shoot, I looked up the phone numbers and addresses of two camera stores in Detroit, intending to pick up the seamless the morning of my arrival. The shoot was scheduled for 1 p.m. about an hour outside of Detroit at the Audi corporate headquarters. Based on my arrival time in Detroit, I had four and a half hours to get to the photography store, go back to the

airport and pick up my assistant from her later flight, and get to the location with enough time to set up the shot. The plan was simple and had a good amount of buffer built-in for delays and unexpected problems. Even though neither camera store had picked up their phone when I had called the day before, I was feeling like things were running smoothly.

War Zone

My overnight flight from Los Angeles to Detroit was the only part of the plan that offered no contingency if something went wrong. So, I felt a small burst of relief and confidence when I landed 15 minutes early. I called Denise in Chicago. She was running on time to pick up the camera and lights to make her flight on time. Even if she wasn't, the Chicago to Detroit route was serviced hourly by three different airlines. She could have missed her flight three times over and still not put a wrinkle in the schedule.

I took to the streets in my rental car on my way to the first photography store. There was no answer when I called, but it was 8 a.m. I decided I would hang out in front of the shop and just

wait for them to open. As I drove through the city, I was shocked to see how desolate it was. Many of the buildings had been abandoned and were in a state of decay. I kept waiting for a radical shift in the landscape, assuming that the desolation was confined to a small area, like I had seen in other cities.

A small twinge of panic hit me when I arrived at the abandoned shell, which used to house a nice photography store. Not wasting any time, I called my assistant's voicemail to tell her I would be a little late picking her up. I looked at my map and drove over to my backup photography store, which was no longer a photography store at all. It was, well at least I think was, some sort of mobile phone repair shop. My buffer of time was gone now, so I started speeding back to the airport.

In an attempt to avoid wasting time by potentially getting lost, I asked an airport police officer if the map and directions I had to Audi were correct. He confirmed them and then gave me a quicker route to the interstate. Denise and I agreed that it would be more prudent to overexpose a white wall than it would be to try to locate a photography store on the way to Audi. The potential to get lost and arrive late was too high. Our engineer was incredibly busy and getting ready to leave the country. His assistant barely squeezed us into his schedule. We had access to him for only 30 minutes; if we missed our designated time, we missed the shot.

Dark, Beautiful, and Useless

The Detroit suburb where Audi is located is stunning. A little luck with traffic put us dead on schedule to allow for an hour prep time. The inside of the building was a gorgeous mixture of huge glass windows and dark brown wood paneled walls. Different hues of dark paint accented the wood, giving the whole

interior a very elegant look. To convey an environment of calm sophistication, the interior designers had chosen a color palette completely devoid of any white, anywhere.

Denise and I split up in a manic search for a white wall. The hour of appointment was fast approaching, and we had not even lit our set, nor had we made contact with the ad agency to arrange image transfers across the Internet.

I peered in through the locked glass doors of the Audi/Volkswagen museum. There, next to a vintage VW Bug, was a gorgeous four-foot-wide *white* pillar. "How do we get into here?" I yelled to the front desk receptionist.

"You don't. The museum is closed."

I ran upstairs to Marc Trahan's executive assistant—our liaison. She got the doors unlocked and Denise started to set up lights while I found an open Ethernet cable so I could get access to the Internet.

Back in Seattle at the agency, the account executive for the job was in the conference room talking to me over a speakerphone. She gathered the art director, and by the time I sent my first test shot of Denise, we had a viable system for remote art direction and approval.

The art director was a very soft-spoken guy with a heavy Japanese accent. I was thrilled to be working with him because his work was really cool, but over the phone, without the benefit of visual cues, I was having a little trouble understanding what he was saying.

The account executive was trying her best to be helpful by repeating key words from his softly spoken sentences without drawing attention to the fact that he was soft spoken. It's a skill that should only be attempted by persons working on the

account side of our industry. On the third set of test images of Denise, I asked the art director if he liked what I did with the light to favor a three-quarter angle towards the camera.

I thought I heard him say he really liked the three-quarter angle. This was readily confirmed by the AE who repeated key words in her own sentence: "Yah Lou, the three-quarter angle looks great."

Marc Trahan walked up and introduced himself. Inside my head, a 30-minute timer started to count down.

Brazil

Marc Trahan is a brilliant, cool guy who likes good wine. As we were quickly trying various styles of black shirts on him, he apologized for having so little time. Apparently, he was the key guy for the huge "Brazil" meeting, which started in 27 minutes. I pushed him for details about what was going on in Brazil. He told me it was very hush, hush. What he could tell me was that he was called in to save the project at the last minute. He wasn't all that happy about it because he was already pushed to the limit, and he didn't want take any more time away from his family.

I shot a few images, did some fine-tuning of the lights, and then shot a few more to send to the agency for approval. I was down to about 14 minutes. In a Seattle agency conference room, the account executive confirmed receipt of the test shot of Marc Trahan. I asked if they liked that I pulled back to show a three-quarter length of Marc. It was just a skip of beat before I heard, "I agree, the three quarters looks great." What I didn't know was that the art director had left the conference room. The last time I said the words "three quarter," the art director liked it a lot, so the account executive reinforced what was said earlier. Unfortunately, she didn't know that this time I was talking about length and not about angle.

Pressure was mounting for the notorious "Brazil" meeting as more suits started to file past the museum door and Marc's assistant checked in to check on our timing. I must say, to her distinct credit, she approached the time issue with extraordinary diplomacy. Marc, in true cool guy spirit, told me not to worry too much about the time. He would make everything work out. I started firing off frames as fast as the strobe lights would cycle.

One hundred and forty frames and 20 minutes later, I declared that "we got it." Marc and I shook hands. He changed back to his own shirt and disappeared. Denise went outside to have a cigarette and I went upstairs to send some images to the art director. I did a quick edit of the images and sent my favorite three to the agency. I breathed a long sigh of relief as the images transferred. I looked at the clock—we had plenty of time to catch our flights, which was great because they were the last two of the day for our respective destinations.

Could You Repeat That?

"The lighting looks great!" The art director was looking at the images and I was smiling to myself. "Are you going to shoot some shots tighter so they'll fit the sizing perspective of the ad?" I didn't miss a single syllable of that sentence, and, yet, I still apologized out loud like I didn't hear him. "We need the images to be shot a little tighter than half length."

We went back and forth, politely, trying to figure out how the miscommunication happened. I took a glance at the clock. I told the art director to stay by the phone and his computer. Somehow, I had to get Marc Trahan out of the "Brazil" meeting for a re-shoot.

Marc's assistant looked at me like I was a leader of a Salem witch-hunt mob. There was no way she was getting Marc out of that

meeting. She was as nice as could be about the matter, but she wasn't budging. I politely pushed. I tried everything, until she finally said that she would look in on the meeting. Denise followed her to find out which conference room the meeting was being held in. Marc's assistant came back to me and said there might be a break, but she was unsure that Marc could get away. Her phone rang. As soon as she picked it up, I bolted toward the "Brazil" meeting. I was getting him out of that meeting.

As I was walking down the hallways, I checked in with Seattle. "Just waiting for Marc to finish a conversation," I said. "Just please stand by the computer, and I'll get back to you." By now, a crowd had gathered in the agency conference room. Everyone loves watching a train wreck, I thought to myself.

I discreetly looked into the door of "Brazil." I couldn't see Marc. That meant he was out of my view against the near wall. I guessed what side I would try, swept my hair back in some ridiculous attempt to look more presentable and prepared to walk in like I belonged there. I started doing a quick confident step toward the door when Denise stopped me.

"Marc went into the bathroom." she said.

"Are you sure?"

"Yes, I followed him there."

We sprinted toward the bathrooms. I went in. No Marc. He must have slipped out while she broke away to find me. I ran back toward the meeting. Denise was there. She confirmed he didn't go back in. Denise offered that he was probably fetching something from his desk for the meeting. Brilliant thinking, I thought. She took one hallway; I took the other. I practically collided with him.

If You Do This for Me, the Reward Will Be...

I spoke so fast, that to this day, I still have no idea what I said. Marc was visibly pissed, but agreed to the re-shoot. Denise called Seattle to tell them an image was coming fast for an approval. I walked with Marc downstairs to our mini-set in the museum.

Sometime between Marc putting on the black shirt for the shoot and the first test image (shot tighter), he smiled. "You know what, I don't think I'm going to deal with that Brazil thing." I desperately wanted to ask what the "Brazil" thing was, but I figured I was already on cracking ice. So I just excused myself and sent the test shot to the agency.

I politely asked the art director to pick up the handset to the phone. He approved the image. Ironically, because Marc had decided that the "Brazil" issue wasn't for him, the second set of (tighter) images were much stronger than the first set I shot. Marc was more relaxed and had a lot of fun. I thanked him over and over and then asked him for the quickest route to the airport.

As Denise wrapped the set, Marc drew me a map, in a few short minutes, that rivaled the Thomas Guide. He gave me his card and his cell phone number. He said he would stay at his desk for an hour just in case I got lost. "What about Brazil?" I asked. He just smiled and thanked me again.

Denise made her flight. As for me, I rerouted to New Orleans to surprise my friends and get a very large scotch. Two days later, Monday, I was back in Seattle on a studio set shooting the second image for the campaign.

Figure 14.1 The ad of the coolest engineer ever.

That's a Wrap

This *almost* disaster was completely my fault. It was a situation of duality. My two decades of experience fueled my confidence, which made me a little cocky, which caused me to miss some extremely subtle cues that, had I caught, would have avoided the drama. The art director is your boss, approval to move forward comes from them only. But it was also my experience that kept me focused on getting the shot no matter what the short-term consequences. Mr. Trahan was leaving town and a later re-shoot, given the campaign deadline, was not going to be an option. The frightening part is had Marc not been such a cool guy, I would have been doomed. For that, I will always be thankful. Because no amount of experience or confidence can make someone do something they don't want to do. This is why I urge you to follow the advice I heard from an elderly woman in New Orleans: "Be kind and everything else will work itself out."

Yesterday, I received a check for the usage of an image that I shot over 10 years ago. It is an incredibly simple photo of a runner on a dry lakebed. My friend Kristen, the runner, and I were sitting around one morning looking for something to do. I spied her running shoes on the floor of her apartment and suggested a trip out to a dry lakebed with camera and running attire. The drive out took two hours. The shot, 20 minutes.

That was the extent of the planning and execution of an image that, over the last decade, has netted me a couple of thousand dollars and has placed 12 times in two different countries.

At the time that I shot the image, making money from it wasn't remotely on my mind. That came later with the guidance of a photo editor name Julie who worked at Corbis images. What was on my mind was trying to illustrate a feeling I had that was part fantasy—being alone on a remote plain—and part experience—

I was an avid runner at the time. Okay, maybe the fact that Kristen had killer legs didn't hurt the cause either.

It still strikes me exceedingly bizarre that a random vision that popped into my head can net me the means for a living. After all these years, I still find it odd to get paid for what I love to do so much. And then I think about all the politics and garbage I have to tolerate and begin wondering if I shouldn't get paid more.

Every vocation has its ups and downs. You're here because you love what you do, and you're probably pretty fabulous at it. Completely contrary to what you may think, the tough part of photography is making a living at it. Improving your practical and creative skills happens every time you pick up a camera or toy with a concept in your head. Any experience you have at all makes you just a bit better today than you were yesterday.

Don't get too intimidated by the superstars. They provide something to aspire to, and I truly wish you all the luck and success in achieving your goals. But as you're working your fanny off trying get there, don't forget to stop every once in a while and take a look at what you have. You have the gift to deliver visual stories that affect the people who view your images. This is an epic feeling.

There was a second half to the advice I got from the old woman in New Orleans. The full quote is:

> Be kind and everything else will work itself out. And always be thankful for the people who are kind to you.

This profession is incredibly solitary. And yet we would be nothing without the people who help us along the way. Keep them in mind as you become increasingly successful and don't forget to pass on the knowledge of your experiences to the people who are following behind you.

Goodnight, good luck, and may good fortune follow you wherever you go.

Figure 14.2 Kristen running.

Index